TECHNIQUE ANGLAISE
CURRENT TRENDS IN BRITISH ART

TECHNIQUE ANGLAISE

CURRENT TRENDS IN BRITISH ART

EDITED BY
ANDREW RENTON AND LIAM GILLICK

THAMES AND HUDSON

ONE-OFF PRESS

Library of Congress Catalog Number: 91-65321

First published in Great Britain in 1991 by Thames and Hudson Ltd, London.

First published in the United States of America in 1991 by Thames and Hudson Inc., 500 Fifth Avenue, New York, New York 10110.

Printed and bound in Great Britain by EGA, Brighton.
Design and layout by Liam Gillick.

CONTENTS

DISCUSSION

Lynne Cooke
Art critic and curator

William Furlong
Artist and lecturer

Liam Gillick
Artist and critic

Maureen Paley
Interim Art

Andrew Renton
Art critic and curator

Karsten Schubert
Karsten Schubert Ltd

Renton: *Technique Anglaise* alludes to the French phrase for certain kinds of sexual games. The French perceive English technique as a repressive public school activity.

Gillick: I hate the title. Everyone in the book hates the title.

Renton: But you thought of it.

Gillick: Yes, but I didn't expect you to take it seriously.

Renton: History does some funny things. Look at the international reputation of British art. We are a nation isolated geographically from the rest of Europe, but I think there has recently been a change in self-perception in Britain, and it starts with students working, not in cultural isolation, but being attuned to what's going on internationally, reading the art magazines, and so on.

Paley: That's true. However, one must take into account the fact that these artists are not the first to have gotten across the channel, or the ocean.

Cooke: Yes, in the past information and work constantly came to Britain and exerted an influence. *When Attitudes Become Form* [1], and then Anne Seymour's show *The New Art* [2], put together British artists who could have been thought to be interested in related ideas. In the late Sixties, too, there was a sense of internationalism and direct participation by certain people here, and that seems to have occurred again now.

Gillick: A lot of older work from the Sixties and Seventies seemed very exciting again. Certain conceptual and minimal work seemed, in the Eighties, quite radical, interesting and worth reconsidering.

Renton: There are one or two points I want to make in relation to this. First of all, if we accept that there is a passing of influence from one generation to the next, that's always been the way that art has regenerated itself. However, the young artists of the Eighties not only emerged out of art school, under the aegis of certain older artists who'd been through the mill, ten, fifteen, twenty years earlier, but they were also attuned to Eighties ideas. They picked up on the international currency through a new, mediated experience of contemporary work. Contemporary art has never been more

broadly disseminated than in the Eighties. It's interesting how important the likes of Jeff Koons and his generation were, even though most people had seen perhaps only one, maybe two, examples of their work in the flesh. Yet the artists in the book seemed to have absorbed an entire oeuvre, through magazines, books and publications. What I'm trying to point out is that there was a double sphere of influence: one which was abstract and international, seemingly very exciting and glamorous, and another one which was very much more rooted in a home tradition.

Gillick: But to a certain extent a lot of things people do come from being slightly perverse, which is actually part of an old tradition, connected to ideas about making bad art as much as anything else. It was kind of perverse to start making some kind of conceptual art when all the major people around who seemed to be having the glamorous shows were making big plate paintings and expressionistic work. What do you do when you go to college in the daytime? You don't want to make that kind of thing, you want to do something else, if only to be perverse. When that happened it was a surprise to the tutors and visitors. They thought that we'd all want to be making big quasi-Schnabel paintings. Tutors would bring in David Salle catalogues when in fact some people just wanted to make Keith Arnatt's work.

Renton: These ideas about influences have to be thought through. I am not necessarily talking about positive influences, but also about an awareness towards rejection or acceptance of those key figures.

Furlong: From the point of view of someone who teaches at art school, I think that is a rather crude analysis of what goes on at the interface between student and tutor. What is art school culture? What is being transmitted through it? Students go in, they work in studios, they learn by doing. But what are the points at which significant influences become part of a direction?

Paley: Maybe it's wrong to think that we are part of a time when information about art is most widely disseminated. Maybe it's because many of the artists in this book are young that they feel part of what's going on.

Cooke: I'm not so sure. If you look at the number of magazines, the number of art shows in the Eighties, everything seems to be happening as in the past, but

9

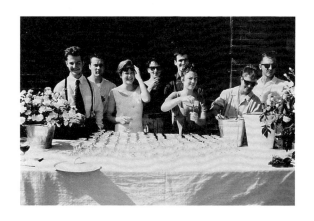

on a much bigger scale. I think another ingredient is a shift in the level of ambition. That came about through a confluence of factors: certain kinds of one-person shows at the Whitechapel Gallery, for example, from the early Eighties, which gave one a sense of work on a different level, from Lüpertz in 1979 to Nauman in 1986. The Saatchi space also has to be taken into account. I think it's really important that the quality of some of those shows, the range and in-depth presentation of work, showed student artists art that had not been available in Britain before. The level of ambition of one or two artists who were then being seen abroad, too: Richard Deacon would be one, Tony Cragg and Gilbert & George would be others, contributed to the broadening of horizons for students. This is very different from the situation in the later Seventies.

Schubert: Students witnessed a whole generation of artists becoming internationally successful, which hadn't happened much in this country previously. What Nicholas Logsdail, for instance, did at the Lisson Gallery, promoting certain artists, was on a new scale in this country.

Gillick: You can never underestimate the strength of recent examples. Certainly at Goldsmiths' College, Julian Opie was an important example; he was having big shows, and I think that was very important psychologically, because students just suddenly thought, Well, hang on, it is possible to do something similar, it is possible to get seen.

Schubert: Opie broke the mould.

Gillick: I never thought that. It was much more practical and day to day. There is no distance suddenly, it's not fantasy land anymore, it's like real life, and you can do it, too. You just make a slight conceptual side-step when you wake up one morning. You decide to get involved. And it's almost as though a lot of people are pushed away from that feeling. When art becomes diverse, there's suddenly a lot of it around. So how do you communicate your thing, too?

Renton: That is an interesting point, leading on from what you've said. Julian Opie emerged out of an art school with a BA, and he did not go on to do post-graduate work. He came out of art school and had a big show at the Lisson Gallery. Didn't that set a trend?

Cooke: It's the rapidity between art school and the first shows, perhaps, more than what kind of degree.

Gillick: Hardly anyone from Goldsmiths' ever got into places like the Royal College of Art. They just weren't getting accepted for post-graduate courses anyway, so it's partly down to just not being taken on, as much as not choosing to go.

Furlong: At the majority of degree shows in art schools thoughout Britain, you will find quite well developed and interesting work. But, for instance, with Julian Opie, there was a mechanism that projected him above and beyond the normal levels of professional attainment. What was different in his case?

Gillick: It was about staying informed, and then responding, whilst keeping a clear view of what is going on around you, outside the art-world – those things which you come into contact with every day.

Cooke: The shows in Cologne at the Kunstverein[3] put Tony Cragg and Julian Opie together, so Cragg, the person who was seen as the bridge figure for a new generation, and Opie, the latest emerging one, were given a kind of parity, which I think was very important. Perhaps what's telling at this moment is that there isn't a single dealer with the space or the resources to take these artists on, in the way that the Lisson Gallery was able to pick up six or seven artists in the past.

Renton: Does that imply that there was nothing else going on previously, or that there was some kind of impoverishment? The list of artists for this book is quite substantial; it indicates a fertile situation. Was it the same in the early Eighties? Was the Lisson grouping a fortuitous one, and did other things slip away?

Paley: I think things were shifting at the time that Nicholas Logsdail did what he did, partly because certain galleries that showed new work in the Seventies had closed. There were a number of galleries that had been quite influential and quite purposeful, but they didn't continue to represent new artists in the Eighties.

Cooke: Or they shifted direction, like Nigel Greenwood, who'd done some very good shows with people like Gilbert & George, and there was Tony Stokes at Garage.

Paley: Also, Felicity Samuels had a gallery, and then there was Robert Self's gallery, which had quite an interesting programme.

Schubert: Perhaps some of those places closed because, internationally, the scene shifted from minimalism and conceptualism, to painting, in the late Seventies. History sometimes does strange things. Nicholas Logsdail couldn't, just wouldn't take that step, he couldn't understand it, it wasn't him. So he had to look for something else, and all those new artists came into that vacuum.

Cooke: In the late Seventies, especially in Britain, there was a terrific amount of attention being given to art with a social purpose, in shows organised by the Arts Council, with artists like Stuart Brisley and others. That was the kind of work which didn't enter into the commercial galleries on the whole. It was seen very much in public spaces, in alternative spaces, and somehow it was passed over. The artists we're talking about now were first picked up at that time, and their work threw the other kind of activity into shadow.

Renton: The early Eighties taught us that there was a market place for art.

Schubert: And the kind of art that refused the market place loudest, the market place then tried to embrace twice as hard. It seems that the emphasis shifts from country to country, that the Eighties were very much an American decade, in art terms.

Paley: But the Germans, too, came up heavily then.

Cooke: The market may have been dominated by America, but I don't think the art was dominated by Americans. There's a sense in which, in terms of the amount of words devoted to an artist like Schnabel, they appeared to dominate the scene, but in terms of how the dynamics of art moved across the decade, I don't think America determined it. Partly because when people came to look at German art they were forced to consider two or three generations simultaneously, rather than a single emergent group.

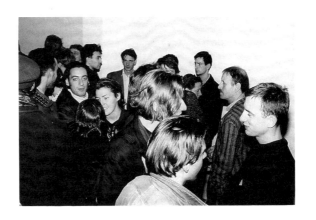

Paley: What's interesting in terms of Britain is that, if they had been in New York, Stuart Brisley might have been taken on by a dealer like John Weber, and Susan Hiller taken on by a dealer like Paula Cooper. But we didn't have such dealers in London.

Schubert: But that wasn't the dealers' fault. There was nobody who really paid attention. If you don't have anyone to buy, then galleries aren't going to happen. Americans, at that stage, firmly believed that there was nothing of any interest internationally anyway. All that changed in 1981 with *A New Spirit in Painting* [4] at the Royal Academy and *Zeitgeist* [5], in 1982, in Berlin. Suddenly, you had an international situation. I remember that there were German painters at the time who nobody with a brain in Germany could argue would ever become international, because the Americans weren't looking at their work. And then in 1981, the floodgates broke, all that stuff arrived in New York. Within six months every major European artist had his or her first show in New York. 1982, Polke's first show, Baselitz's first show, Lüpertz's first show, all the Italians having first shows – the list goes on endlessly.

Cooke: Remember, however, the Institute of Contemporary Arts in London did the show *Objects and Sculpture* [6] at that time, and there was a new generation of curators in Britain who came of age, too, like Lewis Biggs, Mark Francis and Sandy Nairne, working with artists who were their peers – Cragg, Woodrow, Deacon and Wilding, for example.

Schubert: In the Eighties, the marketplace broadened to a degree we had never seen before. In the Seventies, the situation was unbelievably narrow with the critics' narrowness and the art market's narrowness. What we saw in the Eighties was that the critics lost their voice, because they were trying to stand on a narrow band, and the market just said, Well, you know, that's just too bad, we'll do it anyway. What we saw was that the market in the Eighties totally undermined critical judgement and, in the process, a lot of stuff which in the past would not have been looked at, suddenly you could look at. It's a bit like medical research. If you only have a million pounds, you specialise in one field, but if you have ten million pounds, you can broaden the band of things that you're looking at considerably, and that was the achievement of the Eighties. There's probably twenty times as much printed matter now on contemporary art than there was a couple of dec-

ades ago. There are probably thirty times as many collectors as there were at the beginning of the Eighties, and about five times as many galleries in New York as there were in the past. When you look at it very closely, though, you realise that it doesn't mean that there is five times as much good work.

Gillick: But I would say that the ground had already been broken, both conceptually and philosophically, as a theoretical necessity for diversity within art. There's no doubt that people were thinking and writing about the notion of lots of different things going on, but whether or not artists could then sustain any kind of career, or visibility, is another matter.

Schubert: I think that's the great thing right now. You can sustain visibility much more easily than you could ten, fifteen years ago, because there are more resources available to all of us.

Cooke: Yet there have been moments when what was called an 'artist's artist' – Dan Graham would be a good case – was rarely seen in shows, yet earned enormous respect. He isn't a big figure at the moment but, on another level, he's an absolutely crucial figure. So, sustaining visibility serves only certain ends.

Gillick: One of the things that characterises certain people represented in this book is that they saw certain early Eighties work without feeling that it meant very much to them. So, finding out about people like Dan Graham, conceptual artists, and others who seemed so much more irresponsible, seemed so much more interesting. Even though, perversely, you might say that those artists seem to have more of a conscience about various things, in another way, in terms of the look of the work, and what it actually is, when it's in front of you. It seemed far more irresponsible than a big Clemente painting, which seemed to me to be a big step backwards.

Schubert: But that happens when you have a broad cultural consensus about something; it becomes automatically uninteresting. You don't have to discuss it any longer, and so you then go to the fringes, and you make new discoveries there. I think artists do the same; they tend to look at work that has not been over-exposed.

Renton: A certain kind of irresponsibility seems to me to be a very key concept that brings all these people together, aesthetically. They're dealing with, if you like, irresponsible images, they're dealing with irresponsible constructions.

Paley: I think that there still lingers an avant-garde notion that implies a necessary rejection of a responsible position; because, how could one be responsible in this world? Yet I wouldn't say that Dan Graham thinks of himself as irresponsible, I don't think he is, or Bruce Nauman. It can be dangerous to try to attach certain adjectives like this to the situation.

Schubert: Supposing we replaced the word irresponsible with the word open. The reason why a lot of young artists find Anselm Kiefer uninteresting now is because he appears to be static. I think that there are shared positions for the majority of the people represented in the book. I always felt, for instance, that, while the American artists of the Eighties had an obsession with manufacturing, brand-new goods, shopping, the market, and commodities, when you look at people like Angela Bulloch, Michael Landy and Gary Hume, there is still that manufactured readymade element, but it is used in a bizarre, undermining way, putting things to a use they were not meant to be put to, turning and using a pre-manufactured object, whilst charging it with something emotional.

Cooke: There are parallels to this way of thinking abroad. Take, for example, some of the work of artists like Katharina Fritsch, Rosemarie Trockel or Cady Noland.

Renton: Cady Noland is an interesting example of someone whose time has now come. The *Status of Sculpture* [7] exhibition was interesting in this regard, as it led us to look at certain artists in a new context. Robert Gober, for example, in the same show, is someone who was initially associated in this country with the *New York Art Now* [8] show at the Saatchi Collection, yet he is now someone whom we have needed to reassess and re-contextualise. *Status of Sculpture* reflected a shift away from pristine, commodified readymades.

Schubert: That's why people are looking at British art now. A lot of American work from the Eighties suddenly feels a little like Donald Trump stuff. People are now looking for art where a private element can be introduced, getting

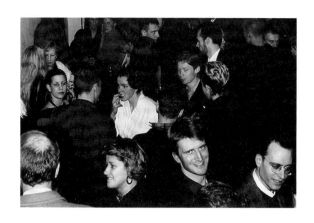

more complicated with each move. I think the British artists have managed to make a really complicated move, without upsetting the rules, sticking to them, and still undermining them.

Renton: There's a word that seems contradictory here. I'd like you to talk a bit more about this notion of privacy.

Schubert: You can't be really private anymore, but you can, I think, be highly personal. It's kind of gentle, it's not brutally direct.

Cooke: There's a very private thing in Katharina Fritsch's work, for example. It is possible to contrast her work in this respect with any of that macho painting of the Eighties.

Renton: Isn't there a big semantic difference between Fritsch's arrangements of luminescent yellow Madonnas stacked up and a bunch of Michael Landy's Sunblest bread crates stacked up?

Paley: No. Not particularly. I think there's some connection with the readymade, but it's a distant one. There's perhaps also some link to a Whitmanesque sense of just looking, like an ode to the everyday, which is something that I think was clear with Tony Cragg and Bill Woodrow earlier.

Gillick: Just thinking about what certain work by artists in this book actually looks like. There seems to be an idea about trying to do something which is simple in the formal sense, and somehow connected with minimalism, yet the constituent elements of the work are not relying on geometry or certain distancing devices. So you look at Gary Hume's paintings and they could seem like monochrome paintings, but there's something else there. The same is true with Bethan Huws' floor piece, at the Riverside[9]. It's like saying, Maybe things aren't so neutral, maybe they are actually quite loaded up with references. It's never just a blank painting, it always has a meaning, always.

Cooke: All Seventies notions about self-referentiality have been exploded. Minimalism can no longer be seen as hermetically referring to itself. Experience, however, involves a degree of projection, and the separation between the self and the other, which is currently said to be inseparable. Therefore, this subjective element, or personal element, within something which is ostensi-

bly out there, exactly corresponds to those kinds of theoretical discussions.

Gillick: Yet as we've said before, the Saatchi Collection was an important influence, especially when they showed that really big Judd plywood piece[10] as some of the artists in the book were definitely playing with things that looked a bit like minimal art.

Renton: And in the same way, how did the shift from a Kiefer or a Schnabel to an Ian Davenport come about? What we are getting in this new generation is people flipping things on the head, saying we're trying to be artless, but not in quite the same manner as modern artists always flipped things in the past.

Gillick: Not at all, because there is an element in a lot of this work which is about the fact that it looks a bit like art.

Renton: But it plays on the fact that it looks a bit like art, and does everything in its power to negate that all the time, teasing you.

Schubert: It looks like a certain type of art. The Landy stacks on the surface look like minimal sculpture, but really have very little to do with that. The concept of pluralism brought on something really strange: suddenly everything was available as a starting point.

Cooke: For many artists the key starting points are somewhere around Duchamp, but not Duchamp as someone who questions what art is. And just as his work is currently being re-examined, so conceptualism and minimalism have been most variously interpreted, and reinterpreted, during the Eighties. The reinterpretations have been enormously diverse, and all this contributes to making these movements freshly available as starting points in the mid to late Eighties.

Paley: There has been a deliberate lack of information or concern with it. Often, among younger artists there is a lack of first-hand experience. Sometimes that produces the best art, because it means you're not overloaded with too much. It's nonsense to talk about minimalism or conceptualism as cold art, for example, because when you look at Brice Marden's work, his paintings are enormously sensual; you look at a Ryman and you could burst into

tears, they are so beautiful. Did Michael Landy go out and think, I'll get these stacks because I can't make a Judd? It's just that he's not having to take into account those years of being exposed to Judd. What sense of hierachy is there between a Judd and a Landy?

Schubert: You would still need to have a basic knowledge. You still have to know the grammar, how to construct a sentence. And it seems to me that the artists in this book know the grammar incredibly well.

Renton: Where did they learn it?

Schubert: In London, in the Eighties, a lot of things came together, which weren't there in the Seventies. Communication in the art world sped up beyond recognition. Maureen described this emergence as a kind of genetic accident.

Paley: No, cultural accident.

Schubert: Well, I think that it was a genetic accident as well. We had, by chance, a bunch of incredibly brilliant people emerging simultaneously and influencing each other.

Cooke: And some very good art school teachers.

Paley: That's a very important point, the fact that people were active artists and they were not just teaching.

Schubert: These new people do a lot of things much earlier now.

Renton: There are dangers in growing up in public, though.

Schubert: Sure it's dangerous. I was asked once, Do you think it's dangerous for those people to be forced to grow up that early?, and I said, In the past, they had an option to take a job and deal with the work on the side. If Rachel Whiteread had to deal with *Ghost* [11] on the side, it wouldn't have taken her two years, it would probably have taken twelve years, if she had found the time and energy to do it all.

Cooke: This happens across the board. Mathematicians, athletes, etc., all tend to

peak earlier. People in all sorts of fields supposedly get to the top, or get to the fullest extension of their powers, very early.

Schubert: Because there is this great demand for the new all around us all the time, that makes for early exposure.

Furlong: Things have changed. If you go to final degree shows now, you go into a very professional environment; you might just as well be in one of your galleries which is there for professional reasons. The floor is painted, the work is straight, the labels are printed, and in most shows now there will be a sales desk. There used to be an in-built assumption, an unspoken assumption, that if you carried on, eventually Mr.Waddington would come knocking at the door. How many times did I go to Space Studios, in the Sixties, on the open day, and the artists would be in a little huddle, in their corner, around their work, with their backs to people, pouring each other wine in plastic containers, and you could have been anybody? They somehow accepted this kind of enclosed world, and hoped eventually something would happen to allow them to break out of it.

Schubert: But the reason why they were in that corner pouring each other wine, was they knew there was no Doris or Charles Saatchi, and Leslie Waddington wouldn't be seen dead out there.

Furlong: Now they would probably send a limousine to get him, or something.

Paley: I kept saying, You shouldn't be waiting for dealers to come to make judgements about the work or to help. There's a lot of responsibility to show yourselves, but not only in the context of a degree show. Don't wait for the institution to do that. We started to see that organisations like the Arts Council and Greater London Arts were no longer giving out artists' grants in the Eighties, especially when cuts were being made by the Thatcher Government, and when all of grant funding was in crisis. With *Freeze* [12], The *East Country Yard Show* [13] and *Modern Medicine* [14], we saw something that grew directly out of the Saatchi mentality of scale and marketing. A lot of things came together, to provide new venues. This new work was available, it was open for collectors and dealers to look at, and it wasn't only open for critics. In the past, when you had an exhibition, you wanted it to have critical response, but you didn't necessarily think further.

Gillick: Also, with the Docklands boom during the Eighties, you could go to companies and ask them for money, and, because they felt guilty, you could get it out of them. All that has gone now. It was a brief window.

Schubert: That was very much the Eighties: new places, the collectors running around, wanting stuff. It was slightly hysterical. I mean *Freeze* was one of the most hysterical things I'd ever seen.

Paley: I think what you're describing was also circumstantial. If it wasn't the Docklands people, something else would have happened. It was this idea of searching for something, people coming together, and if it hadn't happened in the Docklands, I think it would have happened in somebody's house, or in a basement. Yet I think the scale and energy was very particular to the Docklands.

Cooke: Students behaved differently in public, too, because a different model was proposed. Take, for example, the Slade School of Art, where Frank Auerbach was a perfect example of someone who worked incredibly hard, he was never visible, he was known to visit the National Gallery fairly regularly, but nothing much else. These were the constituents of the myth. However, when Bruce McLean started teaching there in the Eighties, he said Get out and hustle, get into Cork Street each day, talk to people, get known. That changed how many students there – and elsewhere – behaved and how they thought they should behave. They were given a kind of licence and approbation. That's important, too, that kind of shift in thinking.

Gillick: Staying informed became crucial: if you're involved in an activity in which other people are involved, why ignore that? You just go and look at it, too, and you try and become part of things. This is something so simple, it almost sounds silly to mention it, but it would come up all the time at Goldsmiths', for example. I'm sure it did at other colleges to a certain extent. It was just that you must stay informed, go and look at other work.

Furlong: If Goldsmiths' encouraged this attention constantly being paid to what was going on externally, that wasn't the case in most art schools. A lot of teaching staff in most art schools aren't professionally engaged in this way, therefore the lure of the outside isn't as significant.

Cooke: For some it's a threat, in fact.

Furlong: It is a threat to a certain generation who perhaps weren't engaged, and the
 longer it's left the harder it is to become engaged in the business of the art
 world.

Renton: It wasn't simply engagement. It was a sophistication of art packaging that
 emerged. *Freeze* just came out of nowhere. Had anyone done anything like
 that before, so professionally? No one had produced such a package
 independently and, what's more, it broke a mould in that there was no
 stigma attached to things being done like that, such was the scale of what
 the artists had achieved.

Schubert: But don't you think they just picked up on what was going on in the outside
 art world anyway, and that *Freeze* wasn't actually that different?

Paley: I can't think of an equivalent elsewhere – although in New York earlier in
 the Eighties there was the *Times Square Show*. [15] Sometimes there are
 seminal shows which are more interesting or more remembered than others
 probably because some collectors and dealers think to go to them, as do the
 critical public and other artists. Something gets consolidated out of that
 experience.

Cooke: And provides a model for an ongoing series of shows.

Furlong: The *New Spirit in Painting* certainly gave permission for all sorts of new
 things to take place.

Cooke: At the time, *New Spirit* was seen as a flawed show. But that didn't ulti-
 mately matter. The rhetoric of it was so persuasive.

Paley: The fact that there was no grant money around produced something
 positive. It didn't produce a huge depression, but produced a positive sense
 that you can take matters into your own hands and somehow turn the
 whole thing on its head. It's also a testimony to brightness on the part of
 these people. There's was real ingenuity, a real sense of necessity.
 Competitive, rivalrous or complicated as they may be, there's a real sense of

positiveness.

Gillick: You didn't need to walk round the Royal College for an hour to know that you weren't going to go there whatever happened, if you'd been at Gold-smiths'.

Schubert: It was about leaving the field as open as possible, and when you look at how the Royal College tried to translate that, they actually got the wrong end of the stick. They just didn't understand a thing. Because they translated the idea of art education, and how to proceed with it, into being successful in the market place, and left it at that. The conclusion must be that they have a fundamental misunderstanding of what the whole thing is about.

Paley: There was an openness to dialogue at Goldsmiths' with tutors like Jon Thompson, Michael Craig-Martin and Richard Wentworth: it wasn't a case of them always agreeing, but of these various articulated points of view. If you're having your own very particular point of view it brings out a clarity among students because they're forced to think. Not that it's exclusive to Goldsmiths' because when you look at CalArts and John Baldessari, for example, there's so much that came out of there in the Eighties.

Renton: It is interesting what Karsten was saying about the idea of re-inventing Goldsmiths' at the RCA. You can't actually make a repetition of Goldsmiths', because it didn't really exist as a dogmatic aesthetic entity.

Furlong: These things are temporary anyway, because as we said earlier important shows suddenly come together and seem to be hugely influential, and you have the same with galleries. But in terms of art schools this could all dissolve, and perhaps it has now, because Goldsmiths' has been talked about so much and the students there are rather self-conscious about it.

Paley: If you consider St Martins School of Art in the Seventies, it was a very interesting place, but that was due to a combination of factors. There was the whole Anthony Caro generation and what came out of that. But there's also the fact that students attract students, so it's the charisma of certain students that make others feel that they want to be seen with them, or just get something from being in a place.

27

Furlong:	It's a complex chemistry: if you talk about Bruce McLean, Barry Flanagan, Richard Long, Hamish Fulton, Gilbert & George, they rejected the Anthony Caro line at St Martins, but somehow fed off it, too.
Gillick:	The rejection of Caro was so quick. He was only starting to be looked at largely because of an American involvement, an American critical interest. And then within four years you've suddenly got all these other people, before he's had a chance to show anything.
Schubert:	By today's standards that seems a very long period of time.
Cooke:	Caro had a big show at the Whitechapel [16], in the Sixties, which was the first indication of a new sensibility. Brian Robertson's shows at the Whitechapel of Rauschenberg [16] and others were very important. So, again, it's a series of things coming together.
Furlong:	Going back to Goldsmiths' and St Martins, we're not talking about a model which is an *atelier* system where the professor dictates and determines what the kind of form and look is going to be. Here, a lot of work is formally very different, so you haven't got direct tutorial dogmatism.
Schubert:	That was why we didn't go to the Slade very often; all the paintings looked alike, and there seemed to be no chance for anyone to disagree with any-thing.
Cooke:	It also has a lot to do with a certain kind of teaching, because you could mention examples like Peter Kardia teaching at the RCA, in the mid to early Seventies, with students like Cragg, Deacon, Wilding and Wentworth.
Paley:	There was something special that Michael Craig-Martin did at Goldsmiths': he gave students a sense of possibility, a sense that they could do anything, and when they talked to him he was able to teach by suggestion. Partly because his style or his manner of working was so diverse and so complex, he would not really dictate a particular style to students.
Furlong:	Michael Craig-Martin allowed the student to determine his or her own position, and he learned as much from the students, perhaps, as they learned from him. I'm sure he's encouraged the process of students taking

on responsibility for their own learning.

Paley: Michael Craig-Martin and Jon Thompson are both good writers, and some-
 how have engaged in explaining art not only to students, but to the general
 public.

Gillick: Both of them are very good at using language in a way that is really
 inspiring, yet bound up with a degree of cynicism and irony. You could all
 sit round, gee each other up and get somewhere, rather than saying, Well,
 you can't really talk about work like that, you really have to be in front of it.

Renton: Does that preclude the need actually to make every work? If you have the
 idea for the work, is that sometimes enough?

Gillick: No. In the end you can only judge your own work by what you produce, but
 it's possible to get going or get excited about an idea by talking about it.

Paley: It excites ambition, confidence and enthusiasm.

Gillick: Damien Hirst, who curated *Freeze*, is a classic case. You sit around with him
 for an evening, he will talk about work to make, he'll come up with more
 pieces and describe what they'll be. It's a way to do it, and some people
 have this kind of energy.

Renton: Damien is a very interesting example of an artist who can consider someone
 else's work and encourage them to go in certain directions.

Paley: With the advent of the Milch gallery, it was very interesting to watch some-
 body like Simon Patterson blossom in that situation because he was allowed
 to do whatever he pleased. So when he might have been feeling that he'd
 have to continue painting he was suddenly able to do something new.

Gillick: But never underestimate the extent to which ambition is totally intertwined
 with competitiveness – a kind of extreme rivalry.

Paley: It's early days. We may see certain shake downs occur later.

Gillick: I wonder how sustainable things will end up being in this country, though,

in the longer term. Certain things looked like they could have been exciting, or could have been interesting, at one point, but were then allowed to fizzle away. It may have something to do with the fact that there aren't enough galleries to support those artists who could be interesting but who don't fit into the existing system, and are then lost, because there's nowhere for them to go. I remember seeing a book of the McAlpine Collection, with all those English artists, and I'd only heard of a few of them. It was a complete mystery to me how this had been allowed to happen. Now, whether or not these artists were just out of touch or just not interesting is another matter; but how does this happen?

Schubert: I think that has to do with the scale, the scope of the market place that dictates what is visible, and what isn't visible. And in a narrow market place only the very best work remains visible. That's what I think might have happened to those British people. In the Eighties, a lot more artists were given opportunities. However, if resources are suddenly not available any longer, it will become more difficult for an artist to stay in that visible group. I think it will be the artists who are most compulsive about what they are doing.

Cooke: I think there is more than one way of making it. On one hand, you have artists like Frank Auerbach, who have largely stayed outside a particular system. And on the other hand, there are artists who show over and over, who are very active, and their work gets honed by the situation.

Schubert: It has to do with how compulsive an artist is. Somebody like Ed Ruscha is a very good example of compulsiveness. There were moments when there was very little interest in his work. Ruscha said to me that sometimes he didn't know how to pay the telephone bill. Well, if you're compulsive enough, somehow you deal with that.

Furlong: Yet there are artists, perhaps now in their middle age, who go on painting painting and painting, and who do not bother to show their work, to have their work seen. Their rooms must become smaller and smaller, as they stack the canvases against the wall.

Gillick: Certain people in this book are concerned about context and about things being broader than just working away on some personal project. When Alan McCollum was here for his show at the Serpentine Gallery[18], he talked

31

about the notion of trying to make paintings now, the idea of painting as a cultural sign, recognisable but bound up with all kinds of references beyond the aesthetic. Originally, he thought of just doing the one picture that might suffice as a sign for every-painting, but of course it was a failure as an artwork, because by just making one sign he was ignoring the cultural influence the market has over the production and consumption of art. It wasn't a very effective sign, because it didn't acknowledge a broader aspect.

Schubert: I think the situation right now is that with the wider dissemination of the artwork, information has actually become part of the strategy. Frank Auerbach can sit in his studio until he drops dead without anyone paying any attention. That probably will not make any real difference, because everything, for him, is in the painting. Whereas someone like Michael Landy needs to show what he is doing and display it in a certain fashion, making it accessible.

Cooke: But so did Warhol. These different types coexist constantly. I don't think it's a new thing.

Paley: It's true that there are artists who are peer-respected and make good art, who do not enter the dealer/critic system, or who deal with the critics but not with the dealers, and who go on to be well respected. Look at Stuart Brisley, for example, or even look at the career of Christian Boltanski, and how he's considered. We can talk all we like about certain artists being visible, but I will be very curious to know who from this book will be valued by their peers as being incredibly important, and is going to continue to work consistently.

Renton: Economic recession now will undoubtedly shape the way that art is circulated and which things will last. There will not be the same opportunities for one-person shows in the way there used to be. There will not be the same opportunities for catalogues and publications as there were.

Gillick: Most of the artists in this book – who are after all only in their twenties – were pretty poor during the economic boom of the Eighties, and so they'll just remain poor. Some galleries won't be around, and there won't be that many openings. It's unlikely that another five new galleries will open in London during a recession.

Paley: The economic situation of the artists here is not great by any means, not at the stage they are at. One must also consider another matter which relates to their financial situation. In New York, it is interesting to observe that the young galleries, or the galleries that are established but showing younger artists, or showing artists that are somehow relevant in the discussion now, are not as hard hit as secondary dealers, or those who have hugely inflated prices on works and who, I think, might be feeling the brunt of it because collectors are very concerned and panicked. Something else, particular to Britain, is that people here often look to America, because of the language similarities, among other reasons. People, therefore, think that America is where financial and cultural trends emerge, but really Europe is not having quite the same experience as America with recession.

Schubert: It's arriving. The Germans have just admitted that recession is arriving there, and it has arrived in France. It's not as big a trauma as it looks on the surface, however, because there has been incredible inflation in the contemporary art world. Gallery operations have become incredibly big. So if the market is contracting, those galleries just contract. Yet this need not detract from the good work, or diminish its visibility.

Renton: But markets rely on growth, and artists often depend on that growth. In art magazines advertising is supposed to be down by 60 per cent, and *Contemporanea* has just folded. Visibility, therefore, changes. The number of shows being done by museums and places that depend on sponsorship will contract equally.

Schubert: It will not change the visibility of the really good work.

Cooke: I think you are contradicting your own argument. You just told us that Ed Ruscha, a good artist, was invisible in the Seventies. Are you saying that good artists will be visible or invisible within a depressed art market?

Schubert: Good artists are visible to the people who really care, and that's all that matters.

Renton: I'm not sure that's true, because I think along with Ruscha's growth of reputation and price rises has come a re-embracing of Ed Ruscha into the

system. For example he wasn't in the *New Spirit in Painting* exhibition in 1981. What is extraordinary is that the same curators of that show have just included him in the *Metropolis* [19] exhibition, the supposed new *New Spirit* or *Zeitgeist,* ten years on.

Schubert: I accept that he wasn't one of the insiders at that time. But we're talking about the art world having become diverse to a degree which it had never been in its history. Don't forget the most active gallery in London in the Seventies was the Lisson Gallery. Those two little shops in Bell Street, as it was then. If the scale goes back down, that's that.

Cooke: One of the most striking factors, looking down the list of artists in this book, is the number of women, which is unprecedented, I think. What do you attribute that to, and what impact has that had?

Gillick: As someone who was at college with some of the artists in the book, I think that partly this is because, during the Eighties, the people around who were making some of the most interesting art happened to be women. Barbara Kruger, Cindy Sherman, Sherrie Levine, Jenny Holzer, and various other people. They were the good emergent artists.

Renton: We didn't balance this list out by gender, it just balanced itself.

Paley: Even so, there's perhaps a sort of gender blindness at the moment as well.

Schubert: Do you think it's because we're now faced with the first generation who were brought up during feminism and sort of took it on board really automatically?

Paley: I think so. Yet feminism is still a big issue. When you think of the Guerrilla Girls in New York, and when you look at museum shows worldwide, major curators in Europe still don't see the value of a great deal of art made by women, or the fact that women are artists.

Schubert: Perhaps, though, the greater attention given to women artists has also to do with the general shift towards areas which have either been neglected or not taken in. Suddenly, we all look at South American art, minority groups.

35

The funny thing in New York now is that the majority of the artists who are emerging are gay or women. There's something really odd going on, you can't even pin it down. It's not just a coincidence that they are gay or women. Because they seem to bring a freshness to the debate, which a certain type of male heterosexual artist can't bring in any longer. It opens the field, and makes the whole thing very interesting.

Renton: It does imply that being an artist has to do with a sense of otherness. And then there is the diversity of the artists in the book which allows various underlying currents to be exposed.

Gillick: When art becomes about identity, about modes of representation, and about the way things are manipulated in the media, or the way they appear to be, and so on, a lot of those issues really come out of a kind of feminist discourse; they were highlighted by a certain kind of thinking that has resulted from feminism. This kind of thinking is also slightly away from the dogmatic formalism of the past. Ashley Bickerton said something quite funny but indicative, being rude about Carl Andre, and likening his attitude and work to scatter-bombing in Vietnam: you find one answer and throw it at every problem, rather than look at things in a completely different way each time.

Cooke: The greater attention given to women artists is the result of a certain genera-tion of curators being very careful and insistently conscious about including women in shows. Until that happened, you probably wouldn't get this swell from underneath. That hasn't been as much a programmatic issue in Western Europe as it is in the US and, consequently, I think you see fewer young women artists emerging in most Western European countries than you do in North America.

Furlong: It might be interesting to talk about how the list of artists for this book was constructed. Did you consider a lot more and pare it down?

Renton: The list was constructed in, literally, a few minutes. It was the most obvious list that could have occurred to us. It was tweaked here and there, but I would say that 80 per cent of it is exactly as it appeared in the first instance. There is, to me, something inevitable about this grouping.

Schubert: Doesn't it have to do with the visibility of these artists?

Paley: It's the first kind of grouping, and I do think that there will be things that will emerge later.

Renton: It is a very obvious, but very specific, take on the way things are.

Gillick: It's partly geographical.

Schubert: I think that's a specific British problem. Nobody in London thinks that anything outside London is worth looking at. It's a real problem. They always talk about France being centralised. Well, they haven't seen anything like this. Oxford, Cambridge, Glasgow, wherever – nothing exists any more. It might as well be open sea.

Gillick: There was no attempt to go round and see thousands of studios. But the artists all know each other, and that's one of the important things.

Cooke: That, in conjunction with geographical proximity, and access to the same culture.

Renton: The artists wrote the list in a way. I don't think any of us would be 100 per cent in favour of it. Yet I think that it is also important to me that this is not a curatorial effort on my part, or Liam's part. We're not trying to promote a particular aesthetic, we are trying to suggest that there is something that emerges of its own accord. And because certain things have been seen in certain places they have that visibility, so people write themselves into the list in a way. Now, what we didn't do was what many people perceived the *British Art Show* [20] did, which was try to take a broader sweep. We took a sweep that seemed to make sense with itself.

Cooke: I think you are claiming the role of midwife, but actually your role is much stronger.

Schubert: He is actually the father of the baby!

Cooke: For example, there may be some unarticulated relationships that are so familiar to you that you don't perceive them. Nevertheless they're there.

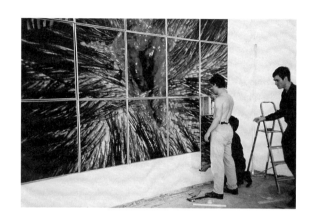

Renton: Well, how do you perceive them?

Cooke: I think it's not up to me from outside to talk about threads that I see. I'd be much more interested in seeing you tease out what this linkage is over and beyond – if it is over and beyond – the geographical, peer group familiarity and shared cultural contexts.

Renton: In many ways what Fiona Rae is doing, and what Ian Davenport is doing, is parodic, it's referential, it's not 100 per cent new, because it can't be, and it knows it can't be.

Cooke: What's common is there seems to be an acceptance of certain things as being important. So while it's not a shared aesthetic, there are shared assumptions about how the issues have to be addressed.

Renton: What seems to be interesting about a lot of these artists, although it's difficult to generalise, is the very positive defeat of metaphor. For me, most of these artists when they are at their best are non-metaphorical artists. They're not taking you elsewhere, they are taking you to the thing. The thing is the thing is the thing. That's my spanner in the works.

Gillick: Yes, but it's not only like that, because there's been enough work that is about ideas of the specific object, to understand fairly quickly that a lot of the work in the book doesn't share that kind of dogma or rigour. There's no shared idealism going on.

Renton: That goes back to irresponsibility in a way.

Schubert: A lot of the work appears very cynical, but when you really look at it, the reverse is true.

Cooke: But this is all predicated on the fact that virtually all of these artists are, as you pointed out before, very knowing. All are highly educated and very sophisticated.

Schubert: It embodies everything, and it does that in the most knowledgeable and all-embracing way I have seen for a very long time.

Paley: I wouldn't say that it's honest necessarily, because there's an interesting point that Duchamp made, that the artist does not have to be sincere. I think there can be a knowing insincerity which is actually a tool that allows the artist to make work that doesn't have to reflect anything of what they feel personally. They just hold up a mirror.

Renton: It is like a language which has been worn out. Part of the irony about these artists is that they belong to a very fertile field which should be completely barren, because there is something that tells you, Well, it's all been said, and we've out-minimalised each other and out-conceptualised each other, and so where now?

Schubert: But the term that springs to my mind about these artists is they're playing for time and they're doing it very, very successfully.

Renton: I want you to talk about playing for time, that's interesting to me. What do you mean?

Schubert: I think it is about creating a space in which to operate. And I have this sense of an emergency situation with all of them. It's probably the best response to what's going on in the world right now.

Cooke: It's to do with resourcefulness. Yet one notion that wouldn't apply is that used by Richard Wentworth for a series of photographs – *Making Do and Getting By* – I can't think of a phrase that would be less appropriate to this generation.

Gillick: Why be alternative when the alternative has already become the main-stream, and when everything's turned on its head, and it doesn't make any sense? There's no motivation to act in that way. It doesn't mean anything any more. None of those terms mean anything, so you might as well go ahead and just do it for real. It was just a group of people thinking Well, I'll make the art instead, seeing as nobody else seems to be doing it. Or not even thinking about doing it. So it's no good waking up in the morning and thinking, History will sort it out.

Renton: On your head....

NOTES

1. *When Attitudes Become Form,* curated by Harald Szeeman, Künsthalle, Berne, and tour, 1969.

2. *The New Art,* curated by Anne Seymour, Hayward Gallery, London, 1972.

3. Two exhibitions, Kunstverein, Cologne, 1984.

4. *A New Spirit in Painting,* curated by Norman Rosenthal, Christos Joachimides and Nicholas Serota, Royal Academy, London, 1981.

5. *Zeitgeist,* curated by Norman Rosenthal and Christos Joachimides, Martin-Gropius-Bau, Berlin, 1982-3.

6. *Objects and Sculpture,* curated by Sandy Nairne, Lewis Biggs, and Iwona Blaswick, Institute of Contemporary Arts, London; Arnolfini, Bristol, 1981.

7. *Status of Sculpture,* curated by Bernard Brunon, Espace Lyonnais d'art contemporain, Lyons; Institute of Contemporary Arts, London,1990.

8. *New York Art Now,* Parts I and II, Saatchi Collection, London, 1987-88.

9. *Installed Work,* American oak, Riverside Studios, London, 1989.

10. Donald Judd, *Untitled,* 1981, plywood, 138.37 x 927.62 x 45.37. In *Donald Judd, Brice Marden, Cy Twombly, Andy Warhol,* Saatchi Collection, London, 1985.

11. *Ghost,* Chisenhale Gallery, London, 1990.

12. *Freeze,* curated by Damien Hirst, PLA Building, London, 1988.

13. *East Country Yard Show,* curated by Henry Bond and Sarah Lucas, East Country Yard, London, 1990.

14. *Modern Medicine,* curated by Billee Sellman and Carl Freedman, Building One, London, 1989.

15. *Times Square Show,* 1980.

16. *Anthony Caro,* Whitechapel Gallery, London, 1963.

17. *Robert Rauschenberg,* Whitechapel Gallery, London, 1964.

18. *Alan McCollum,* Stedelijk van Abbemuseum, Eindhoven; Serpentine Gallery, London; and IVAM Centre de Carme, Valencia, 1989-90.

19. *Metropolis,* curated by Norman Rosenthal and Christos Joachamides, Martin-Gropius-Bau, Berlin, 1991.

20. *The British Art Show 1990,* curated by Caroline Collier, Andrew Nairne and David Ward, McLellan Galleries, Glasgow; Leeds City Art Gallery; Hayward Gallery, London, 1990.

ARTISTS

Henry Bond & Liam Gillick

Mat Collishaw

Melanie Counsell

Ian Davenport

Grenville Davey

Cathy de Monchaux

Dominic Denis

Angus Fairhurst

Anya Gallaccio

Markus Hansen

Damien Hirst

Gary Hume

Michael Landy

Abigail Lane

Langlands & Bell

Simon Linke

Sarah Lucas

Lisa Milroy

Julian Opie

Simon Patterson

Perry Roberts

Tessa Robins

Caroline Russell

Rachel Whiteread

Gerard Williams

Craig Wood

Cosmonauts at viewing of new TV series on Soviet achievements in space. BAFTA.

"There are certain systems that use urine, well the system cleans this water, to the level of distilled water, and afterwards this water can be used to produce oxygen."

Henry Bond & Liam Gillick

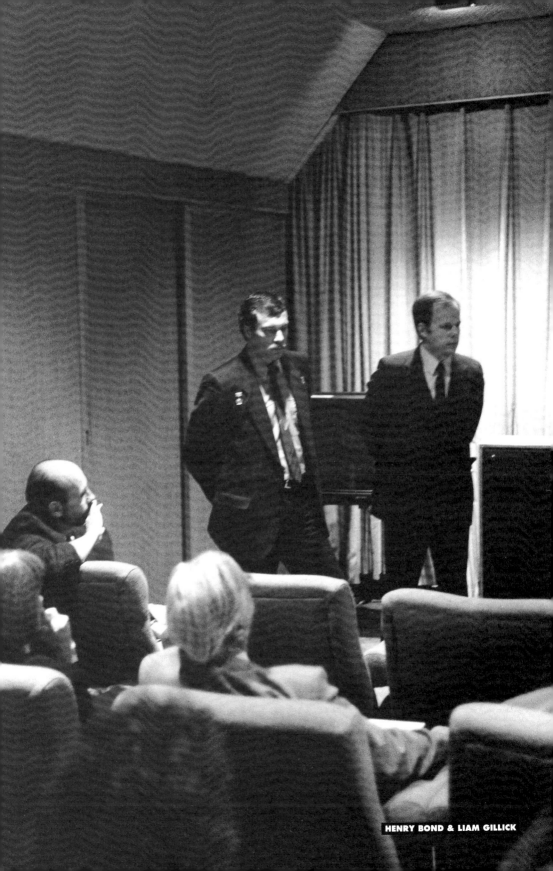

HENRY BOND & LIAM GILLICK

22 November 1990 London England 11.00

Media facility to view new court building. 81 Chancery Lane.

.

Henry Bond & Liam Gillick

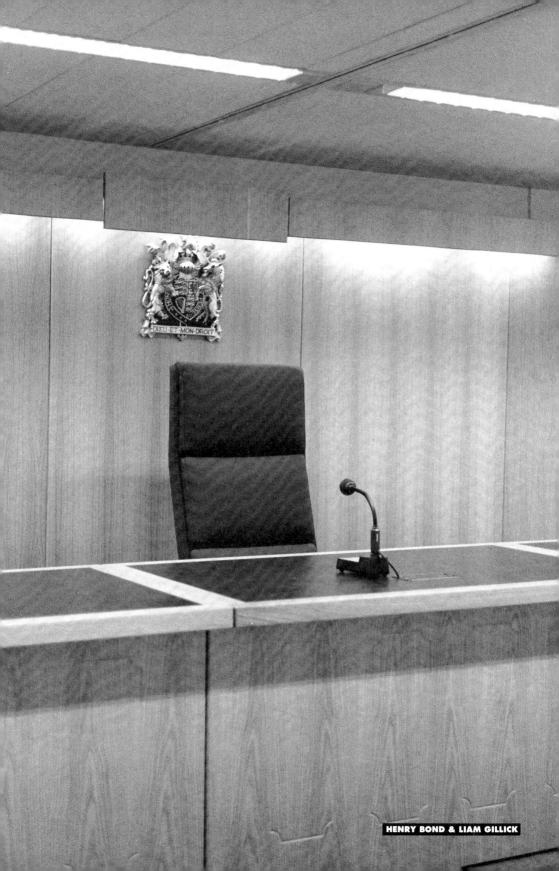

Auction of Stradivarius, expected to reach £1,000,000. Sotheby's.

"Lot 127
Starting at £400,000,
£400,000
£400,000
£400,000
£420,000
£440,000
£460,000
£480,000
£500,000
£500,000
£520,000
£560,000
£580,000
£600,000
£620,000
£620,000
£620,000
All done at £620,000
£620,000 last time
£620,000
£620,000."

Henry Bond & Liam Gillick

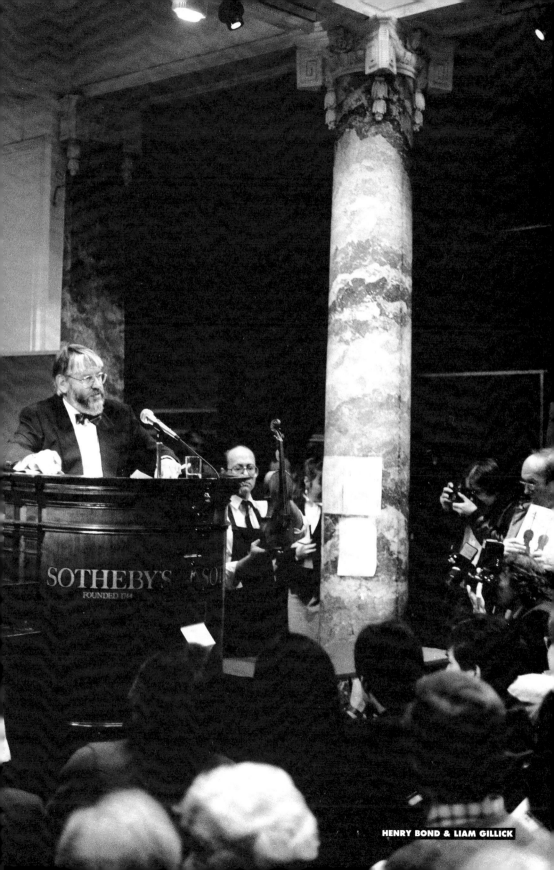

SOTHEBY'S
FOUNDED 1744

HENRY BOND & LIAM GILLICK

MAT COLLISHAW

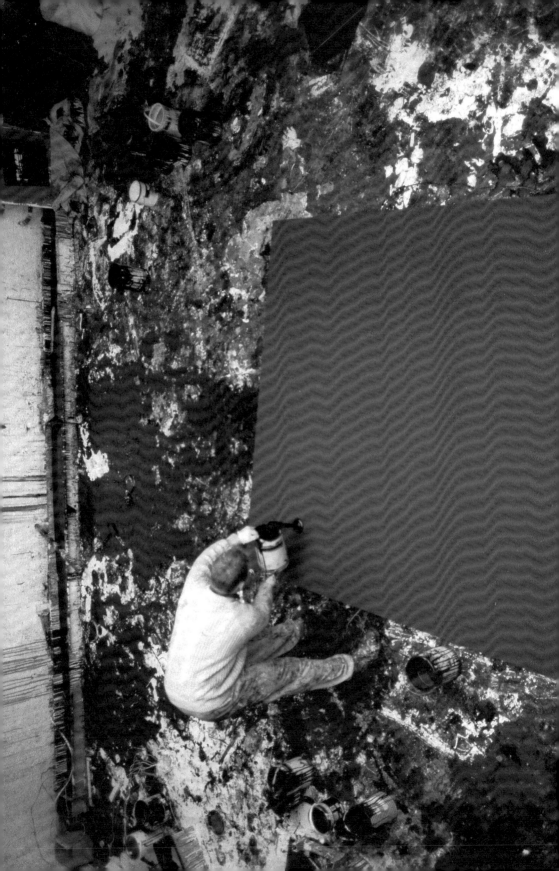

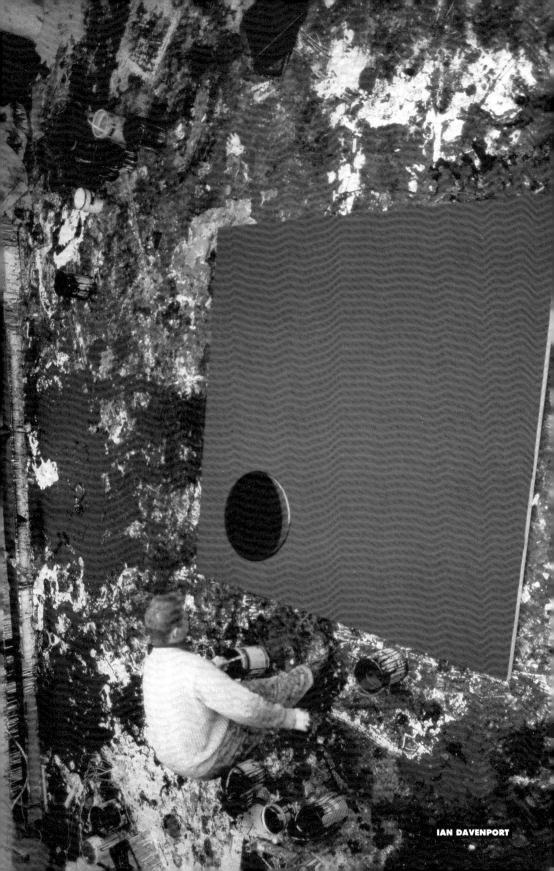

IAN DAVENPORT

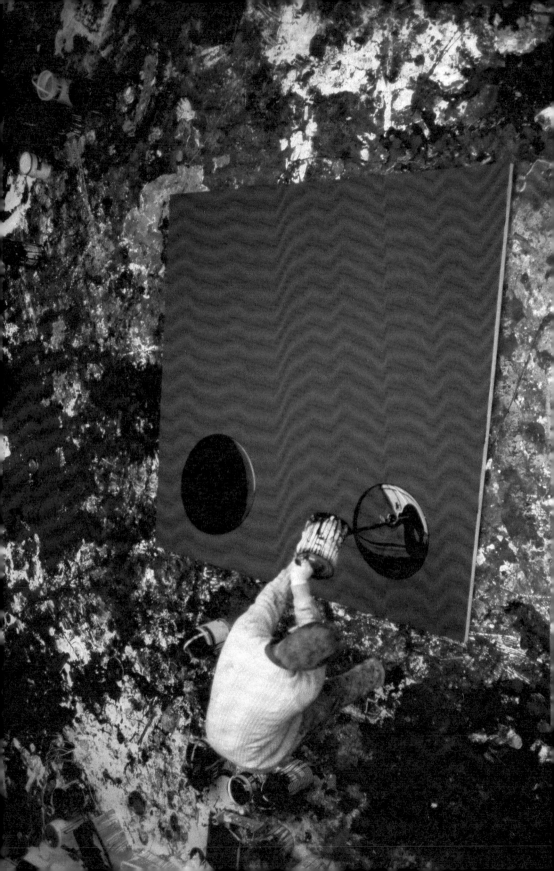

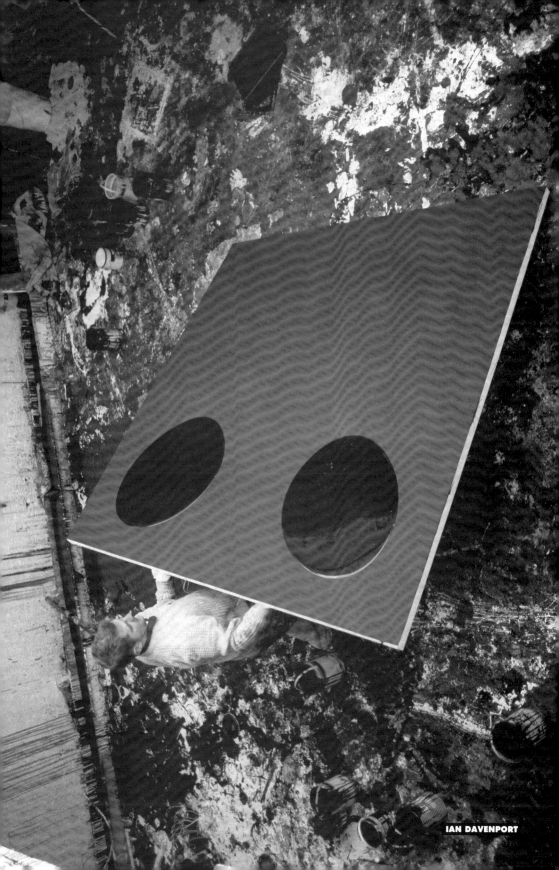

IAN DAVENPORT

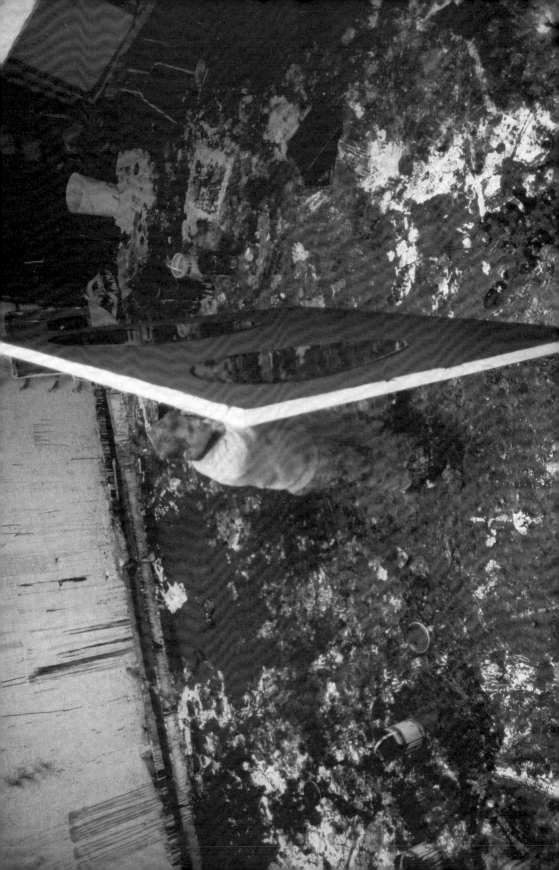

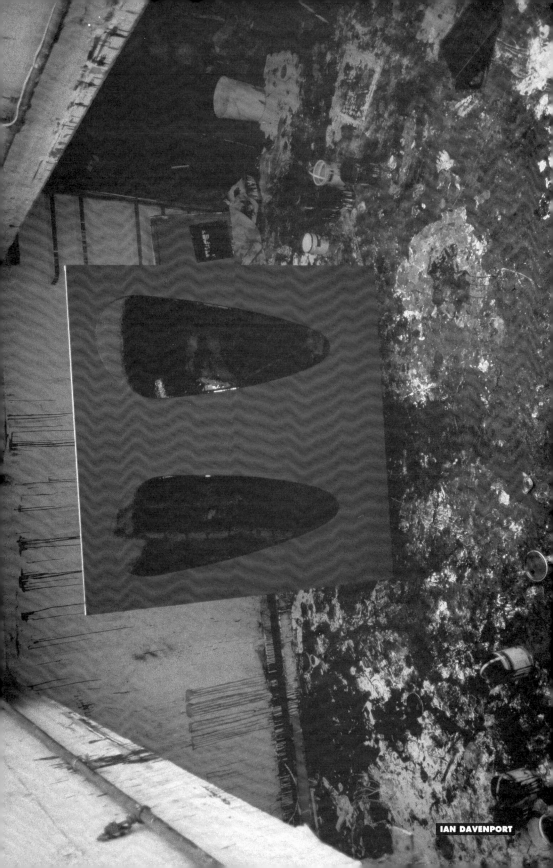

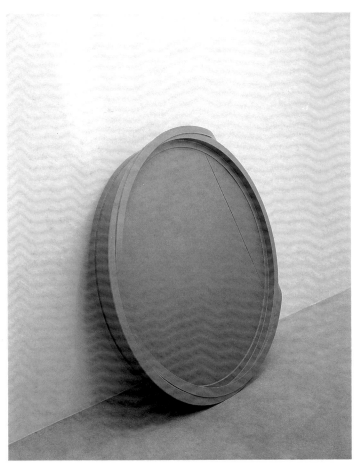

1 Granville Davey, $\frac{1}{3}$ *Eye* 1991, Painted steel, diam 166 x 22 cm

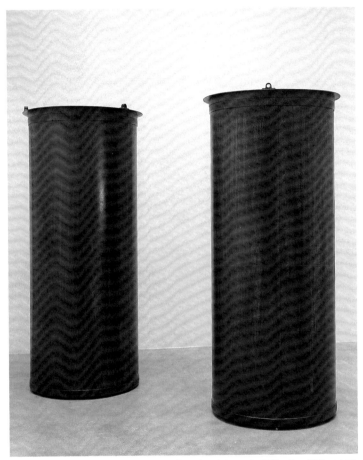

2 Granville Davey, *Two Rules Pair 1991*, 1991, Rusted steel, two parts, 225.5 x diam 100.5 cm each

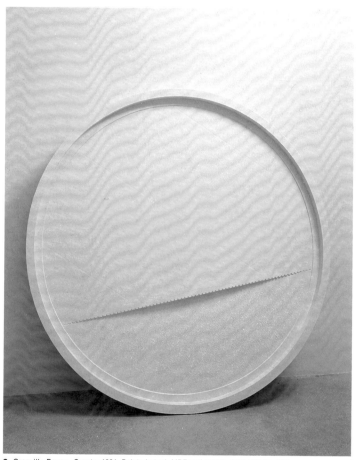

3 Granville Davey, *Quarter* 1991, Painted steel, MDF and paper, diam 191.5 x 15.5 cm

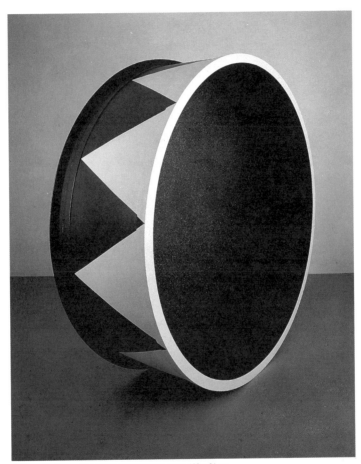

4 Granville Davey, *Type* 1990, Painted steel, diam 188 x 61 cm

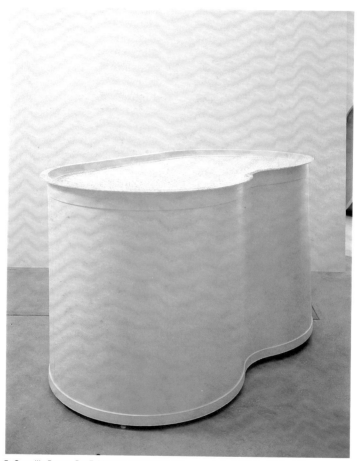

5 Granville Davey, *Dry Table* 1991, Painted and zinc sprayed steel, 224.5 x 130.5 x 119 cm

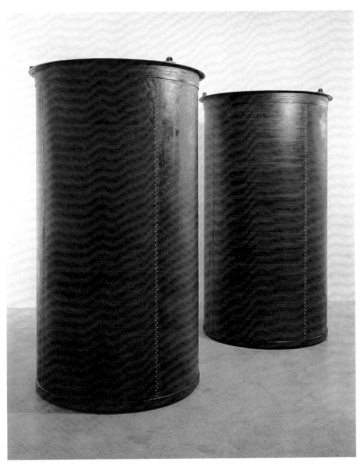

6 Granville Davey, *Idiot Wind* 1991, Rusted steel and rivets, 2 parts, 225.5 x diam 131 cm each

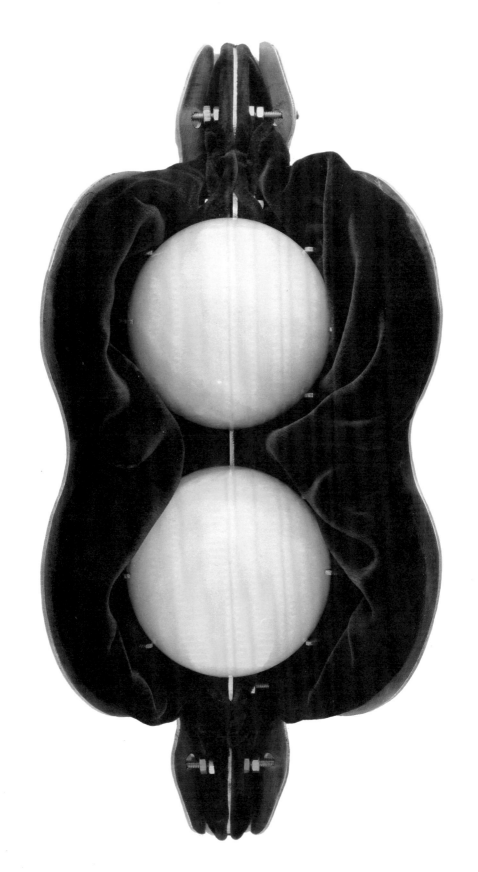

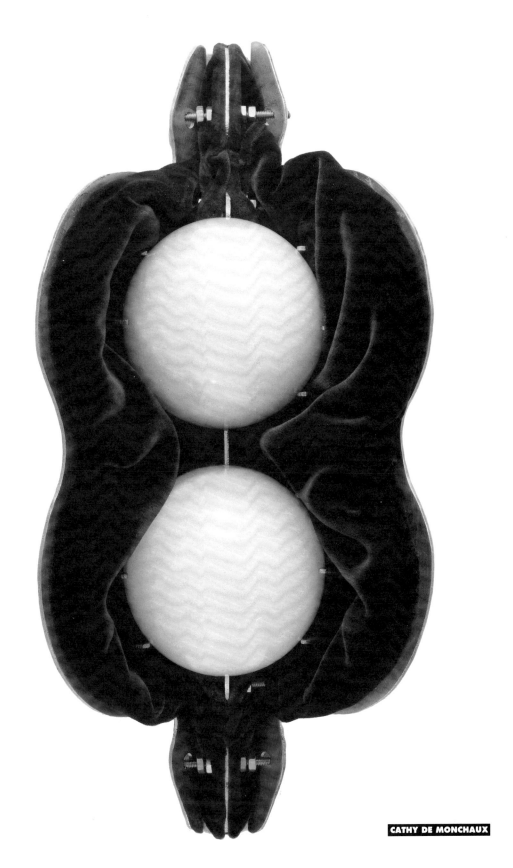

CATHY DE MONCHAUX

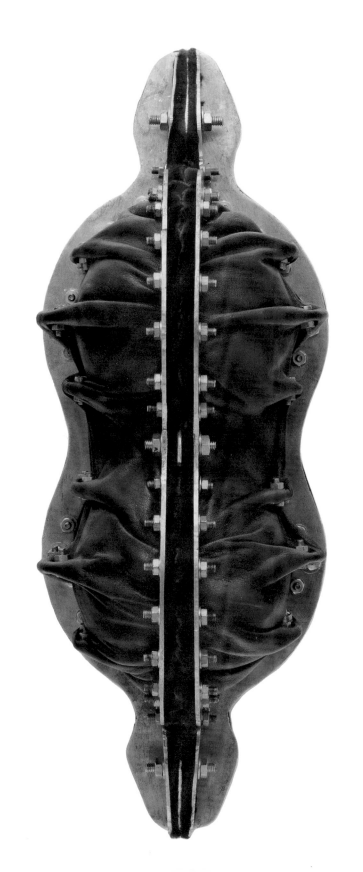

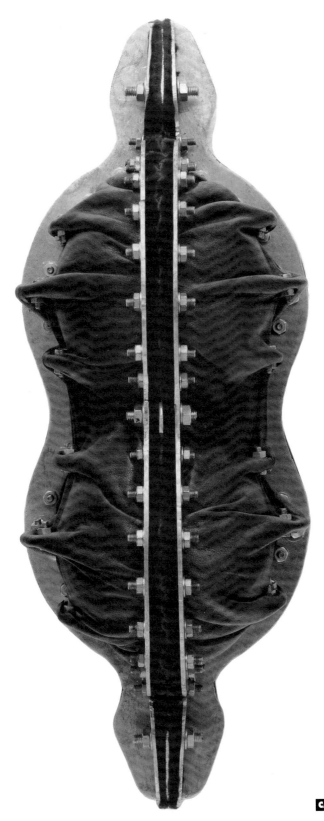

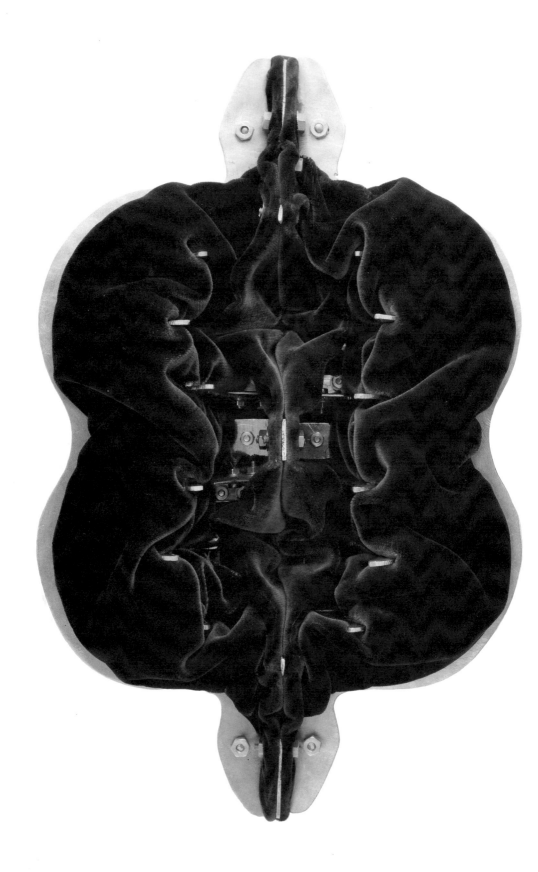

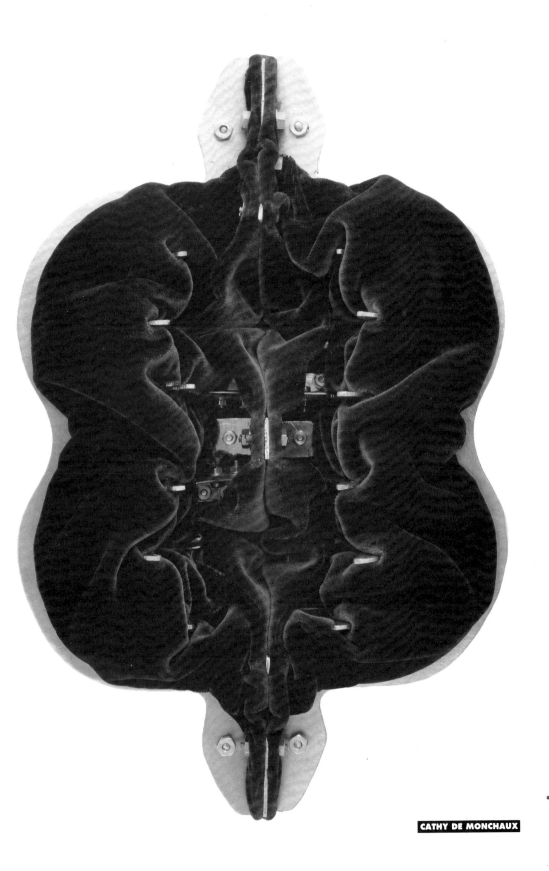

'Untitled Interior' 1991

'Untitled Object' 1991

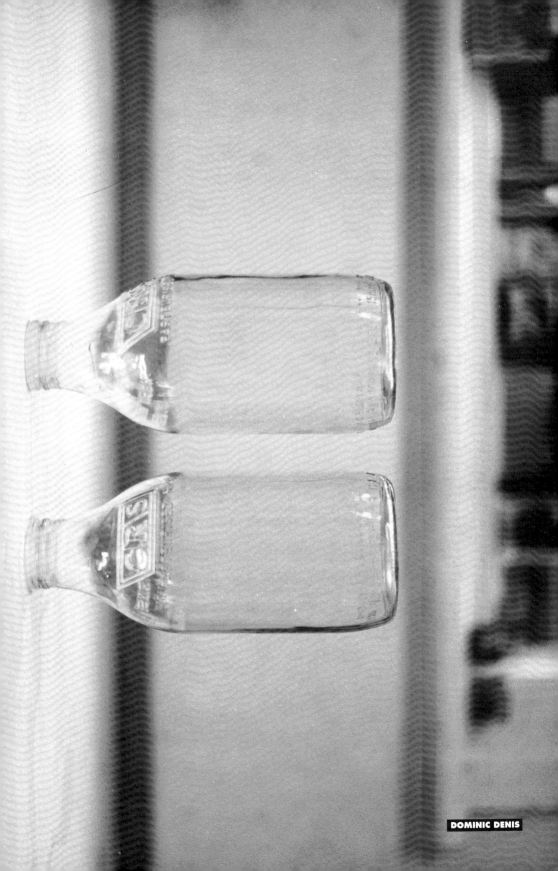

DOMINIC DENIS

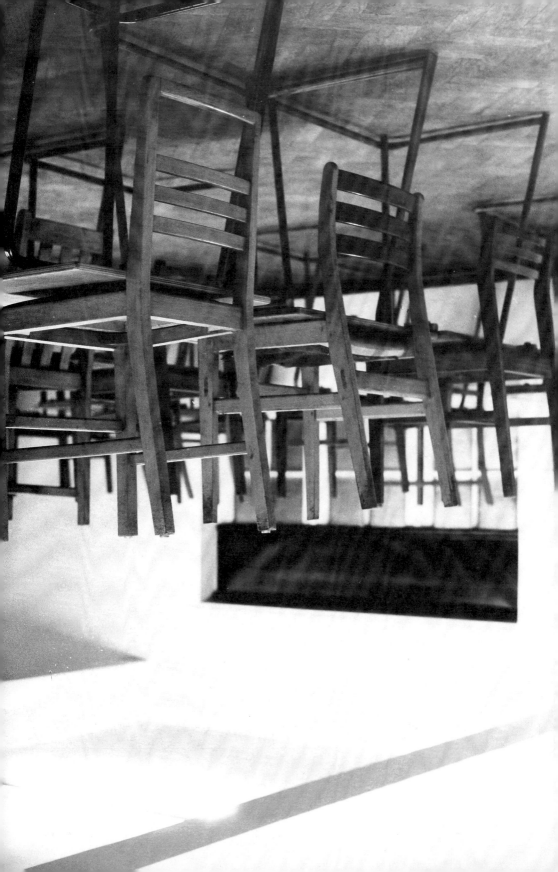

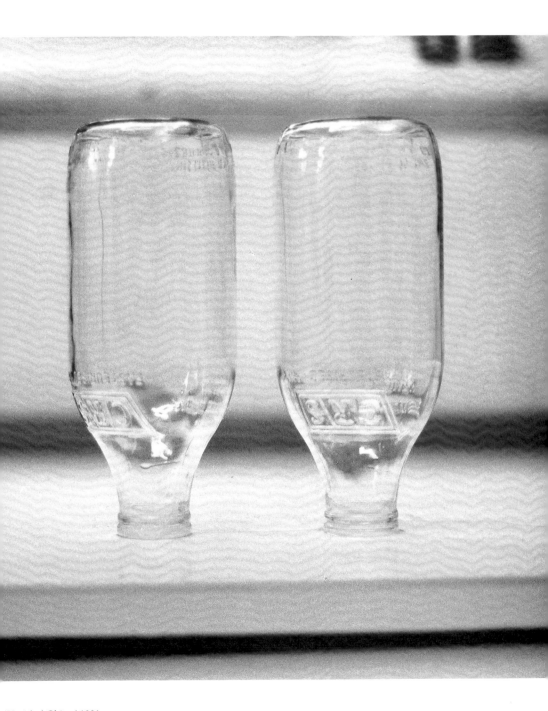

'Untitled Object' 1991

'Untitled Interior' 1991

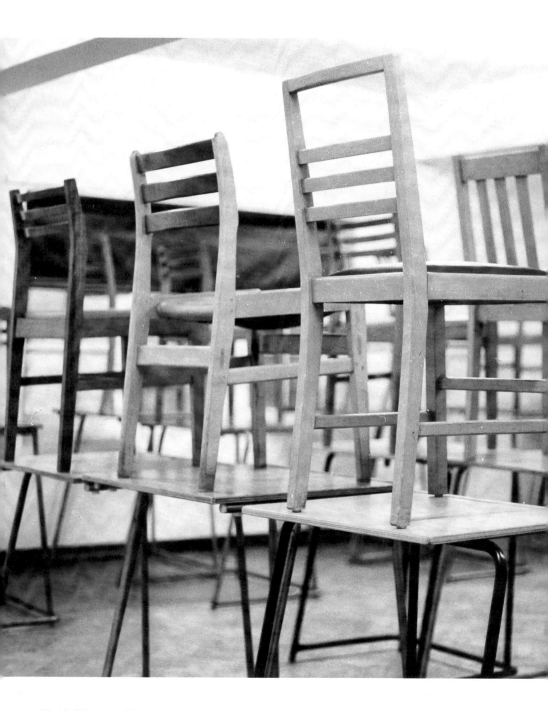

'Untitled Interior' 1991

'Untitled Object' 1991

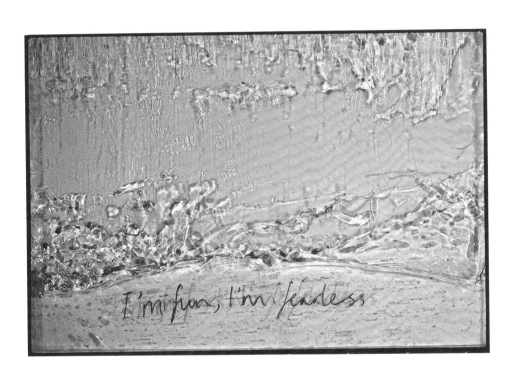

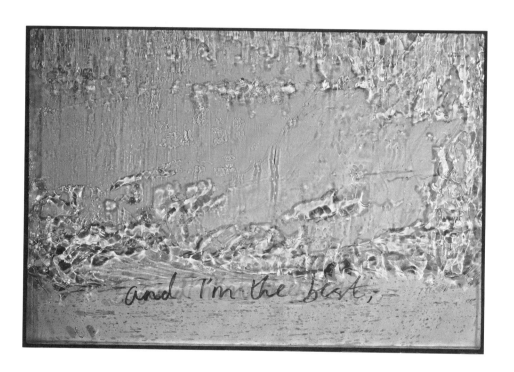

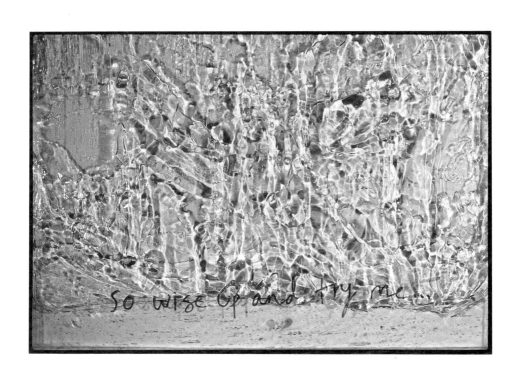

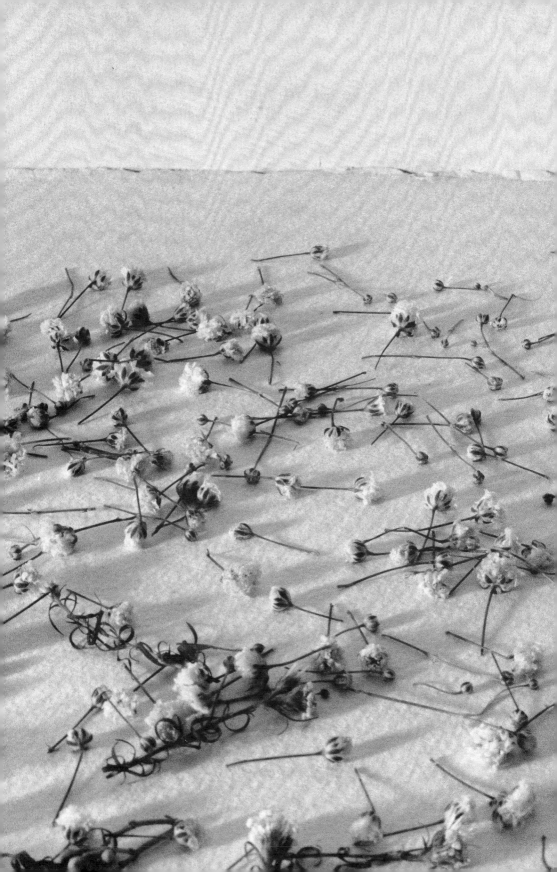

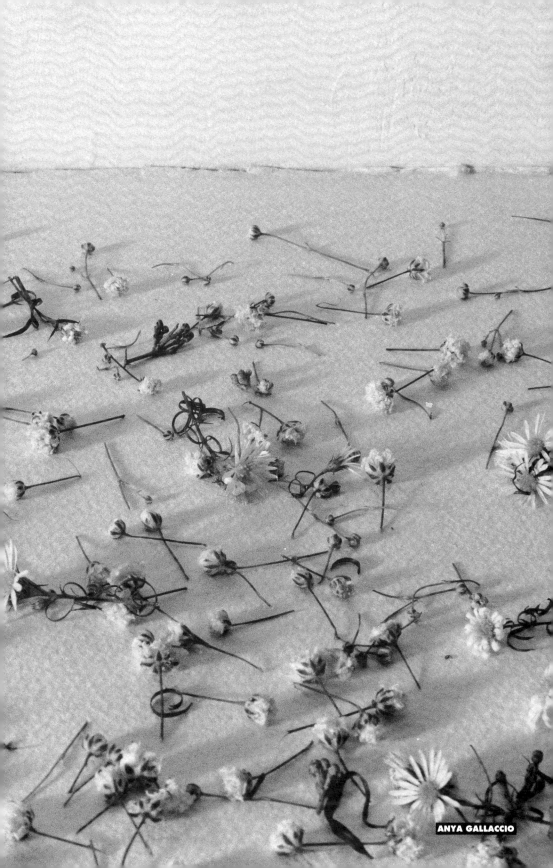

ANYA GALLACCIO

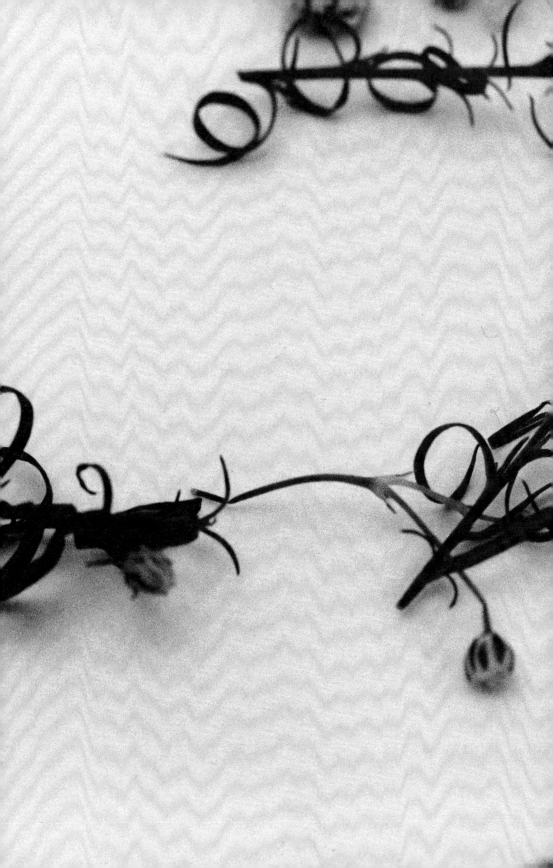

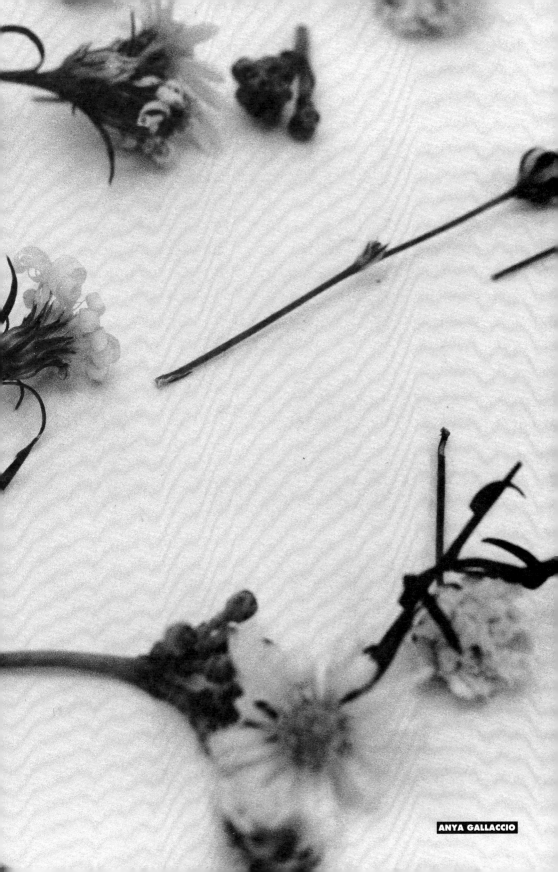

ANYA GALLACCIO

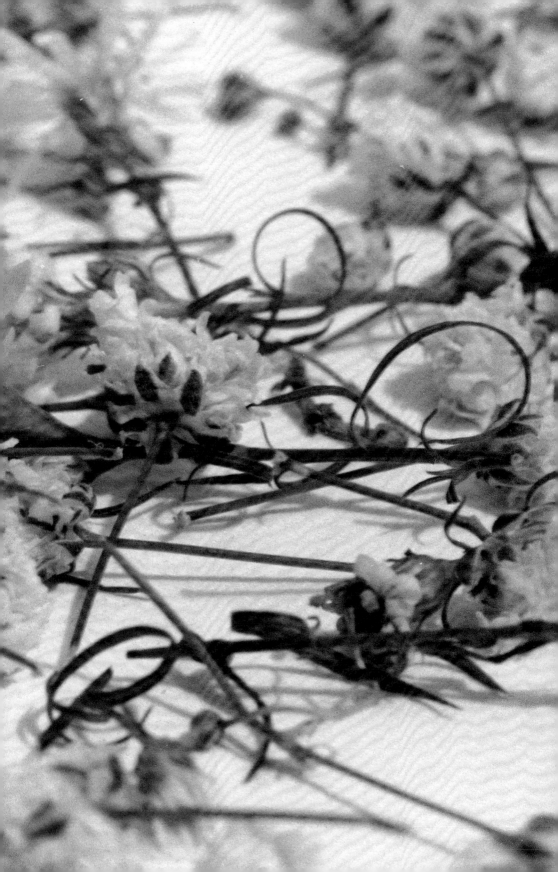

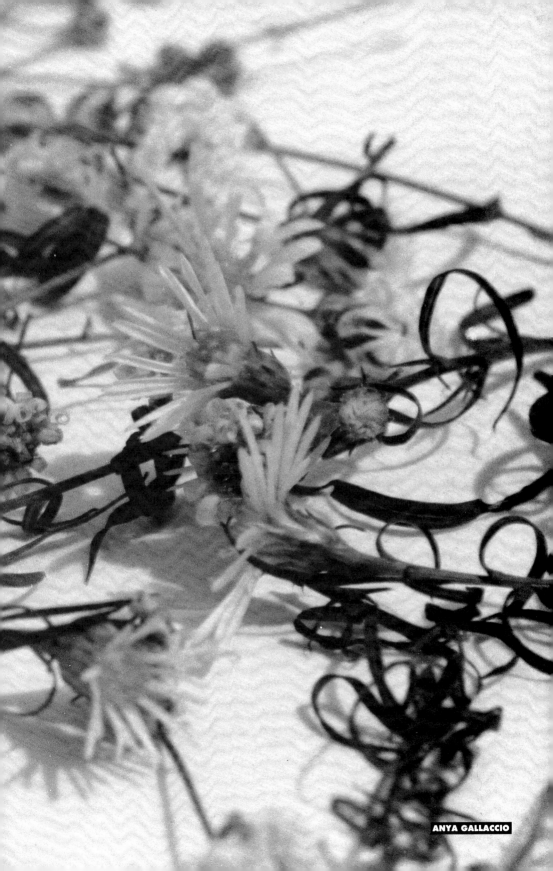

ANYA GALLACCIO

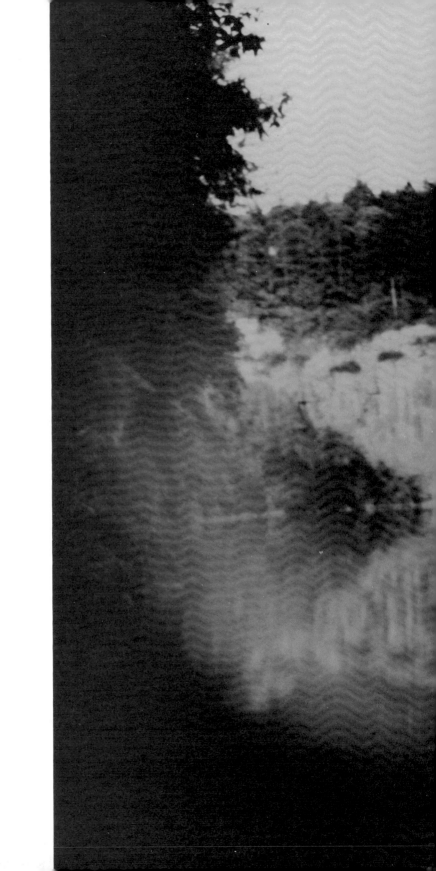

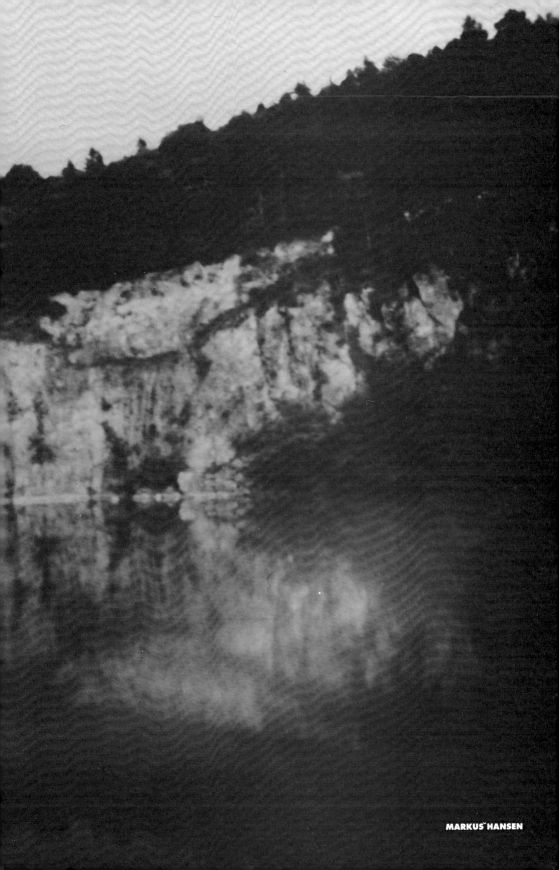

MARKUS HANSEN

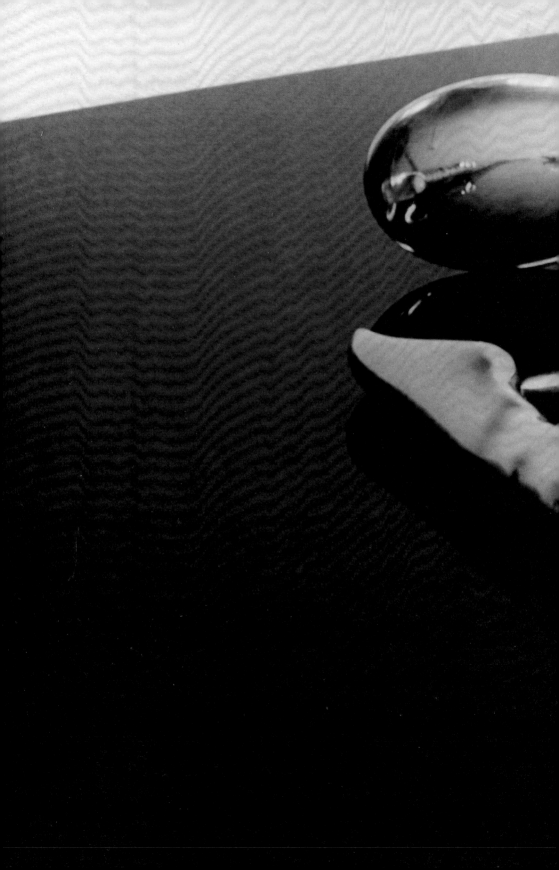

MARKUS HANSEN

35 ΧΡΟΝΙΑ

Φιλελεύθερος

ΙΔΡΥΤΗΣ: ΝΙΚΟΣ ΧΡ. ΠΑΤΤΙΧΗΣ

20 ΣΕΛΙΔΕΣ
Τετάρτη 12 Δεκεμβρίου 1990

ΕΤΟΣ 36ο ΑΡ. 11316 - ΤΙΜΗ 30 ΣΕΝΤ

ΠΑΝΕΠΙΣΤΗΜΙΟ: ΚΑΘΥΣΤΕΡΕΙ Η ΑΠΟΣΤΟΛΗ ΕΓΓΡΑΦΩΝ ΣΤΗ ΒΟΥΛΗ

Αντιδράσεις στη διάρκεια συνεδρίας της Επιτροπής Παιδείας

Γράφει: Λένα Τσικούλλα

Δεν έγιναν σοβαρές μελέτες;

ΜΕΤΑ ΤΗΝ ΑΝΑΤΙΜΗΣΗ ΤΩΝ ΚΑΥΣΙΜΩΝ

Αυξήθηκαν 8% τα εισιτήρια Κυπριακών Αερογραμμών

ΟΙ ΦΟΙΤΗΤΕΣ ΣΤΗΝ ΑΘΗΝΑ ΣΥΝΕΧΙΖΟΥΝ ΚΑΤΑΛΗΨΗ ΤΩΝ ΚΤΙΡΙΩΝ ΤΩΝ Κ.Α.

Γράφει: Τάκης Κουντουρής

ΕΠΡΕΠΕ ΝΑ ΗΤΑΝ ΜΙΚΡΟΤΕΡΕΣ — ΠΡΕΠΕΙ ΝΑ ΔΕΙΧΝΟΥΝ ΤΟ ΚΑΛΟ ΠΑΡΑΔΕΙΓΜΑ

ΨΗΛΕΣ ΟΙ ΑΥΞΗΣΕΙΣ

● Ο Βασιλείου δεν δέχθηκε να πάρει αύξηση

● Πρόεδρος της Δημοκρατίας κ. Γ. Βασιλείου δεν θα δεχθεί να αυξήσει — και ο ίδιος του μισθός και το επίδομα...

ΥΠΟΥΡΓΩΝ ΒΟΥΛΕΥΤΩΝ
ΣΤΟΥΣ ΜΙΣΘΟΥΣ ΛΕΝΕ ΟΙ ΣΥΝΤΕΧΝΙΕΣ

ΑΔΗΣΟΚ: Ναι στη διαφάνεια εσόδων των κομμάτων

Γράφει: Ιωσήφ Ιωσήφ

Κληρίδης: Δεν ήταν αρκετή η αντιμισθία

ΑΠΟΦΑΣΗ ΣΕΚ
Όχι αναμηλε αξιωματούχων στις εκλογές

Η ΠΑΙΔΕΙΑ ΦΕΥΓΕΙ ΑΠΟ ΤΟΝ ΕΛΕΓΧΟ ΤΟΥ ΚΡΕΜΛΙΝΟΥ

Απειλούνται με διακοπή σπουδών οι Κύπριοι φοιτητές στην ΕΣΣΔ

ΑΝΕΞΑΡΤΗΤΟΠΟΙΗΣΗ ΠΑΝΕΠΙΣΤΗΜΙΩΝ ΚΑΙ ΑΠΑΙΤΗΣΕΙΣ ΓΙΑ ΔΙΔΑΚΤΡΑ - ΕΘΝΙΚΕΣ ΓΛΩΣΣΕΣ ΕΚΤΟΣ ΤΗΣ ΡΩΣΣΙΚΗΣ

Γράφει: Σ. Αγγελίδης

Ο Πρόεδρος της Δημοκρατίας δέχθηκε χθες τη διαπιστευτήρια του νέου πρέσβη της Ιαπωνίας στην Κύπρο. Σχετικό είδηση με αλλο ενθετικό.

● κ. ΜΙΛΤΙΑΔΗΣ ΧΡΙΣΤΟΔΟΥΛΟΥ ΟΜΙΛΕΙ ΣΤΟΝ «ΦΙΛΕΛΕΥΘΕΡΟ»

Σπάνια Αθήνα - Λευκωσία είχαν κοινή πολιτική στο Κυπριακό

Η ΔΥΣΠΙΣΤΙΑ ΜΕΤΑΞΥ ΕΛΛΗΝΩΝ ΚΑΙ ΤΟΥΡΚΩΝ ΤΗΣ ΚΥΠΡΟΥ

● κ. Μιλτιάδης Χριστοδούλου

ΣΥΝΑΝΤΗΘΗΚΕ ΜΕ ΤΟΝ ΛΑΜΠ
Ο Χριστόφιας ζήτησε αμερικανικές πιέσεις στην Τουρκία

ΝΕΑ ΤΡΟΠΗ ΣΤΟ ΘΕΜΑ ΚΑΤΑΓΓΕΛΙΑΣ ΤΗΣ ΠΑΣΥΔΥ

Ο Γενικός Ελεγκτής δεν μπορεί να διενεργήσει ολοκληρωμένη έρευνα με βάση τους όρους εντολής

● ΓΕΝΙΚΟΣ ΕΙΣΑΓΓΕΛΕΑΣ ΘΑ ΚΑΛΕΣΕΙ ΜΑΡΤΥΡΕΣ

Γράφει: Χρ. Ευσταθίου

ΑΥΡΙΟ ΠΕΜΠΤΗ
Συνέρχεται επειγόντως το Γ.Σ. ΠΑΣΥΔΥ
ΓΙΑ ΤΗΝ ΠΕΝΘΗΜΕΡΗ

ΚΤΗΜΑΤΙΚΑ ΘΕΜΑΤΑ
Η καταναγκαστική απόκτηση διόδου

Του κ. Ανδρέα Π. Ιωαννίδη
Κτηματολογικού Λειτουργού

Στην Κύπρο την αέρινη...
Του κ. Κώστα Μ. Πρωσή

η σάτιρα της ημέρας

Άγιε μου Σπυρίδωνα

Δρακάκης

The Global Newspaper
Edited and Published
in Paris

Printed simultaneously in Paris,
London, Zurich, Hong Kong,
Singapore, The Hague, Marseille,
New York, Rome, Tokyo, Frankfurt.

INTERNATIONAL
Herald Tribune

Published With The New York Times and The Washington Post

No. 33,529 50/90 ** ** LONDON, THURSDAY, DECEMBER 13, 1990 ESTABLISHED 1887

Baghdad Replaces Defense Minister With a War Hero

Compiled by Our Staff From Dispatches

NICOSIA — President Saddam Hussein of Iraq has dismissed his defense minister, the second major change in his military high command in a month, Baghdad radio, monitored here, reported Wednesday.

General Abdul Jabbar Khalil Shanshal, who had held the post for over a year, was replaced by Major General Saadi Tuma Abbas, who was honored during the Iran-Iraq war for defending a strategic point against Iranian "human wave" assaults.

"Replacing Shanshal with a new defense minister and war hero like Tuma

radio quoted the president as saying in talks in Tehran with a group of Muslim personalities.

● President Chadli Bendjedid of Algeria arrived in Baghdad on a Gulf peace mission and met Mr. Hussein, Arab diplomats said. The diplomats said Colonel Bendjedid was trying to arrange a meeting between Mr. Hussein and King Fahd of Saudi Arabia. No details of the talks were reported.

● The official Iraqi press agency, INA, quoted Foreign Minister Tariq Aziz as confirming the U.S. stand in the Security Council as "complete alliance with the United States to link Middle East problems, particularly the Palestinian issue, with the current Gulf crisis." The United States has rejected such linkage.

Crisis in the Gulf

● Germany and Japan rejected Pentagon complaints over aid. Page 2.

● A hostage exodus from Baghdad and Kuwait slowed to "a trickle." Articles on Page 4.

Saddam's way of telling the Americans his military means business," an Arab envoy in Cairo said. The move is also significant because it comes before Iraq-U.S. talks on the Gulf.

There were three related developments Wednesday in the Gulf crisis.

The United States accused Iraq of blocking agreement on the timing of high-level talks. A State Department spokesman, Richard Boucher, said Iraq was still insisting that Mr. Baker come to Baghdad on Jan. 12 to meet Mr. Aziz. The United States has refused the proposal because it says too close to the Jan. 15 deadline down by the UN Security Council authorizing the use of force against Iraq if it has not withdrawn from Kuwait by then.

President Hashemi Rafsanjani said Iraq appeared increasingly to yield to U.S. pressures to withdraw from Kuwait. "It's much clearer and clearer that we will renounce Kuwait sooner or later than the Americans, with the Muslim nations and the because it will be in the interest of imperialism," Tehran

See IRAQ, Page 4

Middle East experts said that General Abbas was credited with being the strategist behind the successful Iraqi defense of the southern port city of Basra, using formidable defensive lines. The Iraqis, who have an estimated 450,000 troops in and around Kuwait, have built similar fortifications around the emirate.

General Abbas, who is in his 50s, had been the inspector-general of the armed forces and was a former deputy chief of staff.

The appointment of General Abbas "could mean that Saddam is less than ready to compromise" on Kuwait, said Paul Rogers, a military analyst at Bradford University in England and an expert on Middle East military affairs.

"The implication is that he's making sure that all those involved in military decision-making will toe the line," Mr. Rogers said.

The decree said General Shanshal, 70, was retiring because of his age. He was named a minister of state for military affairs, the post he held before he was appointed defense minister. Analysts said it carried no authority or influence.

Bon Katz

U.S. Gives Soviets Waiver to Buy Food

Summit Meeting Is Set in Moscow For Feb. 11-13

Compiled by Our Staff From Dispatches

WASHINGTON — President George Bush said Wednesday that he would waive trade restrictions in U.S. law until June 1991 on the Soviet Union could buy grain and other agricultural commodities to alleviate food shortages in the Soviet Union.

He also said that a summit meeting with Mikhail S. Gorbachev had been set to occur in Moscow from Feb. 11 to 13 and that he hoped he and Mr. Gorbachev would be able to sign a treaty cutting long-range nuclear weapons.

Mr. Bush said the food aid would be accompanied by pharmaceutical, technical and economic assistance, as well as U.S. recognition that Moscow be allowed "a special association" with the International Monetary Fund and the World Bank.

Foreign Minister Eduard A. Shevardnadze of the Soviet Union, appearing with Mr. Bush, acknowledged growing instability in the Soviet Union, but he said Mr. Gorbachev would check the mounting economic and political uncertainty.

Mr. Bush also said he was making the Soviets eligible for credits totaling $1 billion to buy U.S. agricultural products ranging from grain to cheese.

"The Soviet Union faces tough times," the president said at a Rose Garden appearance with Mr. Shevardnadze and Secretary of State James A. Baker 3d. "I want perestroika to succeed," Mr. Bush added, referring to the Soviet restructuring program.

Mr. Shevardnadze hailed Mr. Bush's comments as a "very important statement" and said he looked forward to seeing the signing of the arms control treaty that has been long sought at the summit.

The arms treaty would reduce the most powerful and dangerous nuclear weapons in both countries' arsenals by about 30 percent.

Mr. Bush granted the Soviets a temporary waiver of legislation that has made expanded U.S.-Soviet trade contingent on liberalized Soviet emigration policy. The waiver does not need to be approved by Congress.

Mr. Bush said he welcomed the "generally excellent progress" during the last year, during which the Soviets have permitted tens of thousands of Jews to emigrate to Israel.

But he added, "I still look for

See TRADE, Page 4

A Muslim carrying his child into Beirut's Christian zone through a recently reopened passage.

For Once, Some Good News From the Mideast

The Gunmen Gone, Beirut Hopes the Peace Will Last

By Ihsan A. Hijazi
New York Times Service

BEIRUT — An oasis of peace has been established in Lebanon, and there is genuine hope that this small country, which has lost 150,000 dead in the longest civil war in the turbulent Middle East, may be on its way to recovery.

Beirut and areas surrounding the capital have shaken off the rule of various militias and been reunited under the control of a legitimate government and a national army.

Most of the gunmen and most of their guns have departed, leaving a 250-square-mile (650,000-square-kilometer) zone free of private armies for the first time since factional strife began nearly 16 years ago. And the outside powers that had supplied the Lebanese private armies are now losing interest in them.

As Muslim and Christian areas opened up to each other after the army dismantled the Green Line dividing Beirut, which had stood as a symbol of partition, residents had a rare view of the ugliness war leaves. The old downtown area, once the heart of Beirut, is devastated. Collapsed structures and shell-pocked building facades carry the scars of violence.

High wild grass grows in abandoned roads. Bulldozer crews start to remove the rubble are repeatedly slowed by the unearthing of skeletons of those killed in the years of fighting.

But, hardly a week after the "Greater Beirut Zone" was carved out, images of peace and business obliterate those of war.

Among advertisements that filled the front page of a daily newspaper was one announcing the arrival of French cheese. Norwegian salmon and travian caviar for the holidays. Traffic is again bumper-to-bumper.

A bank manager said he had been processing 50 pre ac-

counts in foreign exchange every day, indicating that the flight of capital had been reversed, and the Lebanese pound is rising on exchange markets.

Even the Gulf crisis, thousands of rich Lebanese who were in Kuwait and Saudi Arabia have come home, bringing their money with them. Kuwaitis who bought houses in Lebanese mountain resorts before Saddam Hussein made them exiles are here to claim their property.

Even other foreigners have begun to return, once a thriving community in this city known as the hub of the Middle East, foreigners were driven out by the violence and kidnappings.

Although six Americans and six other Westerners are still held in Lebanon, newspapers carry daily reports of behind-the-scenes negotiations to free them, and the pro-Iranian groups that are believed responsible for the kidnappings are spreading the word that hostage-taking is over.

"Western citizens are welcome to return to Lebanon, for they no longer have to worry for their safety," said Hussein Musawi, a senior member of Hezbollah, the Party of God, the main Iranian-backed group, which is widely thought to be an umbrella for the clandestine cells holding the captives.

The United States helped inject optimism by sending its ambassador back to Beirut after an absence of 15 months. The envoy, Ryan Crocker, delighted Lebanese when he told them in Arabic that their capital would soon recover its past glory.

"There is no substitute for Beirut in the Middle East," he said.

Although he a newly appointed, the ambassador has been driving around the Muslim

See LEBANON, Page 4

Massive Soviet Exodus Is Unlikely, Experts Say

By Joseph Fitchett
International Herald Tribune

HAGUE — The threat of a wave of Soviet refugees pouring westward this winter is highly exaggerated in the Western press, according to specialists from West governments who are in charge of the issue.

Although discounting most scenarios for an imminent exodus on the Soviet Union, the officials said specialists on refugee issues met that even gradual growth in a number of Soviets arriving in eastern Europe to seek asylum of jobs could strain the European community's capacity to absorb them.

The specter portrayed in some proposals here is a far more dramatic nightmare of a widespread rush out of the Soviet Union will operate people liking across the nuntry's northern frontiers, turning up in Western asylum of embassies or simply trampling down the border fences.

Variants of this vision — spiced with reports of refugee camps being readied in Eastern and Western Europe — have recently appeared in major publications in Britain, France and Germany. One early scenario said 1 million Soviets could be coming, and a more recent one speculated that more than 4 million could be involved.

Such apocalyptic fears arouse skeptical reactions among the experts. "Unless civil war erupts throughout western areas of the Soviet Union, there is little evidence pointing to significant prospective overflows," according to Jean-Claude Chesnais, a French expert on population movements.

His view was shared by government officials from the United States, Canada, Australia, Germany, Sweden, Switzerland, the Soviet Union, Czechoslovakia, Hungary and Poland. They spoke at a meeting on Soviet emigration conducted last week by the Washington-based Refugee Policy Group and the Institute for East-West Security Studies, a U.S.-based foundation that opened a study center in Prague last month to help East Europeans develop democratic institutions.

Soviet emigration is a topic that has suddenly preoccupied the European agenda. During the Cold War, Communist countries viewed emigration as tantamount to treason. Most emigrants were either Soviet dissidents who were Jewish, freed under U.S. pressure, or else Soviets of German ancestry, bought out by Bonn.

Now, the West has to reckon with the possible consequences of a Soviet law that will authorize freer emigration. The proposed law, drafted mainly in response to U.S. human-rights demands for free-dom of travel — could theoretically enable millions of Soviet citizens to leave. Soviet officials say the new emigration law is unlikely to take effect before next summer.

With or without the statute, some analysts have predicted that famine, accompanied by worsening

See EMIGRATE, Page 2

A Soviet transport plane in Melbourne loading donated provisions to help ease Moscow's food shortage. Related article, Page 2.

Shamir Supports Nonnuclear Mideast

Compiled by Our Staff From Dispatches

WASHINGTON — Prime Minister Yitzhak Shamir said Wednesday that he favored in principle a Soviet proposal to establish a nuclear-free zone in the Middle East, and he repeated Israel's rejection of an international peace conference on the region.

Before a meeting with Eduard A. Shevardnadze, the Soviet foreign minister, Mr. Shamir also said that Israel was seeking immediate full diplomatic relations with Moscow.

Responding to Mr. Shevardnadze's proposal this week for the creation of a zone free of nuclear and chemical weapons, Mr. Shamir said: "Our answer is positive in principle. We are ready to start a serious study of all these problems in order to limit and annihilate any possibility of the use of nonconventional arms in our area."

Secretary of State James A. Baker 3d said he was sympathetic to the idea, but stopped short of saying that Washington would ask Israel to give up its nuclear weapons.

Israel's customary position on nuclear weapons has been neither to confirm nor deny having them, but to say it would not be the first Middle East nation to use them. The rapid progress of Iraq's nuclear program, however, and its possession of chemical and biological weapons and ballistic missiles have alarmed the Israelis.

Mr. Shamir said Israel would have to respond if attacked by Iraq, although it is being urged by the United States not to react to provocations.

Soviet-Israeli relations, marked by enmity for decades, have warmed in the last year as Moscow opened the door for hundreds of thousands of Soviet Jews to immigrate to Israel.

"Our relations with the Soviet Union are becoming closer every day," Mr. Shamir said. "We have to establish normal diplomatic relations, and we don't see any reason for not establishing them now."

The Soviet Union cut diplomatic ties with Israel after the 1967 Middle East war. But the countries have quietly built up large consular missions and have re-established sporting, cultural and commercial links in the last three years.

Moscow, in effect excluded from Middle East peace efforts for a decade, has made restoration of full ties conditional on Israel's accepting an international peace conference, of which it would be co-chairman.

The issue is under discussion in the United Nations Security Council, where the United States is trying to prevent its inclusion in a resolution calling for the protection of Palestinians in Israeli-occupied territories.

But Mr. Shamir, on his first visit to Washington in 15 months, said Wednesday that "Israel will not participate in such a conference and Israel will not accept any imposed solutions."

(Reuters, AP, WP)

Intifada: Israel Orders Sniper Fire

By Joel Brinkley
New York Times Service

JERUSALEM — The Israeli Army has begun deploying hidden snipers along highways in the West Bank with authorization to shoot at Palestinians caught throwing stones at Israeli cars.

The "sharpshooters," as the army chief of staff, Lieutenant General Dan Shomron, called them, use live ammunition and are permitted to fire without warning only if they believe the stone throwers are endangering the lives of drivers.

The army acknowledges that not one Israeli driver has been killed as the result of a hurled stone since the Palestinian uprising began three years ago, though many have been wounded, some seriously.

Still, so far this week the snipers have shot and wounded at least four Palestinian youths caught in the act of throwing stones. The snipers' standing orders are to shoot to wound, not to kill.

The "tactical adjustment" in the West Bank, as an army spokesman described the sharpshooter deployment, has set off an angry domestic debate. Israelis of the political left are calling the new orders "monstrous" and out of proportion to the threat, as one of them put it. At the same time, politicians of the right are complaining that the army is still showing too much restraint.

The new order is the latest tactic tried over the last 36 months to stop the stone-throwing, a common Palestinian tactic since even before the intifada began. But even with dozens of new weapons and strategies,

See ISRAEL, Page 4

Kiosk

Prague Votes Power Division

PRAGUE (AP) — Czechoslovakia's parliament approved a new division of power on Wednesday between the federal government and the country's two regional republics, settling a lingering crisis and saving national unity.

Deputies voted, 237 to 24, in favor of handing broad economic powers to the Czech and Slovak republics, while the federation retains jurisdiction over the military, foreign policy, economic and fiscal strategy. The decision was a compromise reached after Slovak leaders threatened to proclaim the sovereignty of Slovakia over two federal legislation if their demands for economic control were not met.

General News

Albania celebrated the founding of the first legal opposition party. Page 2.

Sweden will seek membership in the EC. Page 2.

Business/Finance

CBS Inc. is to buy back its stock for up to $2 billion. Page 13.

Technology Quarterly

The Mediterranean Sea's health is linked to preserving a humble seagrass. Pages 9-11.

Crossword Page 8

The Dollar
New York, Wed. close
Up	
38.14	Pound 1.9602
2,822.29	Yen 131.45
	FF 5.0115

Rating Wine: Does Computer Have Better Taste?

By Peter Passell
New York Times Service

NEW YORK — Is an Ashenfelter, a Princeton University econometrician and nemesis of the snobbish world of wine rating, is up to his old tricks.

Mr. Ashenfelter, who publishes a wine market newsletter called Liquid Assets, has already caused many a critic to choke on his claret by insisting that computers could reliably assess vintage quality long before tasters could.

Now his weather-based statistical model is predicting that the 1990 French red wines, still raw fermented grape juice, are likely to become the most coveted since the 1961s — and perhaps the best ever made.

This is good news for people ready to pay $20 and (way) up for the pedigreed Bordeaux that set the standard for red wines worldwide. But in Mr. Ashenfelter's view, it could prove an embarrassment of riches for industry middlemen, who are carrying inventories from the 1980s at very high costs.

And it could seriously strain the marketing arrangements — a polite term for informal cartel — that French vintners apparently use to smooth income from good to bad years.

Most red wines are ready to drink a year or two after they are made. But the very best mature in wood casks for

at least 18 months and keep getting better in the bottle for a decade or more.

Judging wines by taste while they are still in the cask or freshly bottled is an uncertain science, and one prone to conflict of interest since wine critics must depend on vintners and wholesalers for access to very young wines.

Many initially touted vintages — the latest, Mr. Ashenfelter believes, is 1986 — prove no better than average. But the Princeton researcher has demonstrated to the satisfaction of mathematically sophisticated analysts that knowledge of temperature and rainfall is all that is needed to predict the average quality of a new vintage.

The very hot, very dry summer across Europe last year, Mr. Ashenfelter reckons, will yield Bordeaux wines that surpass even the legendary 1961s in quality.

Once the 1990s are mature enough to judge reliably by taste, Mr. Ashenfelter says, they will sell for five times the price of the overrated 1986s and three times the price of the highly respected 1978s that now crown the displays in upscale stores.

What might opportunity for wine enthusiasts, however, may spell trouble for wine marketers. The spectacular 1990s come hard on the heels of the almost-as-spectacular 1989s and the merely terrific 1988s, 1985s, 1982s and 1983s — a run of vintages, Mr. Ashenfelter's calculation suggests, superior to any since the 1920s.

This could make it difficult for wholesalers to sell remaining inventories of mediocre 1986s at a profit. As important, Mr. Ashenfelter argues, it could break the marketing daisy chain that has buttressed vineyard owners' incomes against changes in weather and crop size. The heavyweights of the wine business, Mr. Ashenfelter surmises, have long intuited the relationship between weather and vintage quality, and have thus pretty much known where they stood the day the harvest was completed. But they have encouraged critics to exaggerate the quality of bad vintages and, by implication, to understate the giant qualities of good ones to smooth out the price cycle.

The giant wholesalers, which bear the initial financial risk, go along, presumably moving as much of the overrated vintages in the early years when they are too young to evaluate by taste.

Complaints are few — perhaps because many consumers are more interested in the snob value of the labels than the brew itself, perhaps because amateur wine investors are happy to forget their errors and the experts who encouraged them to err have an incentive to let them forget. Mr. Ashenfelter says this tacit conspiracy could break down.

For one thing, the remarkable growing weather in the

See VERITAS, Page 15

GARY HUME

SUMMARY

Israel agrees nuclear ban in principle

The Israeli Prime Minister, Yitzhak Shamir, accepted the principle of a nuclear and chemical arms ban in the Middle East. Responding to a proposal from the Soviet Foreign Minister, Eduard Shevardnadze, he said Israel would be ready to "start a serious study" of a nuclear-free zone, when the Gulf crisis ended. **Page 13**

Trethowan dies

Sir Ian Trethowan, chairman of Thames Television and a former Director General of the BBC, died last night after a battle against motor neurone disease. He was 68.

No charges

Undercover soldiers who shot dead three small-time criminals during a robbery at west Belfast in January are unlikely to face charges. **Page 2**

Alibis 'hidden'

Barristers prosecuting the Guildford Four failed to disclose crucial alibi statements that could have presented a grave miscarriage of justice, evidence to be seen on ITV Television show. **Page 5**

Albania opposition

The final European domino seemed to have fallen with the formation in Albania of a first legal opposition party. **Page 13**
Leading article, page 22

Oil prices slump

The price of crude oil has fallen to $25.15, its lowest since the invasion of Kuwait, on fears of oversupply in the wake of a peaceful settlement of the Gulf crisis. **Page 24**

Mason wins

The British heavyweight champion Gary Mason, returning to the boxing ring after nine months, defeated the American James Pritchard in the ninth round. **Page 36**

Trainer fined

The Newmarket racehorse trainer Mohamed Moubarak was fined £8,000, the biggest fine ever levied by the Jockey Club, after six horses were found to have been given anabolic steroids. **Page 36**

"The architects of Canary Wharf — £3 million square feet of new office space, 24 buildings, half a million square feet of shops, 3,500 building workers, 90,000 office workers and a total investment of at least £4bn — gives its real notion of Paul Reichmann's finest for risk. Let's just say that he is trying to turn back a westward shift in London's population that has been going on since the Great Fire."
— James Buchan looks at Canary Wharf in *The Independent on Sunday* this weekend.

INSIDE

FASHION
Supporting players 17

EDUCATION
Speaking French.............. 19

CONTENTS

Lamont gloomy on recession

Chancellor rules out early cut in base rates despite fall in inflation

By Colin Brown and Peter Rodgers

NORMAN LAMONT yesterday appeared to rule out a pre-Christmas cut in interest rates, and gave a bleak view of the severity of the recession that could dissolve any Conservative hopes of a snap general election in the new year.

The Chancellor warned that unemployment figures today would show a continuing rise from last month's 1.7 million, and made clear that the expected fall in the inflation rate tomorrow should not be taken as a signal for easing interest rates. He emphasised that interest rates would not fall while sterling remained weak in the European Exchange Rate Mechanism, and dismissed as "nonsense" City rumours that Britain would soon move the pound into the narrow band of the ERM.

Though interest bands are a tougher discipline in the long run, the City had suspected that the move would be accompanied by devaluation and lower base lending rates, which industry has been demanding to ease the recession. In narrow bands, currencies fluctuate only 2.25 per cent either side of a central rate in the ERM, compared with the 6 per cent now allowed for sterling.

Mr Lamont's pessimistic review of the economy was seen as an attempt to correct the impression given last week, before a Commons select committee that he was speaking in too interest rates as soon as inflation starts falling.

With a decline of more than 1 percentage point in November inflation expected tomorrow, from 10.9 per cent in October, many City dealers have been betting on lower base rates before Christmas — a view reinforced by the decide of recession flooding in. Sterling is less attractive to hold when interest rates fall, so the prospect has pushed it

sharply downwards on the ERM bands. But Mr Lamont said: "There can be no question of a reduction in interest rates which is not fully justified by our position in the ERM. This will be the case however strong the pressure for lower interest rates from other indicators."

The City has until now been sceptical about Treasury and Bank of England assertions that interest rates must stay where they are, because the same was said in the weeks before the base rate cut to 14 per cent in October.

Mr Lamont yesterday put the reduction of inflation as his top priority. The Chancellor said: "I do not believe we should use fiscal policy to give a short-term stimulus to demand. The best way to bring an upturn in activity is to stick to the policy of getting inflation down."

Peter Spencer, of the investment bankers Shearson Lehman, said: "His ERM commitment means that they are not going to do anything by way of early base rate cuts or realignments they perceive as weakness."

The Chancellor said the Treasury estimate that inflation would fall to 5.5 per

Britain entered the ERM at the central rate of DM2.95 to the pound which, the Chancellor said, struck the right balance. Sterling closed at DM2.8745, after rising 0.7 pfennigs on the back of the Chancellor's dismissal of early base rate cuts. But it is only about five pfennigs above its effective floor in the system, which is currently set by the peseta.

Mr Lamont's remarks, in the first full-scale Commons debate since being appointed as Chancellor by John Major, were judged by senior Tory MPs to be a bravura picture of the tough time ahead.

One former minister said: "It reflects the mood from on high, that you have to tell it like it is and if it also helps the Prime Minister to show that he can be as tough as well as tender. He can say 'Sorry, I can't help because I've got no cash.'"

cen by the fourth quarter next year was "if anything, towards the upper end of the range." But business was "about to enter a testing time." Replying to a Labour motion condemning the Government, Mr Lamont said there could be no guarantees that the recession would be short-lived or relatively shallow. There were uncertainties in the Gulf relating to oil prices and it would also depend on keeping wage claims down.

■ A Labour lead of 16 per cent has been turned into a Conservative lead of 2 per cent since John Major became Prime Minister, according to an ICM survey carried out last weekend. The Guardian poll showed Tory support up by 12 percentage points to 45 per cent, compared with last month, while Labour fell six points to 43 per cent.

Parliament, page 9
Commentary, page 25

Cape blown well by the strong winds yesterday during a rehearsal for Friday's Sovereign's Parade at the Royal Military Academy Sandhurst Photograph: Glyn Griffiths

Six drown in North Sea storms

By James Cusick
Scotland Correspondent

VIOLENT STORMS in the North Sea claimed the lives of six fishermen after their boat capsized off Shetland yesterday. The storms caused havoc in the North Sea with more than 200 men evacuated from oil rigs, and communities along Britain's east coast were put on flood alert as high tides threatened sea defences.

The fishing boat Premier, based at Lossiemouth in Morayshire, was the first casualty in a day described by Scottish coastguards as one of the "busiest ever" in the North Sea. Aberdeen Weather Centre reported gale force 11 conditions in the North Sea. Two places in Scotland recorded 70-knot winds — more than 100mph. A freak "90-year" wave reaching 80ft struck the Gullfaks Arctic III platform, ripping away two lifeboats. Five men were believed to be from the area were believed to be brothers. The missing men were from the Morayshire villages of Hopeman, Burghead and Lossiemouth.

Three men flooding in areas of Norfolk and southern East Anglia, with normal sea levels rising by more than two feet.

Five days after blizzards swept the North Sea in areas of the East and West Midlands, Nottingham-shire, Leicestershire and Derbyshire were still without power or water supplies.

It is estimated that more than 100,000 people are still without electricity.

defences. There was flooding in the area of Norfolk and southern East Anglia, with normal sea levels rising by more than two feet.

Delors attacks US over trade talks deadlock

From David Usborne
in Strasbourg

JACQUES DELORS yesterday accused the United States of treating the European Community like a leper in the farm subsidy war and said he saw no early prospect of reopening negotiations in the deadlocked world trade negotiations.

Proposals for a radical reform of the Common Agricultural Policy (CAP), to de-couple subsidies from farm production, are under consideration in Brussels. The European Commission President, however, who was presenting proposals for the EC summit this opening tomorrow in Rome, did not mention this in a likely topic.

The 12 EC leaders will consider the crisis in the trade negotiations for the first time. They are also due to discuss the Gulf crisis and aid to the Soviet Union, besides seizing fast gridlock for the next governmental conferences on political union, due to open after the summit, on Saturday.

Mr Delors dismissed that these guidelines should not be at the table as though aid for monetary union, implying that they should not lead to any indecision of the Plane Maastheer John Major.

On agriculture, Mr Delors said the US and the economic Community, which include Latin American agricultural exporters, Canada and Australia, had resisted the Community as though at this point the phrase and protracted others to treat us in the same way." He concluded: "I really don't think that we can reopen discussions on that basis."

In a wide ranging interview in *The Independent* today, Mr Delors reveals that he warned President George Bush before last week's ill-starred round of the General Agreement on Tariffs and Trade (Gatt) talks in Brussels that the belligerence of the most American tax negotiators was making agreement impossible.

The proposals to shift the emphasis of CAP support away from propping up prices and towards direct income aid for farmers should help unblock the Gatt impasse. Mr Delors emphasised that any reform would have to be designed so as to avoid sending poorer farmers to the wall. "We know we have to come to adopt the CAP. But I'm not going to be an accomplice to encouraging people to leave the land," he said.

Ray MacSharry, the EC Agriculture Commissioner, also took steps in Strasbourg yesterday to reassure MEPs that the reform package would not mean disaster for small farmers. "We have no intention of eliminating subsidies. Indeed, in some cases these may even be increased. But it is vital that we restrict assistance to go on where the greatest subsidies given to 50 per cent of farmers," he said.

Looking towards the summit, Mr Delors emphasised that the guidelines for the political union negotiations, while important, could not be too detailed. "It would be useful to establish a framework, but I believe it will be a lot less precise compared with those agreed in Rome in December in monetary terms." It was that text which led to the brutal incident of Margaret Thatcher.

Guest of Michelis the Italian Foreign Minister, also confirmed to *The Independent* that a draft text was being prepared on political union which would be deliberately phrased to avoid controversy at the summit itself. "We are not going to do anything controversial," he said.

Full steam ahead, page 16
Delors interview, page 27
Peter Jenkins, page 25

New York Mafia boss arrested on murder warrant

From Leonard Doyle
in New York

John Gotti: 'The Teflon Don'

ON LITTLE Italy's Mulberry Street last night, Christmas lights twinkled gaily outside the Ravenite Social Club where once a double-breasted mob seriously presided the floors, consoling themselves that John Gotti, the cager of such mob rule, was once again behind bars in a federal murder warrant.

There is a special romance about the Mafia in crime-ridden New York. It still plays by old-fashioned rules and even when scores are settled in blood, innocent civilians hardly ever get hurt. The city's Italian neighbourhoods, Little Italy in lower Manhattan and Arthur Avenue in The Bronx, are oases of tranquility thanks to the vigilant presence and stranglegram tactics of the Mob.

John Gotti became head of the Gambino "family" five years ago, when the previous boss, "Big Paul" Castellano, was gunned down outside a Manhattan restaurant. The assassination was said to be ordered by Mr Gotti, who had become the young pretender. The move established him as the most powerful boss in the city of New York and leader of five Mafia families.

A cloud disease with a foul temper and a quick temper, Mr Gotti has become a symbol of underworld arrogance and a defiance. The authorities have tried — and failed — to convict Mr Gotti three times in the past five years, earning him the sobriquet of "The Teflon Don" as the prosecution. This time, the federal authorities have brought charges un-der the notorious Racketeer-Influenced Corrupt Organisations Act, and they are said to be based on wiretaps placed in an apartment above the Ravenite Social Club and in other clubs.

The authorities are said to believe that Mr Gotti was two breaks away from John Gotti's Steakhouse, set at East 46th restaurant, where the murder took place. Mafia last has it that "Big Paul" and his top lieutenant, Thomas Bilotti, were to be Sparta's to meet another mobster, Amand Dellacroce. They were to discuss why "Big Paul" had not de-fended the funeral of his Dellacroce's father, Aniello, who was Mr Gotti's mentor in the Gambino hierarchy.

"Big Paul" shot down by some six assassins wearing trench-coats and carrying walkie-talkies as he stepped from his limousine. That night, under-power police waddled while on the steps of The Ravenite Social Club Mr Gotti was enthroned and kissed on the cheeks by other Mafia leaders.

Bush lifts block on grain credits for Soviet Union

From John Lichfield
in Washington

PRESIDENT George Bush has opened the way for the Soviet Union to buy up to $1bn million of grain on subsidised US credit, and will meet Mikhail Gorbachev in Moscow on 11-12 February to sign a treaty cutting strategic nuclear weapons. The announcement came after Mr Bush met the Soviet Foreign Minister, Eduard Shevardnadze, yesterday.

Mr Bush announced a package of measures to keep the Soviet Union through the winter, including emergency medical supplies, a "special technical assistance programme" to tackle problems in the infrastructure, and United States support for a "special association" for the Soviet Union with the World Bank and International Monetary Fund, to allow, as he put it, access to the two institutions' expertise. "The Soviet Union is facing tough times, difficult times, but this is a good moment to do what we can to help in an order to help the gan buying within the next two to three weeks. Such purchases would arrive in the early spring.

Mr Shevardnadze welcomed the decision to waive restrictions on grain credits, which marks the end of its period of efforts to press the Kremlin to relax its emigration rules. "I'm very overview of the Soviet Union will welcome and appreciate that decision," he said. "We are in a very new phase of our relations." During his visit, the US and his Soviet Union have moved closer to agreement on ending the conflicts in Afghanistan and Angola.

Senator Bob Dole, whose farm-state constituents blame the blocked credits for the tumbling grain price, said earlier that $1bn in state credits should be extended immediately, to Moscow would be-

interviewed by Mr St John, although the report was compiled by Mr Assistant Commissioner John Howley, head of the Yard's Complaints Investigation Bureau.

The decision was criticised by supporters of the close Baltic republics, who demonstrated outside the Soviet embassy here, in protest against the announced restriction to the Soviet KGB and military crack down on the in-dependence movements. "It's obscene to herd the KGB, who are about to start locking people up," said a leading Estonian activist.

There remains considerable confusion in the administration about the means and ends of aiding the Soviet Union. Speaking at a joint press conference with Mr Shevardnadze, the US Secretary of State, James Baker, declined to give details of how the grain would reach Soviet consumers, saying the Soviet authorities know exactly where the shortfall were.

Inside file, page 11
Soviet crisis gains pace, page 13

Police chief 'linked to Nadir'

KENNETH BAKER, the Home Secretary, was last night ordering a report into allegations surrounding a senior Scotland Yard officer that may have led to the Polly Peck affair. The report also Assistant Commissioner Wyn Jones was defrosted by the Home Office yesterday afternoon. The Home Office said it was being considered by Mr Baker in his capacity as police authority for London.

There are no established procedures for inquiries into Assistant Commissioner, a rank equivalent to Chief Constable of a metropolitan force, Mr Jones, 47, has been in the job since September 1989.

Asif Nadir, whose Polly Peck trading empire collapsed after the Serious Fraud Office began inves-

By Terry Kirby
Crime Correspondent

tigating alleged share dealing in-regularities, issued a statement saying, "I strongly deny any con-nection whatsoever with Mr Wyn Jones I do not know him at all." Scotland Yard said an inquiry into "circumstances concerning" Mr Jones had been ordered sev-eral weeks ago by Sir John Ballon, Acting Commissioner, after mat-ters that emerged during a disci-plinary inquiry into another offi-cer. There are no suggestions of criminal allegations.

Because of the seniority that officers can only be questioned by three senior in rank, Mr Jones was

She went swimming on Monday, dancing on Tuesday and lame on Wednesday.

How will she feel on Thursday and Friday?

Not knowing where to turn or what will happen next.

Multiple Sclerosis strikes without warning, usually in the prime of life and in many different ways.

Paralysis, impaired sight and speech are just three of them.

But that doesn't mean that people with the disease can't be helped.

You can play an active part by making a donation to the Multiple Sclerosis Society.

□ I/we enclose a donation to the Multiple Sclerosis Society
of £........................... Accept required.

Name...

Address...

...

To: The Multiple Sclerosis Society Freepost, 25 Effie Road, London SW6 1EE. Tel: (01) 736 6267. Give blood. No. 9102000.

MS
Tears lives apart.

L'Intersind a sorpresa: sì a Donat-Cattin

Per i metalmeccanici si riterna a trattare

IL TEMPO CONTESO

SARANNO in molti a chiedersi come sia possibile che le trattative per il rinnovo del contratto dei metalmeccanici siano state interrotte per una divergenza minima in tema di riduzione dell'orario di lavoro. Si indaca e chiedono infatti una riduzione di sedici ore all'orario annuo, mentre gli industriali non detti disposti a discutere elle altre ore che una manciata via da avviare all'inizio del '92. Per ore corrisponde a grosso modo alla metà di un per cento dell'orario annuo alla caocferia; e dunque licite chiedersi perché le trattative per un contratto così ompertanti siane incagliate a tum svigia con piccanti.

Le ragioni fondamentali espresse dalle due parti sono chiare. I sindacati non vogliono mare un contratto meno lasciando aperta questione avanti che l'oraxe ne rele gli industriali cercano di allontanare nel tempo gli letti complessivi della ridu zione dell'orario - che peraltra amminnno ed consider ano siga inevitabile - tra per al sioni casti, sia perché spes che i concorrenti futopel e mondiali siane furzati anch'essi nei prossimi due a tre anni, concodere riduzioni antini.

Ma quando dure cominzano si impegnano con tanta sprezza a disputarsi un ogetto apparentemente mini no, bisogna vedere se l'oggetto stesso non nanocaga altri significati altre a quello sippa sprezza. Si sa che le cittain carce uno un sibietivo cenica del movimento sinda che che vede in essere un mezze per alleviare la fatica dei lavoranci e consentire lore di derneari la famiglia, alla propria crescica civile. S. il ronto appersa quextione ach resti a parla cultura imprenditoriali incli nazioni d'orario - sebbene ani

Luciano Gallino

CONTINUA A PAGINA 2 PRIMA COLONNA

MILANO. Forse una schiarita in vista per i metalmeccanici. Dopo la rottura di venerdì notte a Torino si cerca di riprendere il negoziato per chiudere il contratto. L'operazione non è facile, ma da domani le parti potrebbero rivedersi da Donat-Cattin. L'ipotesi è maturata ieri sera dopo che il presidente della Confindustria Pininfarina ha visto Donat-Cattin. La mattina Pininfarina, che oggi riunisce la giunta della Confindustria, si era incontrato con Lan drotti.

Donat-Cattin attende la via libera degli industriali prima di convocare le parti. Qualche segnale è già venuto ieri dal Consiglio delegato della Federmeccanica: «bisogna utilizzare l'intelligenza, noi l'abbiamo fatto, speriamo che lo facciano anche il sindacato e il governo». In serata anche Martelli si è schierato per una rapida conclusione del contratto. «En ultiore atto di buona volontà dovrà consentire di chiudere questa vicenda. Ian sapendo che la vera partita si gioca sul trattativa sul costo del lavo ro».

Rinaldo Gianola A PAGINA 21

Il Quirinale disponibile a un «incontro» con i commissari

«Non potete interregarmi»

Gladio, Cossiga pone le condizioni

ROMA. Sarà un incontro e non un'audizione. E' l'ultima precisazione che è venuta ieri dal Quirinale con una nota ufficiale sulla vicenda Gladio e sulla richiesta venuta dal contatto nei servizi segreti di sentire il Presidente della Repubblica come testimone. In sostanza Francesco Cossiga smentisce le voci che gli attribuivano l'intenzione di autosospendersi dalla sua carica in caso di un interrogatorio del Parlamento e chiarisce di voler testimoniare ma alle sue condizioni.

Cossiga quindi annuncia di voler collaborare, come già fece per Ustica, ma senza rinunciare alle sue prerogative di Capo dello Stato, che non può essere assoggettato ad alcun altro potere, salvo il caso del procedimento di accusa espressamente previsto e regolato dalla Costituzione. La nota diffusa dal Quirinale ricorda inoltre che il Comitato sui servizi presieduto da Mario Segni, il caso travolto da una dita tecnica del Guardia, non ha la possibilità di procedere all'audizione di un Presidente della Repubblica.

Dopo le pesanti polemiche dei giorni scorsi, il comunicato del Quirinale non sembra però in grado di calmare le tensioni. Si è parlato di crisi istituzionale e ora si è giunti ad un punto di svolta. Tutto si giocherà su parole scontrosa verranno le domande a Cossiga. Anche la data dell'incontro non è certa: si parla di martedì 18, ma i tempi sono legati alla modalità che verrà scelta. E si fa l'ipotesi di domande scritte. Diventa essenziale fin dove si spingerà il pci. Ieri il segretario Occhetto ha presentato una interpellanza per chiedere ad Andreotti perché non ha informato il Parlamento dei contenuti della lettera con la quale Cossiga chiese al governo una marcia indietro rispetto a quanto deciso dal Consiglio di gabinetto.

La prossima settimana rischia di essere ancora più difficile, visto che tra cinque giorni il governo Andreotti perderà lo escudo della presidenza Cee, che sembrava non funzionasse come talismano anti-crisi.

G. Biancani, F. Ceccarelli, R. Martinelli, A. Minzolini
e A. Rapisardo ALLE PAGINE 2 E 3

Un giallo sui Saggi

Il governo non cambia idea «Dovranno giudicare loro»

ROMA. E' polemica sulla commissione dei cinque saggi che dovranno dare un parere su Gladio. Ieri è intervenuto il sottosegretario alla presidenza del Consiglio, Nino Cristofori; il governo intende attuare le decisioni prese dal Consiglio di gabinetto. I contatti sono già stati avviati.

Ma Leonetto Amadei ha ammesso di stare ancora aspettando una comunicazione di Palazzo Chigi. Anche Livio Paladin aspetta da diversi giorni. E' intanto Francesco Saja ha detto: «Aspetto, ma con molto distacco. Infine Antonio La Pergola. «Non ho ricevuto alcuna comunicazione».

Francesco Grignetti PAGINA 2

Francesco Saja

Gli speleologi scomparsi da tre giorni. Continua l'emergenza maltempo in Europa

Dramma nella neve per i 9 dispersi

Disperate ricerche sulle montagne del Cuneese

CUNEO. Una lotta contro il tempo. Ma è una lotta disperata, difficile, che offre speranze troppo ostacoli. E di ora in ora si riducono le speranze per ritrovare i nove speleologi bloccati da domenica sulle montagne del Cuneese, sulle Alpi Marittime. Uscivano da una grotta, li sorpresi una tempesta di neve. Erano in dodici e hanno cercato, dividendosi, di scendere a valle. Tre sono stati soccorsi da un elicottero, di nove si sono perse le tracce.

Due speleologi (secondo il racconto dei compagni di spedizione) sono stati sepolti da una slavina. Le operazioni di soccorso sono difficili. L'inferno bianco di bufere e slavine che imperversa sulla zona frena i tentativi di soccorso, impedisce agli elicotteri di levarsi in volo.

Ieri il maltempo ha imposto uno stop alle ricerche, per i militari degli speleologi si allungano le ore di ansia. Nel Cuneese sono mobilitati settanta uomini, i volontari del soccorso alpino ieri si sono trovati di fronte a una massa di neve incredibile metri.

Intanto l'ondata di maltempo che da alcuni giorni ha colpito l'Italia e l'Europa non accenna a diminuire. Difficoltà a Roma nel traffico in mattinata e ancora di notte. Neve in Valle d'Aosta, Abruzzo e Campania. In Piemonte sono state recuperate sette persone disperse in Val d'Ossola. Al Gargello manca ancora un cacciatore, che è stato travolto da una slavina.

Emergenza maltempo anche in Europa. Fra le nazioni più colpite Inghilterra. La Germania non difficoltà nel traffico e la Spagna sotto tormentati marinai dispersi per la collisione fra due pescherecci, un treno è deragliato, soltanto sette alpinisti dispersi sulle montagne. Morte e disseguono anche in Giappone, da un giorno flagellato da forti raffiche di vento.

Renato Rizzo
e Luigi Suagliana A PAGINA 5

Mafia, 55 delitti impuniti

*Palermo, polemica sulla sentenza
Falcone: un clima intimidatorio*

di Antonio Ravida A PAGINA 8

Napolitano: con noi la svolta

*Pci: si presentano i miglioristi
con un manifesto riformista*

di Fabio Martini A PAGINA 7

Ferruzzi: il timone a Gardini

*Raul resta leader della holding
E in consiglio figlio e nipote*

SERVIZIO A PAGINA 27

LE MOSSE DI SADDAM

KUWAIT ULTIMO OSTAGGIO

SADDAM Hussein non è Babbo Natale. Giusto. Nessuno deve dirgli grazie perché libererà gli ostaggi «era un atto dovuto». Giusto. E tuttavia la liberazione incondizionata degli ospiti-ostaggi è un grosso avvenimento. Che, per altro, non cambia nulla. Per altro apparentemente. Rimane, infatti, l'ultimo ostaggio: il Kuwait.

«Trentatré giorni, a contare da oggi, ecco quanti ne mancano alla scadenza del 15 di gennaio. A partire da quella data, giusta la risoluzione 678 del Consiglio di Sicurezza, l'uso della forza sarà «scenario lo consociamo a memoria: se Saddam Hussein non si inchinerà al volere dell'Onu, gli Stati Uniti, di conserva con gli alleati antichi e di giornata, mecanicamente, definitivamente, per citare il segretario di Stato Baker.

Gli Stati Uniti non cessano di agitare il bastone ma, come sappiamo, hanno offerto una bella carota al dittatore mesopotamico. Il «dialogo». A sua volta, colui che Bush definì l'Hitler del Medio Oriente ha giocato la carta del rilascio degli ostaggi, annunciando, d'altra parte, l'invio di nuove forze in Kuwait.

Ora si dà il caso che i satelliti-spia americani abbiano accertato come le forze di Saddam in Kuwait anziché aumentare siano diminuendo proprio in questi giorni. Ma allora siamo alle ultime grida prima dei sussurri della trattativa? E con il che? E con il che dalla guerra? Come la mettiamo con gli ostaggi, han perduto ogni valore per Saddam? «Non è improbabile» scrive il Teheran Times, «per non dire sicuro, che segreti negoziati abbiano arbiano garantito a Saddam Hussein che il rilascio degli ostaggi non sarebbe seguito un attacco».

Igor Man

CONTINUA A PAG. 5 SECONDA COLONNA

Ha dominato la prima gara italiana di Coppa

Grande ritorno di Tomba nello slalom del Sestriere

SESTRIERE. Alberto Tomba si è imposto trionfalmente nello slalom speciale del Sestriere, collocandosi in testa alla classifica di Coppa del Mondo. L'azzurro, nella nebbia, è stata protagonista di una straordinaria seconda manche che gli ha consentito di recuperare svantaggio e distacco dal norvegese Furuseth, conservando il primato dello slalom dei folti nebbiolo.

Carlo Caselta A PAGINA 33

Dal 1° gennaio in funzione tessere magnetiche: ma non tutti gli uffici pubblici ne sono dotati

Guinzaglio elettronico per gli assenteisti

Nei ministeri parte la guerra ai furbi: controllate anche le pause

ROMA. Anno nuovo, vita nuova per i dipendenti pubblici: dice Remo Gaspari, ministro della Funzione Pubblica. E annuncia l'ennesima iniziativa per tentare l'incontenibile disaffezione verso il lavoro di cui sembrano contagiati stuoli di ministeriali.

A partire dal primo gennaio '91 recita una circolare - large alle apparecchiature elettroniche per il controllo automatico dell'orario di lavoro, entrino in funzione le macchinette con tanto di scheda magnetica in grado di registrare l'entrata, l'uscita, le epuses dei dipendenti pubblici, che è le flow della parcha? Un brutto regalo di Natale per i ritardatari cronici, gli appassionati dei cappuccini guasati fuori dai tetri uffici ministeriali, la madri di famiglia che devono conciliare il doppio ruolo e si affannano con lo shopping durante le pause d'ufficio?

Gaspari sembra deciso a fare piazza pulita del grande spreco di professionalità e di soldi, che allo Stato costa ogni anno decine di miliardi «che il semplice cittadino - quando si misura con i ritardi o le negligenze della burocrazia - benissimo conosce. Il 20 ottobre scorso - scompiendo per la prima volta dopo anni di levantieri come gli riconosce l'on. Costa, un veterano della lotta all'assenteismo ha depositato in Parlamento i dati ufficiali relativi al 1989 sulla presenza al lavoro dei pubblici dipendenti».

Peccato - fa notare il guastatore - è solito on Costa su un'interroga zione parlamentare - che questi dati non siano certi in completi, per cui talvolta parte delle cifre corrisponde a presenze e presentate a non serialmente conteggiate.

Gaspari non si è fatto scoraggiare da questi appunti che gli sono stati mossi e ha continuato per la sua strada. Riperie in fretta perché siamo in ritardo che ora con non taglente, nella laconicità del linguaggio burocratico. Nel 1987 - il ministro ricorda e annunciosa - il Presidente della Repubblica aveva introdotto un decreto grario flessibile, a patto che negli uffici ci fosse obbligatori l'orario controllo, anche in tipo automatico, nelle presenze del personale. La rivoluzione nel mondo del pubblico impiego non avvenne, i macchinari arrivarono ma non furono usati. «Molte amministrazioni ne sono dotate di conformi e disposte apparecchiature, la cui utilizzazione però spesso non è andata oltre la fase sperimentale e dunque risultata parzialmente e parziale.

Ma adesso cambia il vento «le amministrazioni presto cui sia stato installato un sistema per la rilevazione automatizzata delle presenze e di controllo degli accessi, a far data dal 1° gennaio 1991» le faccciano funzionare per Gaspari «La spa!

Ma i più pazienti, quelli capaci di leggere sino in fondo il provvedimento del ministro, scopriranno che non tutto è perduto. Già si avrà la circolazione di una proroga. La circolare dice: «Le amministrazioni ancora sprovviste dei predetti sistemi avranno cura di disporre, con ogni sollecitudine, gli atti istruttori finalizzati all'entrata in vigore, comunque, entro il 1991».

Liliana Madeo

Heute in der WELT

Schlechte Prognose für Moskau

Der russische Literaturnobelpreisträger Joseph Brodsky, der seit seiner Ausbürgerung (1972) in den USA lebt, gibt der UdSSR im Gespräch mit der WELT eine schlechte Prognose. Die Krise werde mindestens ein Jahrzehnt anhalten. Die Sowjetunion werde schon deswegen „kleiner werden müssen", weil die einzelnen Völker einander hassen. „Rußland versucht seit siebzig Jahren, mächtig zu sein, es hat nicht geklappt. Rußland ist marginal geworden." Seite 21

Dem Zappelphilipp auf der Spur

Der „Zappelphilipp", der in der Schule nicht stillsitzen kann und Lehrer, Mitschüler sowie Eltern gleichermaßen irritiert, hat häufig eine schwere Zukunft vor sich. Eine amerikanische Gruppe von Medizinern ist jetzt den Ursachen dieser Hyperaktivität auf der Spur: Der Zuckerstoffwechsel im Gehirn dieser Menschen scheint vermindert. Ob die Störung erblich ist oder durch falsche Ernährung begünstigt wird, bleibt unter den Experten umstritten. Seite 23

POLITIK

Dänemark: Die rund 3,9 Millionen wahlberechtigten Dänen waren gestern zum vierten Mal innerhalb von sechs Jahren zur Wahl eines neuen Parlaments aufgefordert. Ministerpräsident Schlüter hatte die vorgezogene Wahl angesetzt, nachdem sich seine Minderheitsregierung nicht mit den Sozialdemokraten über die geplante Steuerreform verständigen konnte.

Österreich: Die Alpenrepublik wird auch in den kommenden vier Jahren von einer großen Koalition aus Sozialisten und Konservativen regiert werden. Darauf haben sich die Vorstände der Sozialistischen Partei Österreichs (SPÖ) und der Österreichischen Volkspartei (ÖVP) geeinigt.

Immobilien: Von Krawallen und Demonstrationen war die erste private Immobilienauktion in der ehemaligen DDR im Berliner Bezirk Mitte begleitet. (S. 3)

Bangladesch: Der vor einer Woche zurückgetretene bengalische Staatspräsident Hussain Mohammad Erschad ist gestern festgenommen worden. Auf Anordnung des früheren britischen Hochkommissars in Dhaka unter Hausarrest gestellt.

Berlin: Die Berliner CDU wird aufgrund des amtlichen Berliner Wahlergebnisses mit zwei weiteren Ausgleichsmandaten rechnen.

Südafrika: Der Präsident des ANC, Oliver Tambo, kehrt heute nach 30 Jahren im Exil in seine südafrikanische Heimat zurück.

Prepenafia: Nach knapp dreieinhalb Monaten ist der deutsche Journalist Hero Buss von der kolumbianischen Drogenmafia freigelassen worden.

Landesrundfunk: Das Land Brandenburg leitet eine Mediekennzeichnung an, ab und will ein Landesprogramm in eigener Verantwortung veranstalten.

Parteiagenten: In Düsseldorfer Parteispendenprozeß hat der Anwalt der angeklagten CDU-Schatzmeisters Walther Leisler Kiep den Vorsitzenden Richter Manfred Obermann, gestern wegen Besorgnis der Befangenheit abgelehnt.

WIRTSCHAFT

Bundesbank: Die wirtschaftliche Lage der Deutschen Bundesbank ist, so die Regierungskommission „Bundesschatz", weiterhin schlechter als vielfach angenommen. Eine Vorwärtsstrategie der Bahn für erforderlich. (S. 9)

Börse: Am Mittwoch gab es an den deutschen Aktienbörsen eine Kursfestsetzung. Am Rentenmarkt kam es bei guten Umsätzen zu leichten Kursgewinnen.

Aktienindex der WELT

Bonn rätselt: Woher stammt „Karteikarte" de Maizière?

Experten sprechen von „Merkwürdigkeiten" / Anfrage beim Bundeskriminalamt

JW. Bonn

In Kreisen der Bundesregierung rätselt man über die Herkunft jener „Karteikarte", die im letzten „Spiegel" als Beleg für eine Mitarbeit von Bundesminister Lothar de Maizière beim früheren DDR-Ministerium für Staatssicherheit (MfS) veröffentlicht wurde. In Bonn wird in diesem Zusammenhang von „Merkwürdigkeiten" gesprochen. So sei ein Vergleich mit „Spiegel"-Exemplaren ergeben, daß auf dieser angeblichen Karteikarte nicht nur zwei, sondern mindestens drei Veränderungen stattgefunden haben. So müssen während dieses Drucks vorgenommen worden sein. Auf dieser Abbildung ist von einem Decknamen „Czerni" die Rede, der „Am Treptower Park" wohne. Die Hausnummern werden in einzelnen Ausgaben des Magazins wie folgt angegeben: Mit 31, mit 91 und mit 91. Die Veränderungen wurden offenkundig mit einem Stift vorgenommen.

Eine Originalkarteikarte mit diesen Angaben wurde bisher in den staatlichen verwahrten Aktenbergen des MfS nicht gefunden. Am Montag war der für diese Akten zuständige Behördenleiter Gauck nach Bonn geeilt worden. Hier hatte ihm Bundesinnenminister Schäuble im Beisein seiner Staatssekretäre Neusel und Kroppenstedt den „ausdrücklichen Wunsch" des Kanzlers und von de Maizière mitgeteilt, alsbald Aufklärung in dieser Angelegenheit zu schaffen.

Experten vermissen außerdem auf der vom „Spiegel" abgelichteten Kar-

teikarte Handzeichen/Unterschriebene, se Unterschriften von MfS-Angehörigen. Auf anderen Karteikarten dieser Art seien solche Handzeichen oder Unterschriften von den jeweiligen Führungsoffizieren enthalten.

Nach Informationen der WELT hat der „Spiegel" im Verfeld seiner Veröffentlichung Kontakt mit dem Berlinkriminalamt (BKA) aufgenommen. Die Redaktion wolle wissen, ob man auf der Basis eines Hellfax einer Ko-

pie feststellen könne, ob Einfügungen vorgenommen worden seien. Es wird, wie hieß, ist diese Verbindung zum BKA auf inoffizieller Ebene zustande gekommen. Eine nicht wissenschaftlich fundierte Auskunft aus dem Institut habe gelautet: „Dem ersten Anschein nach ist alles echt."

Nach Ansicht von FDP-Chef Graf Lambsdorff sollte die angebliche Stasi-Mitarbeit von de Maizière möglichst schnell bis zur Kabinettsbildung geklärt werden.

Die verschiedenen Varianten der Adresse des angeblichen Stasi-Agenten „Czerni". Die unterschiedlichen Hausnummern sind eingekreist.

Noch wenig Bewegung in Steuerfrage

Waigel fordert von der Koalition Ermächtigung zu Umschichtungen und Kürzungen

HB. Bonn

Im ersten Schlagabtausch über massive Steuerlenkungen in den neuen Bundesländern gab es in der gestrigen - der fünften - Koalitionsrunde offenbar keine nennenswerte Annäherung zwischen den Parteispitzen von CDU/CSU und FDP. Nach Wochen kontrovers diskutierter Thema „Steuerzusagen", durch ein Kanzlerjektatus des FDP-Vorsitzenden B. in Graf Lambsdorff zusätzlich belastet, wird nun eine Arbeitsgruppe beschäftigen, die bis zum 3. Januar versuchen muß, einen für beide Koalitionspartner akzeptablen Kompromiß zu finden.

Ohne von der Union vorgeschlagene vorübergehende Verzicht auf die Erhöhung einheitsverabredungen liege kann Festigkeit der betrieblichen Vermögen- und Gewerbekapitalsteuer reicht der FDP nicht aus. Das Bundesministerium verlangte abgelehnt

Dagegen sind die in dieser Frage restriktiven Koalitionspartner bei der Unternehmenssteuerreform, die in der gesamten Bundesrepublik näher behandeln. Waigel hat bereits jetzt das Bundesziel über den beschlossenen Einpartneruntersuchungsrahmen für die Unternehmenssteuerreform (WELT vom 12.12.) erhalten, dessen Aussagen in die gestrigen Beratungen eingeflossen sind. Allerdings stehen für die alle ausgleichbelasteten Beschlüsse unter Finanzierungsvorbehalt. Nach dem von den Finanzministern des Bundes und den Ländern im November des 2nd geeint wurde. Die Vorverschiebung des Bundes von 1991 bis 1994 ohne Steuererhöhungen von 70 auf 80 Milliarden Mark zurückzuführen, will Waigel in den Koalitionsverhandlungen zu Ausgabenbindungen und Umschichtungen in dieser Legislaturperiode ermächtigt werden.

In Albanien fällt letzte KP-Bastion

Studenten erzwingen Zulassung unabhängiger Parteien / 500 Verletzte bei Protesten?

CARL GUSTAF STRÖHM. JW

Albaniens Kommunisten mußten sich unter dem Druck von studentischen Massendemonstrationen in der Hauptstadt Tirana zu grundsätzlichen politischen Konzessionen entschließen, die ein baldiges Ende der seit mehr orthodoxen kommunistischen Regime in dieser Land bedeuten könnten. So beschloß das ZK der KP „Partei der Arbeit", ab sofort unabhängige politische Parteien zuzulassen. Bei Bildung unabhängiger politischer Organisationen, so hieß es in einem ZK-Beschluß, sei der „Pluralismus" förderlich. Außerdem wurden mehrere Schäuble im Beisein ihrer Posten entlassen.

Mitglieder des zwölfköpfigen engsten Führungsgremiums der Universität Tirana haben sich auf Seiten der Studenten von Ti Staatschef Ramiz Alia getroffen. Es kam zu heftigen Auseinandersetzungen.

"Von Verrat ausgehen"

Schröder an Desinformationskampagnen des MfS beteiligt?

„22 Milliarden Mark werden in neuen Ländern investiert"

Wissmann: Unsicherheitsfaktor durch SED-Seilschaften

WERNER KALINKA. Bonn

Im kommenden Jahr werden nach Informationen des wirtschaftspolitischen Sprechers der CDU/CSU-Bundestagsfraktion, Matthias Wissmann, rund 22 Milliarden Mark von Unternehmen aus dem Westen Deutschlands in den fünf neuen Bundesländern investiert werden.

Leserbriefe und Personalien Seite 6
Fernsehen Seite 22
Umwelt — Forschung — Technik Seite 23
Wetter: Schneeschauer Seite 24

الأحداث
AI-AHDATH

الخميس ٢٥ جمادى الأول ١٤١١ هـ - ١٣ ديسمبر (كانون الأول) ١٩٩٠ - السنة الثالثة العدد ٦٥٨

Thursday 13 December 1990 3rd year No 658

فتور خليجي إزاء المبادرة الجزائرية
الخليج يعتبر الخيار العربي سببا لتمديد الازمة
ويفضل الخيار الدولي المدعوم عسكريا

كتب : توفيق تقي

عزل الفريق شنشل .. ومخاوف
بغداد من مفاجآت على صعيد الحكم

كتب المحرر السياسي

رئيس وزراء البحرين : العراق اراد احتلال اول خليجية
اخرى .. وقد نطلب بمساندات دائمة من حلفائنا

رئيس المخابرات السوفيتية
ينعقد ببغنع انهيار البلاد

موسكو

حذر من عملاء اجانب

الطلبة نحو الانفتاح والديمقراطية
الطلبة تقروا الحكومة الشيوعية الاخيرة
في اوروبا ، واعلان التعددية الحزبية اول الغيث

نهاية طاغية : حاكم بنغلادش العسكري
معتقل والشرطة تبحث عن انصاره

مجلس الامن ينتخبع بشأن قرار حماية الفلسطينيين
وازمة صياغته تتفاقم بين امريكا وعدم الانحياز

مصادر مطلعة لـ الأحداث
الافراج عن رهائن بريطانيين
قبل اعياد الميلاد

بيروت ــ خاص

بريطانيا تزيد قواتها في الخليج الى ٤٥ الفا
وتستدعي اطباء وممرضين من الاحتياط

لندن

بمناسبة ازمة الخليج البحرين
تلغي احتفالات العيد الوطني

* * *

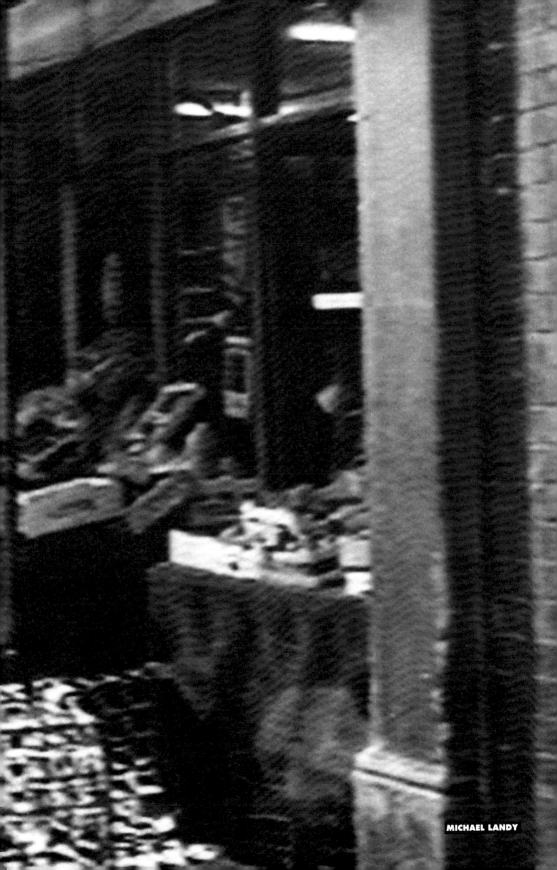

MICHAEL LANDY

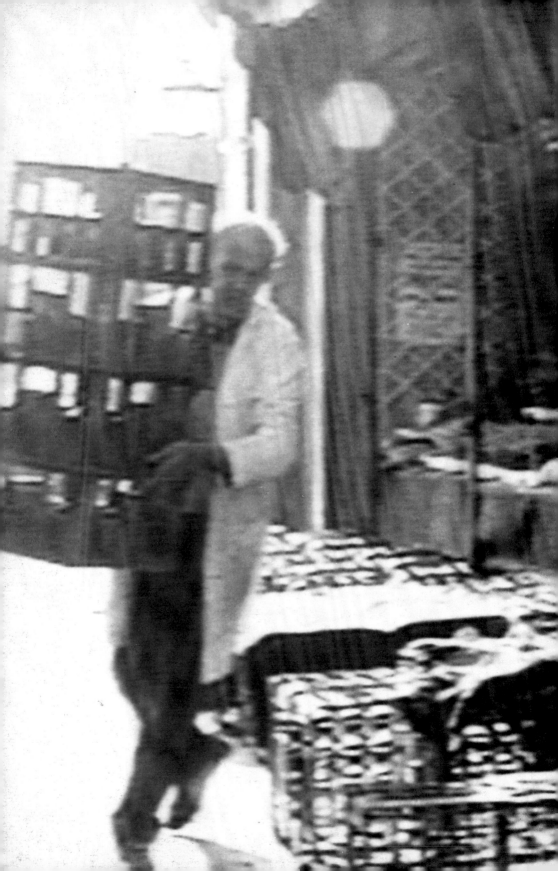

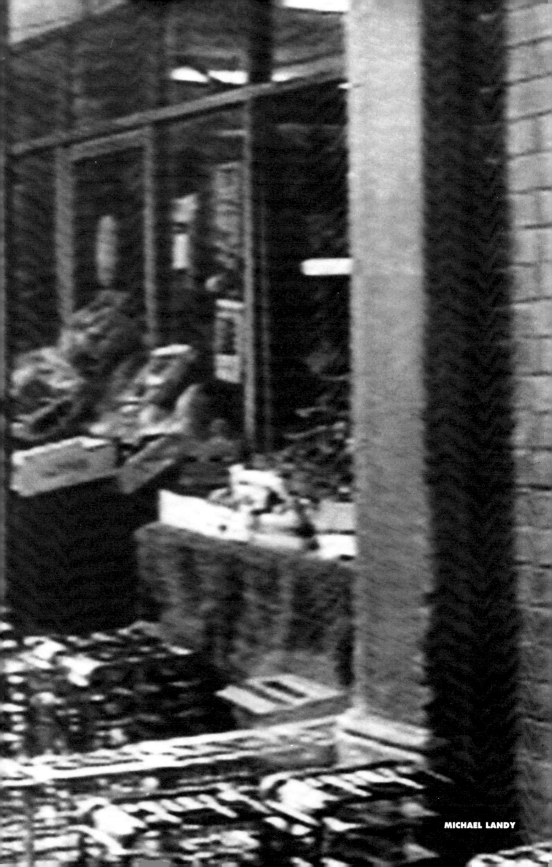

MICHAEL LANDY

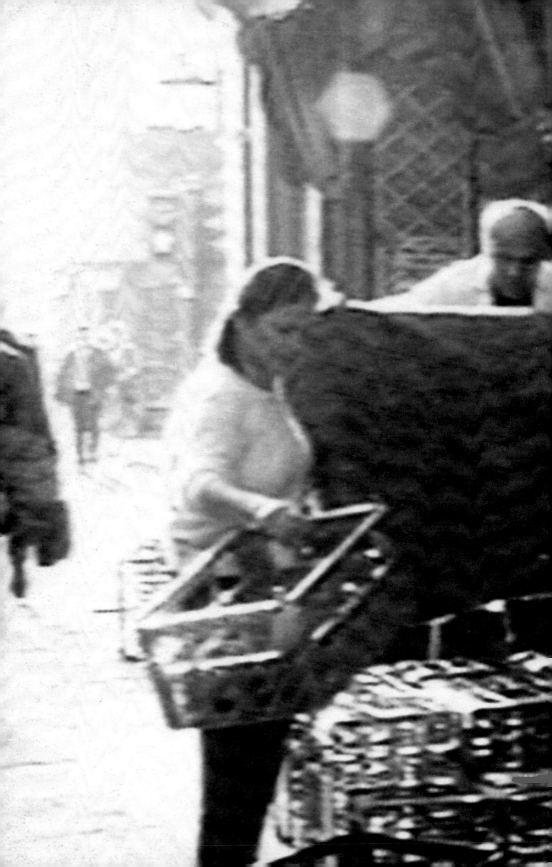

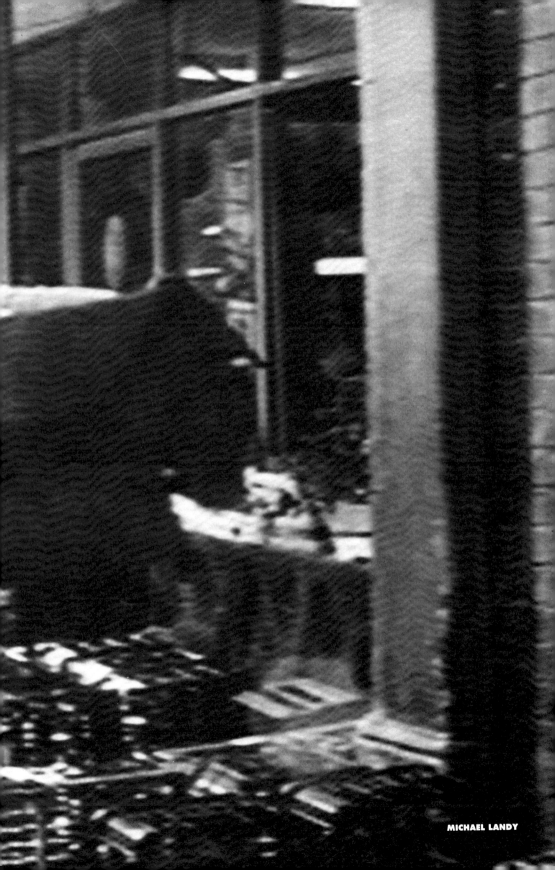

MICHAEL LANDY

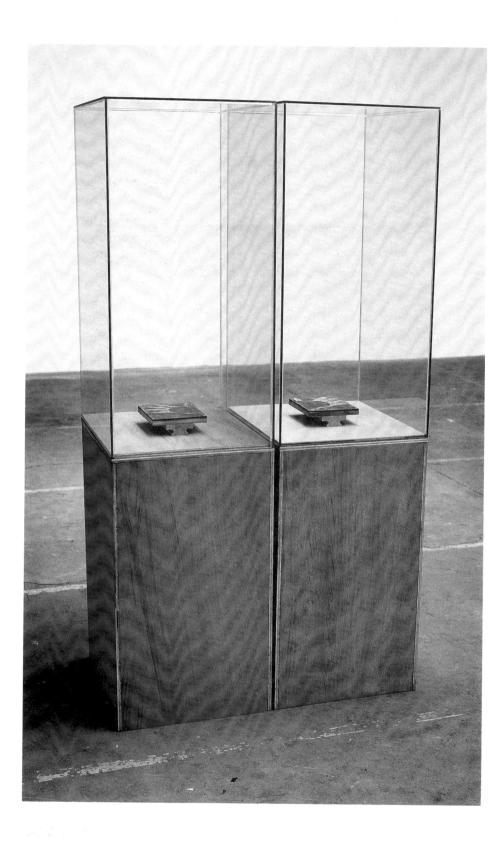

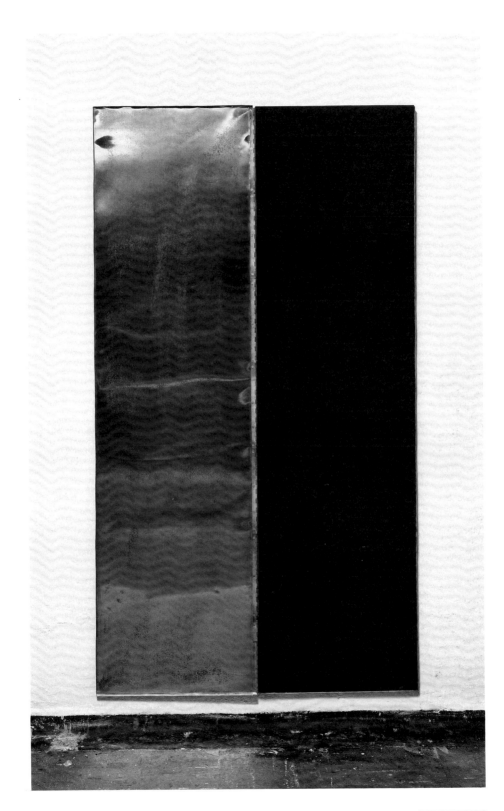

ABIGAIL LANE

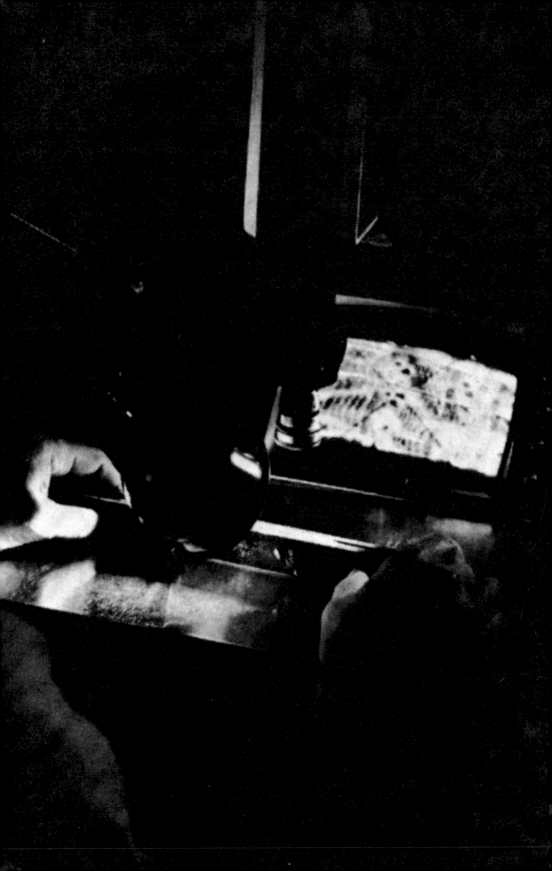

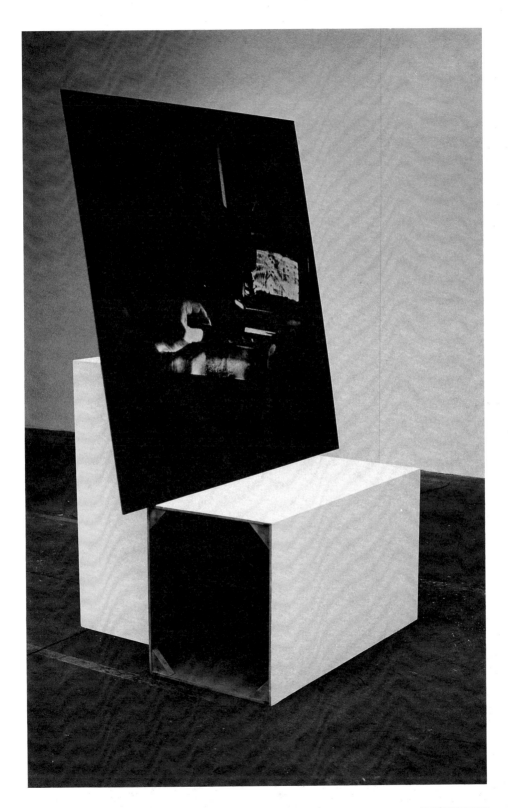

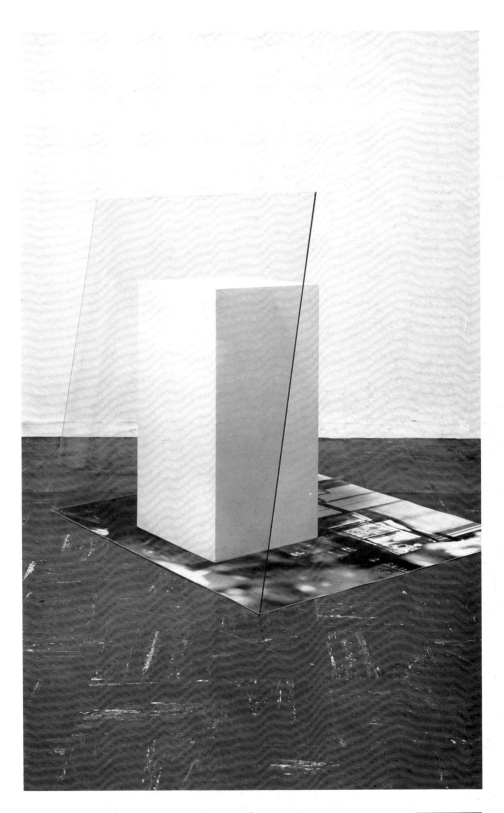

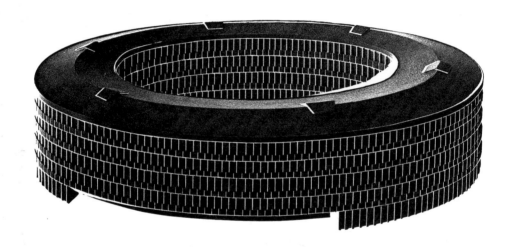

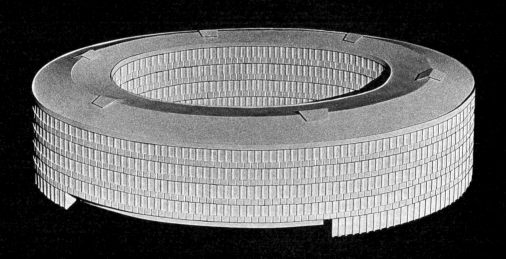

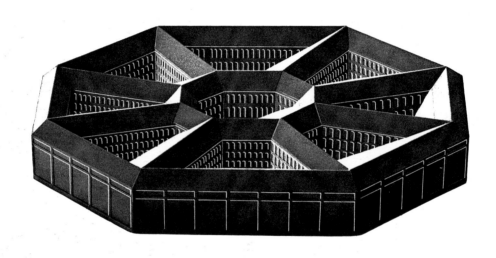

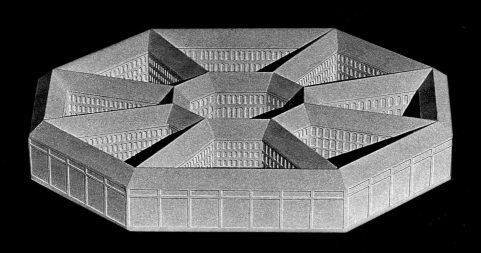

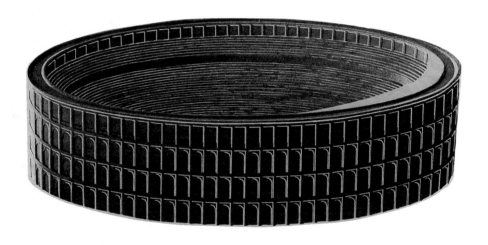

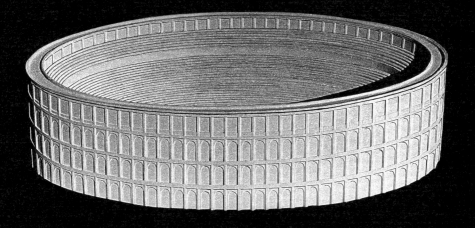

LANGLANDS & BELL

ARSE EATER
ARSEHOLE BANDIT
BENDER
BROWN HATTER
BROWN NOSE
BUMBOY
BUMCHUM
FAGGOT
FAIRY
FISTFUCKER
FRUIT
GAY
HOMO
LIMPWRIST
PANSY
POOF
QUEEN
QUEER
RAVING IRON
RENT BOY
SHITCUNT
SHITSTABBER
TART
TEAPOT
WOOFTA

BALL BAG
BANGER
BELL ENDER
BOLLOCKS
BONKER
BRUTE
CHOPPER
COCK
DICK
DIDDLER
DINKLE
DIPSTICK
DOINK
DRILL BIT
FUCKER
GRINDER
HELMET
HUMPER
KNOB
LENGTH
MEMBER
MOTHER
OLD BILL
PART
PLONKER
PLUGGER
PRICK
ROOTER
SCREW DRIVER
SHAFT
SHAGGER
STONKER
STUFFER
TOOL
WELDER
WILLY
WINKLE

ANIMAL
ASS
BAT
BATTLE AXE
BEAUTY
BIRD
BIT
BITCH
BROAD
CHICK
COW
CRACKER
CUNT
DOLL
DOG
DRAGON
DYKE
FANNY
HAG
HOOKER
MEAT
MONSTER
MUFF
OLD BAG
PET
PIECE
PUSSY
SHITCUNT
SKIRT
SLAG
SLUT
SMASHER
SOCKET
TART
TIT
TRAMP
TROLLOP
TWAT
WHORE
WITCH

BROWN BEAR
CRAP
DAG
DO DO
EXCREMENT
GOLDEN RAIN
JIMMY
LEAK
PACKET
PEE
PIDDLE
PISS
POE
PONY
SHIT
SKID
SLASH
STOOL
TINKLE
TURD
WEE

FIDDLER
FIST FUCKER
IRON PUMPER
JERK
MASTUBATOR
TOSSER
WANKER

LISA MILROY

LISA MILROY

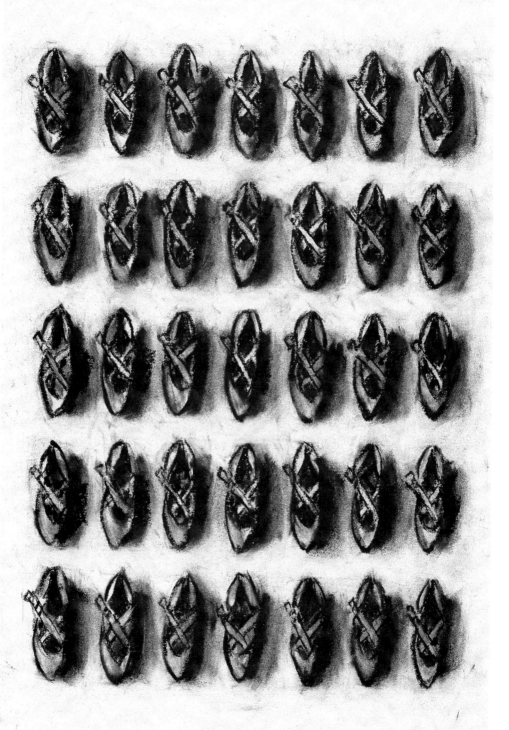

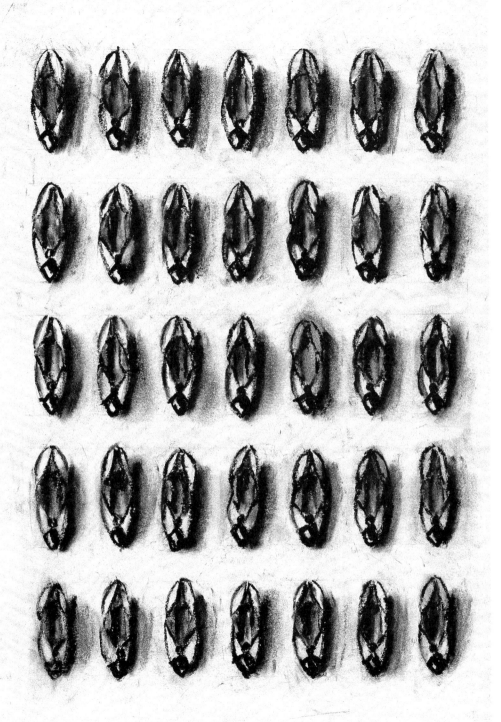

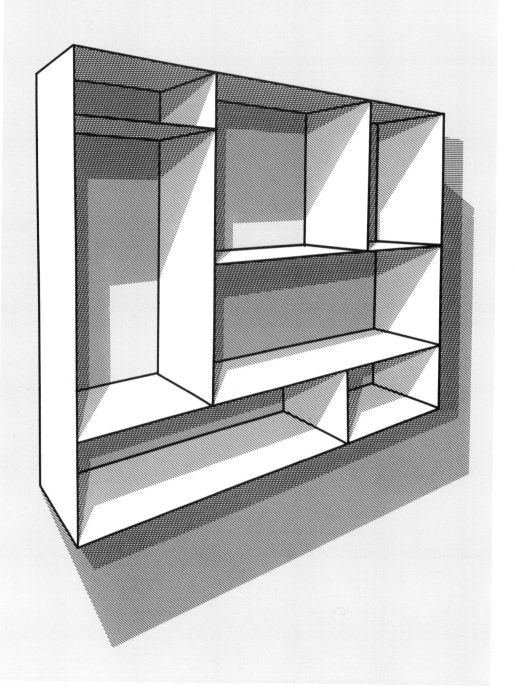

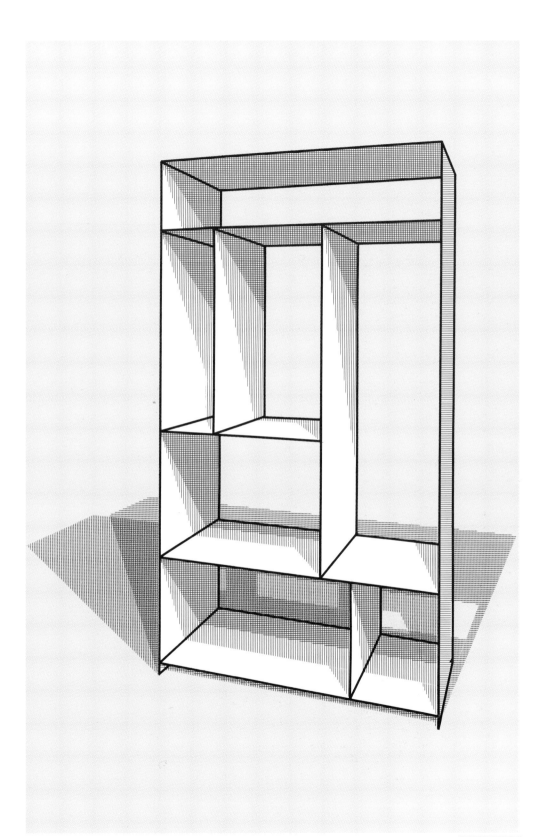

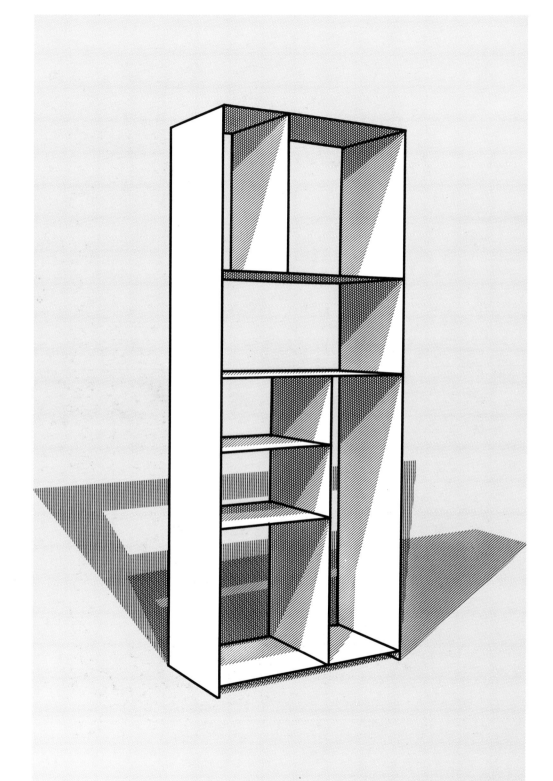

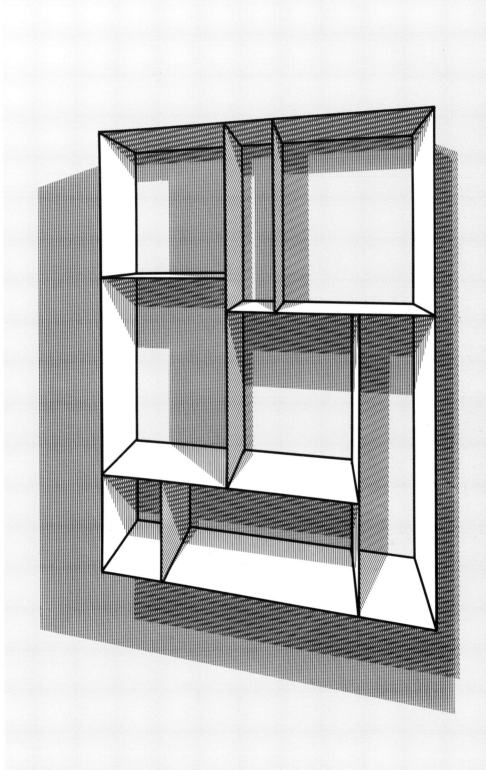

JULIAN OPIE

A

Bat, Schreiber's
Caucasian

Cavy, Cutler's

Deer, Shomburg's

E

F

Gazelle, Grant's

Gazelle, Thomson's

Hartebeest, Li-
chtenstein's

Horse, Przewal-

sky's

Ibex, Severtz's

Caucasian

J

K

L

Monkey, Brazza's

Monkey, Diana

Monkey, Hamlyn's

Mouse, Hudson

Jumping

N

Opossum, Virginia

Potto, Bosman's

Q

R

Sea-Cow, Stellar's

Sea-Lion, Stellar's

Sheep, Marco Polo

Shrew, Savi's Pygmy

Squirrel, Prevost's

T

U

V

Wallaby, Bennet's

X

Y

Zebra, Bohm's

Zebra, Burchell's
(extinct)

Zebra, Chapman's

Zebra, Grant's

Zebra, Grevy's

Zebra, Hartmann's

Aye-aye, Bush's
B
C
D
Elephant, Daktari's
Ferret, Rauschen-
berg's
G
H
I
Jackal, Saddam's
Klipspringer,
Henry's
Lemming, Landsbergis'
M

Narwhal, Streisand's
O
P
Quagga, (extinct)
Racoon, Rembrandt's
S
Tasmanian Devil,
d'Hirst's
Jakari, Sch-
wartzkopf's
Vole, Boulder's
W
X
Yak, Yehudi's
Z

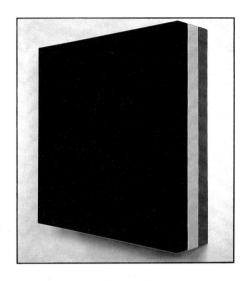

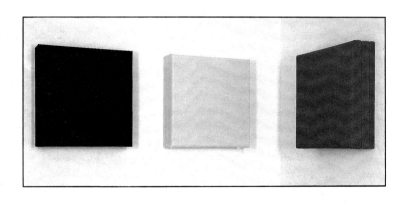

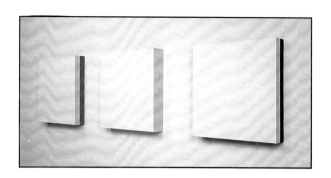

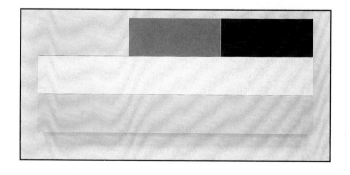

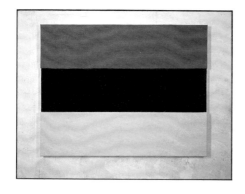

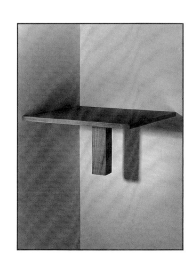

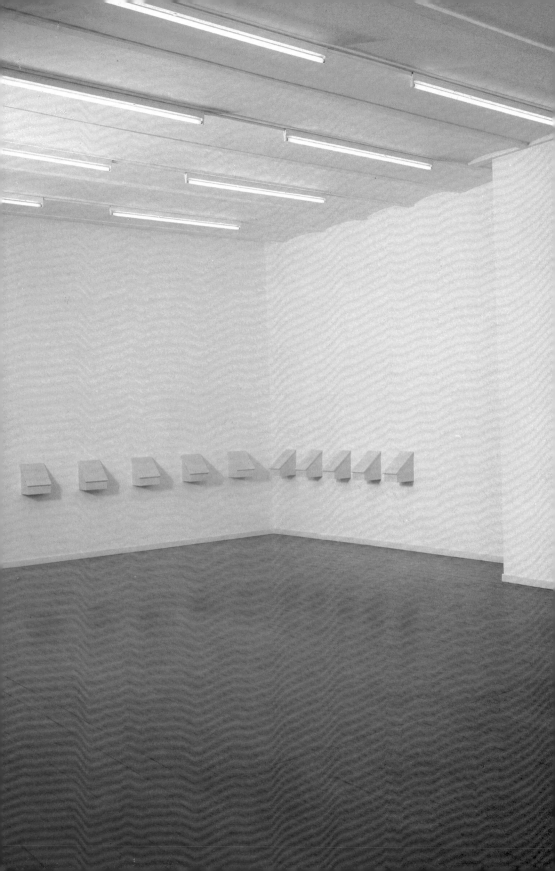

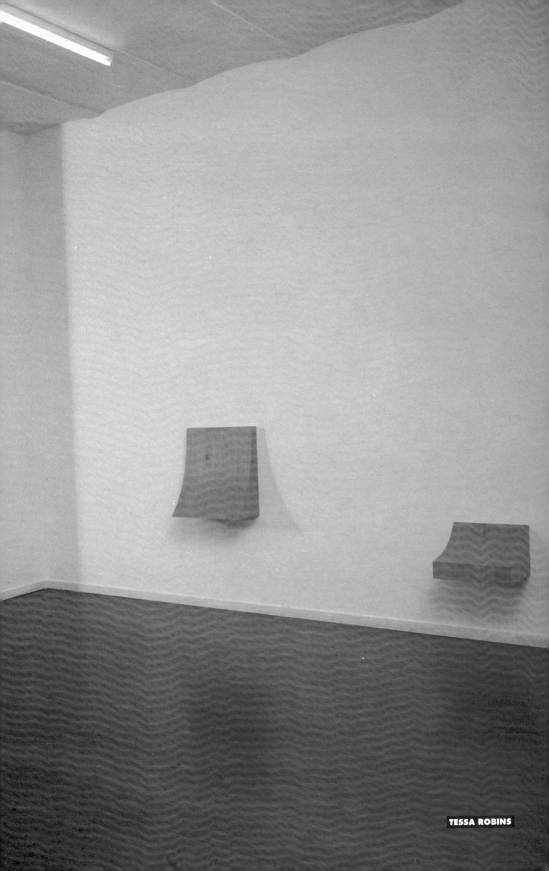

TESSA ROBINS

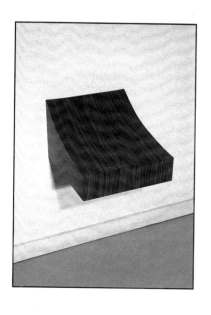

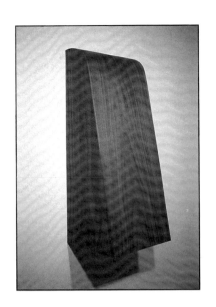

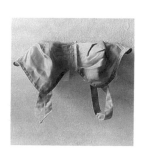

Display 1 1987 (detail)
16 polystyrene cubes
8 Maidenette foundation bras
15cm x 386cm x 9cm
Displayed: Goldsmiths' MA first year show
Photo: Caroline Russell

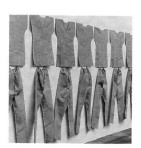

Display 2 1987 (detail)
15 Brevet disposable scrub suits
60 map pins
180cm x 1225cm x 3cm
Displayed: Goldsmiths' MA first year show
Photo: Caroline Russell

Display 3 1987 (detail)
Photocopies of Pelaspan (loose fill polystyrene packing)
6 chrome racks
54 plastic hooks
54 disposable cloths
268cm x 423cm x 33cm
Displayed: Goldsmiths' MA first year show
Photo: Caroline Russell

Display 4 1987 (detail)
Photocopies of bubblewrap
5 chrome racks
25 pedal bin liners
25 steel hangers
238cm x 466cm x 33cm
Displayed: Chisenhale Gallery, London
Photo: Sue Ormerod

Display 5 1987 (detail)
3 plastic hooks
3 garment bags
3 inflatable hangers
164cm x 228cm x 9cm
Displayed: Chisenhale Gallery, London
Photo: Sue Ormerod

Display 6 1987 (detail)
11 disposable theatre aprons
149cm x 1067cm
Displayed: Chisenhale Gallery, London.
Photo: Sue Ormerod

Display 7 1988 (detail)
4 chrome racks
24 plastic skirt hangers
24 dustbin liners
1 circular display rack
183cm x 260cm x 58cm
Displayed: Interim Show, Goldsmiths' Gallery, London;
Grey Matter, Ikon Gallery, Birmingham
Photo: Sue Ormerod

Display 8 1988
30 Scotch-Brite pan cleaners
70cm x 70cm x 2.5cm
Displayed: Studio
Photo: Caroline Russell

Display 9 1988
Offset litho prints from photocopy of polystyrene loose fill packing
12 chrome racks
144 plastic hooks
144 disposable cloths
672cm x 390cm x 41cm
Displayed: 19&&, The Magasin, CNAC, Grenoble; Grey Matter, Ikon Gallery, Birmingham
Photo: Quentin Bertoux

Display 10 1988
1 wall belt/tie half ring units
8 scarf clips
8 dish cloths
57cm x 44cm x 15.5cm
Displayed: Whitechapel Open 1988, Whitechapel Gallery, London
Photo: Caroline Russell

Display 11 1988 (detail)
Offset litho prints of photocopy of Styrofil (polystyrene loose fill packing)
9 chrome racks
108 plastic hooks
108 Swantex serviettes
206.5cm x 756cm x 41cm
Photo: Sue Ormerod

Display 12 1988 (detail)
3 chrome piccolo bars
30 blue bin bags
294cm x 76.5cm x 45cm
Displayed: Anthony Reynolds Gallery, London
Photo: Sue Ormerod

Display 13 1988 (detail)
32 plastic sink mats
158cm x 335cm x 0.5cm
Displayed: Anthony Reynolds Gallery, London
Photo: Sue Ormerod

Display 14 1988 (detail)
A3 catalogue page, Goldsmiths' MA Final Show

Display 15 1988 (detail)
3 Pic'n Mix dispensers (acrylic)
top tray: attachment tags
middle tray: hanging straps
bottom tray: arrow bottle rings
76cm x 22.5cm x 50cm
Displayed: Goldsmiths' MA Final Show; Concept 88, Reality 89, Essex University
Photo: Sue Ormerod

Display 16 1988 (detail)
108 sandwich packets
industrial adhesive
polystyrene loose fill packing: white /Pelaspan; yellow/Styrofil; pink/Flopack
37.4cm x 388cm x 9cm
Displayed: Goldsmiths' MA Final Show
Photo: Sue Ormerod

Display 17 1988 (detail)
204 white paper take-away carriers (SOS style with paper tape handles)
204 sign lift hooks
305.5cm x 765cm x 9cm
Displayed: Goldsmiths' MA Final Show
Photo: Sue Ormerod

Display 18 & 19 1988 (detail)
10 Limb sheets (hip sheets)
Gridwall display system
8 shirt display cradles
400cm x 1098cm x 37cm
Displayed: Show and Tell, Riverside Studios, London
Photo: Sue Ormerod

Display 18 & 19 1988 (detail)
10 Limb sheets (hip sheets)
Gridwall display system
8 shirt display cradles
400cm x 1098cm x 37cm
Displayed: Show and Tell, Riverside Studios, London
Photo: Sue Ormerod

Display 20 1988 (detail)
FA9 Aluminium price ticket rail profile
orange P.V.C. insert
plastic endstops
5cm x 405.5cm x 2.5cm
Displayed: Show and Tell, Riverside Studios, London;
Fields of Vision, Zenit Deposito d'Arte, Turin
Photo: Sue Ormerod

Display 21 1989 (detail)
Extruded plastic bathroom seal (TD850 & TR807)
endstops
corner joints
butt joints
5674cm x 2.5cm x 2.5cm
Displayed: Display 21, Chisenhale Gallery, London
Photo: Sue Ormerod

Display 22 1989
Spot U.V. varnish
12 microns x 16cm x 12cm
Displayed: The British Art Show 1990 catalogue

Display 23 1990 (detail)
Microframe system, cotton buds, Foamex display panels, skin carding film
Panels: 50cm x 50cm x 0.5cm
As displayed British Art Show: McLellan Galleries, Glasgow:
450cm x 200cm x 136cm
As displayed British Art Show: Leeds City Art Gallery & Hayward Gallery, London:
480cm x 105cm x 136cm
Displayed: British Art Show 1990
Photo: Glasgow – John Gilmore, Leeds – David Ward, London – Sue Omerod

Display 24 1988/1990 (detail)
3 Pic 'n' Mix dispensers (acrylic)
top tray: centrifugal vials & Ariel phosphatfrei
middle tray: centrifugal vials & Pervoll
bottom tray: centrifugal vials & Sil
76cm x 22.5cm x 50cm
Displayed: Second Sight, Galerie Conrads, Neuss
Photo: Caroline Russell

Display 25 1990 (detail)
Plastic promotional flag kits
Oyster white prisma board
1096cm x 516cm x 15cm
Each flag: 17cm x 2cm x 15cm
Displayed: British Art Show 1990, Hayward Gallery, London
Photo: Sue Ormerod

Display 26 1990 (detail)
Plastic promotional flag kits
Oyster white prisma board
38.5cm x 700cm x 14cm
Displayed: Second Sight, Galerie Conrads, Neuss
Photo: Caroline Russell

Display 27 1990 (detail)
Installation for the foyer at Imagination, Store Street, London
The permanent display panels were removed from mobile rod system and 16 panels were
placed in the gaps between the usual panel positions
16 Foamex panels laminated both sides with oyster white prisma board
Each panel: 90cm x 37cm x .4cm
Displayed: Swimming Under Water, Imagination Building, London
Photo: Peter White

Display 28 1990 (detail)
200 pack Johnson's cotton buds
glass shelf (300mm x 300mm x 6mm)
Tension cable system
Total dimension: 300cm x 30cm x 30cm
Displayed: Laure Genillard Gallery
Photo: Peter White

Display 29 1990 (detail)
Buds series I (complete series)
(buds 0/6 positive) (buds -19/21 positive) (buds 0/26 positive)
(buds -20/0 positive) (buds 0/0 positive)
Five photo bleach etch panels mounted on Foamex each panel: 115mm x 120mm x 8mm
Tension cable system (wires 8cm apart)
Total dimension: 280cm x 115cm x 5cm
Displayed: Laure Genillard Gallery, London
Photo: Peter White

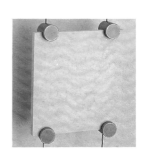

Display 30 1990 (detail)
Buds series II (complete series)
(buds 0/6 positive) (buds 0/6 negative) (buds -19/21 positive)
(buds -19/21 positive) (buds -20/0 positive) (buds -20/0 negative)
Six photo bleach etch panels mounted on Foamex each panel: 300mm x 300mm x 8mm
Tension cable system (wires 200cm apart)
Pair of panels: 280cm x 80cm x 5cm
Displayed: Laure Genillard Gallery, London (2 panels buds 0/6 positive/negative)
Photo: Peter White

CELL 1990
plaster
122 x 125 x 50cm
photo: David Ward

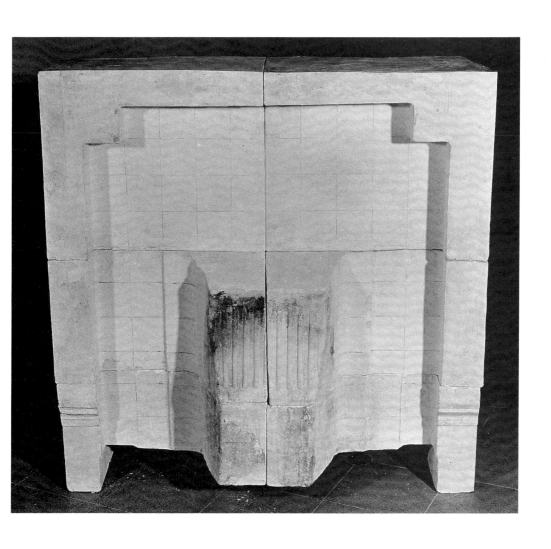

UNTITLED 1990
plaster
107 x 102 x 86cm
photo: Edward Woodman

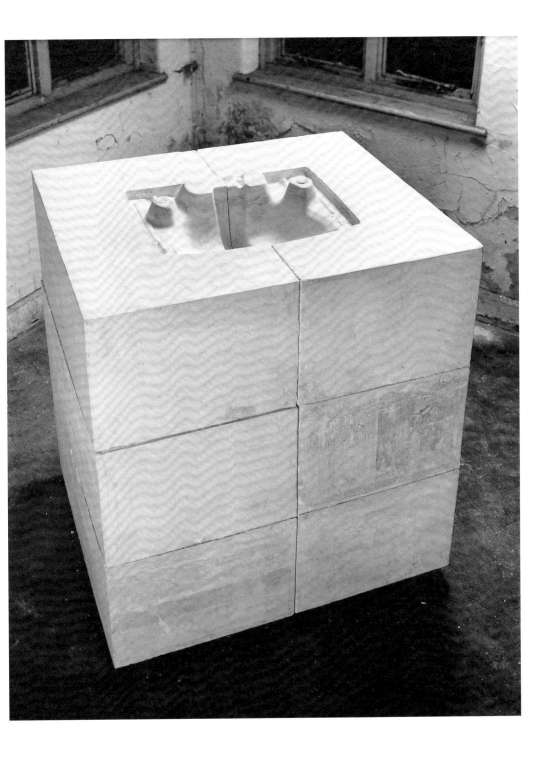

UNTITLED 1990
plaster & glass
103 x 105 x 210cm
photo: Gareth Winters

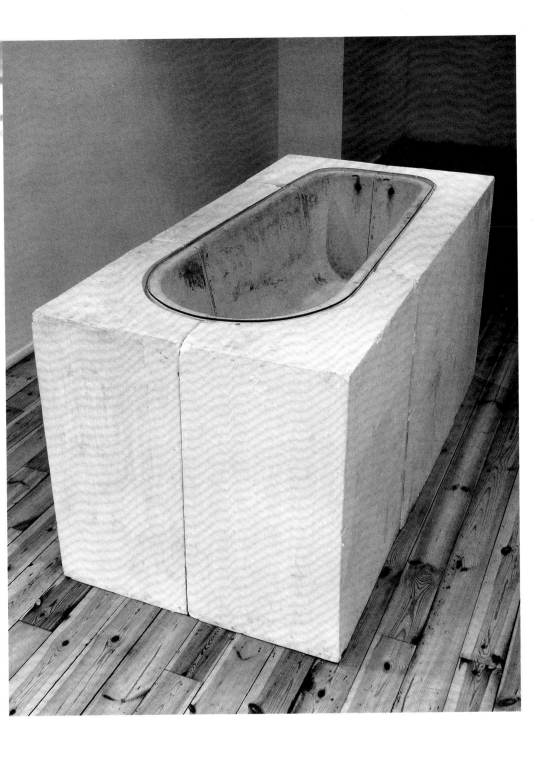

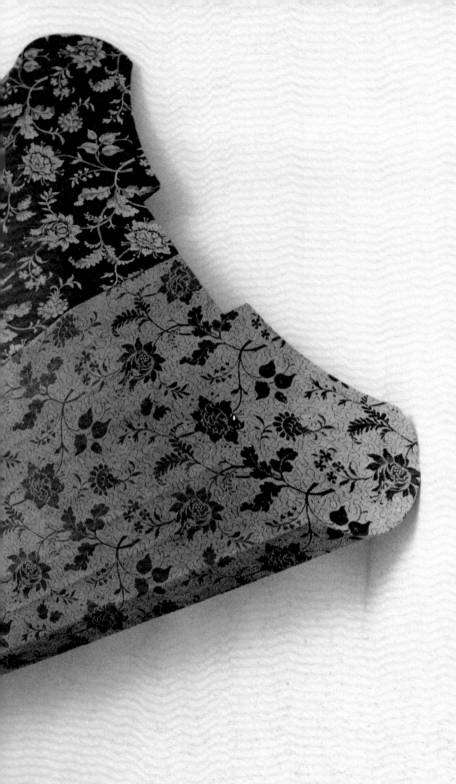

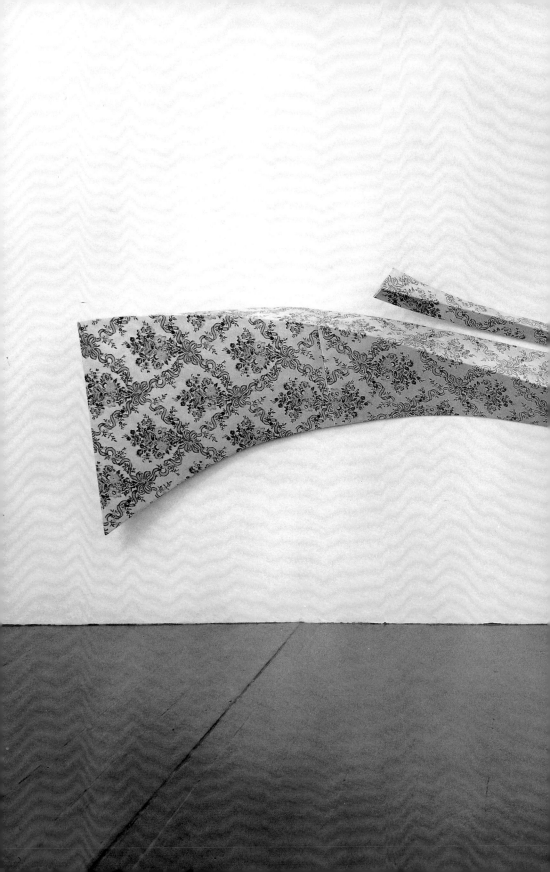

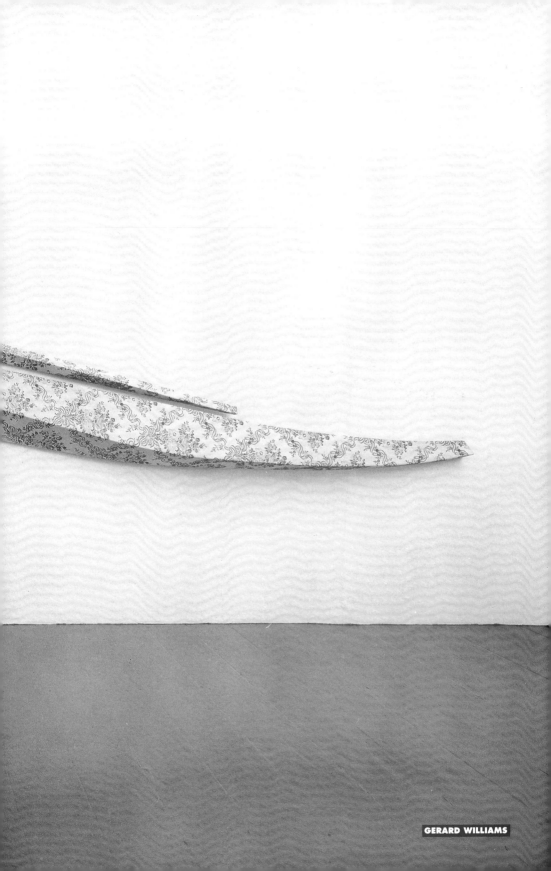

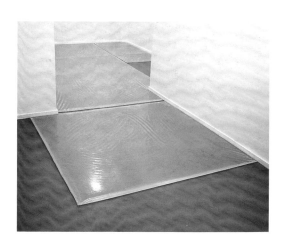

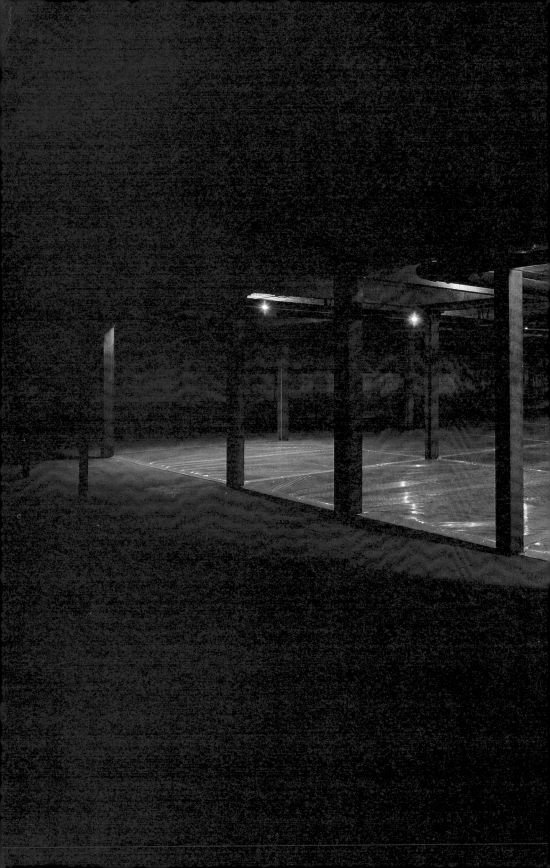

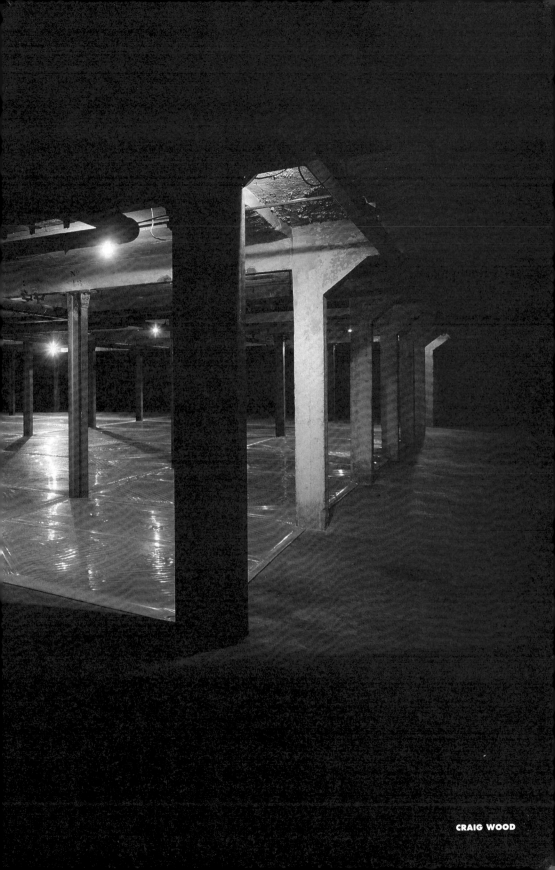

DOCUMENTATION

HENRY BOND

Born 1966, London.

EDUCATION
1984-85 West Surrey College of Art, Farnham,
Surrey.
1985-88 Goldsmiths' College, University of London,
B.A. (Hons.)

ONE-PERSON EXHIBITIONS
1991 *Documents* (with Liam Gillick), Karsten
Schubert Ltd, London.
James Hockey Gallery, Surrey.
Documents (with Liam Gillick), Centre d'Art
Contemporain, A.P.A.C. Nevers.

GROUP EXHIBITIONS
1990 *East Country Yard Show*, Surrey Docks,
London.
The Multiple Projects Room, Air de Paris,
Nice.
1991 *Spy-Stories*, Sergio Casolini, Milan, Il
Campo, Rome.

PUBLICATIONS
1990 *Untitled* (edition), London: Karsten Schubert Ltd.
East Country Yard Show, London.
1991 *Documents*, London and Nevers: One-Off Press
and APAC.

REVIEWS
1990 James Hall, *The Sunday Correspondent*,
June 17.
John Cornall, *'East Country Yard Show'*:
City Limits, June 28.
Andrew Graham-Dixon, 'The Midas
Touch', *The Independent*, July 31.
Liz Brooks, *'East Country Yard Show'*,
Artscribe 83, September-October.
David Batchelor, Kate Bush, Liam Gillick, Jutta
Koether, Sotiris Kyriacou, Adrian Searle.
'It's A Maggot Farm; The B-Boys and
Fly Girls of British Art: Five Statements and
a Conversation', *Artscribe*, no. 84, November-
December.
Tony White, *'East Country Yard Show'*,
Performance, September.
Tony White, *'East Country Yard Show'*,
Artists Newsletter, October.
Andrew Renton, 'Disfiguring: Certain New
Photographers and Uncertain Images', *Creative
Camera* 306, October-November.
Ian Jeffrey, 'The New New, a response',
Creative Camera 308, February-March.
1991 Rose Jennings *'Documents:* Karsten Schubert

Ltd', *City Limits*, February 7-14.
1991 Michael Archer *'Documents:* Karsten Schubert
Ltd', *Artforum*, March.
Ian Jeffrey 'Bond & Gillick', *Art Monthly*, March,
144.

MAT COLLISHAW

Born 1966, Nottingham.

EDUCATION
1985-86 Trent Polytechnic.
1986-89 Goldsmiths' College University of London, B.A.
(Hons.)

ONE-PERSON EXHIBITIONS
1990 Riverside Studios, London.
1991 Karsten Schubert Ltd, London.

GROUP EXHIBITIONS
1988 *Freeze*, PLA Building, London.
1989 *Ghost Photography, The Illusion of the Visible*,
touring exhibition, Italy.
1990 *Modern Medicine*, Building One, London.
A Group Show, Karsten Schubert Ltd, London.

PUBLICATIONS
1988 *Freeze*, London. Text by Ian Jeffrey.
1989 *The Illusion of the Visible*, Italy.
1990 *Modern Medicine*, London: Building One.

REVIEWS
1988 Sasha Craddock, *'Freeze*, The Fast Dockland
Train to Simplicity', *The Guardian*, September
13.
1989 Angela Bulloch, *'Freeze'*, *Art & Design
Magazine*, vol. V, no. 3-4, September.
1990 Stella Santacaterina, 'Arte da Londra; Matthew
Collishaw', *Frigidaire*, February, Italy.
John Stock, *'Modern Medicine'*, *The Times*,
March 27.
James Hall, *'Modern Medicine'*, *Sunday
Correspondent*, April 22.
Mark Currah, *'Modern Medicine'*, *City Limits*,
April 25.
Sarah Kent, *'Modern Medicine'*, *Time Out*, April
25.
Andrew Renton, *'Modern Medicine'*, *Blitz*, June.
Andrew Renton, *'Modern Medicine'*, *Flash Art*,
no. 153, June.
'Modern Medicine', *Artscribe*, no. 82, summer.
Andrew Graham-Dixon, 'Golden Years',
Vogue, September.
Andrew Renton, 'Disfiguring: Certain New

Photographers and Uncertain Images', *Creative Camera*, no. 306, October-November.

James Hall, 'Madonnas of the Medicine Age', *Art International*, no. 12, Autumn.

David Batchelor, Kate Bush, Liam Gillick, Jutta Koether, Sotiris Kyriacou, Adrian Searle. 'It's A Maggot Farm; The B-Boys and Fly Girls of British Art: Five Statements and a Conversation', *Artscribe* 84, November-December.

Tim Hilton, 'Critic's Choice Visual Arts: Mat Collishaw', *The Guardian*, December 12.

1991 David Lillington, 'Mat Collishaw: Karsten Schubert Ltd', *Time Out*, Jan 2-9.

Stella Santacaterina, 'Matthew Collishaw at Riverside Studios, *Tema Celeste*, January-February.

Julian Stallabrass, 'Mat Colishaw: Karsten Schubert Ltd', *Art Monthly*, February.

'Mat Collishaw: Karsten Schubert Ltd', *Nikkei Art*, March.

MELANIE COUNSELL

Born 1964, Cardiff.

EDUCATION
1982-83 South Glamorgan Institute of Higher Education.
1983-86 South Glamorgan Instutute of Higher Education, B.A. (Hons.)
1986-88 Slade School of Fine Art, University College, London, M.A. Fine Art.

PRIZES AND AWARDS
1987 Mary Rischgitz Prize.
1988 Boise Travel Scholarship.
1989 Whitechapel Studio Award.

ONE-PERSON EXHIBITIONS
1989 Tooting Bec Psychiatric Hospital.
 Matt's Gallery, London.

GROUP EXHIBITIONS
1988 *Six Artists Three Shows*, Anthony Reynolds Gallery, London.
1990 *The British Art Show 1990*, McLellan Galleries, Glasgow; Leeds City Art Gallery; Hayward Gallery, London.
 T.S.W.A., Installation at B.R.S. Factory, Derry.
 Seven Obsessions, Whitechapel Art

Gallery, London.
1991 *White Bones*, Walter Phillips Gallery, Banff, Canada.

PUBLICATIONS
1990 *The British Art Show 1990*, London: Hayward Gallery.
1991 *T.S.W.A. New Works for Different Places*. James Lingwood (ed.)
 White Bones, Banff: Walter Phillips.

REVIEWS
1989 Mark Currah, 'Melanie Counsell: Matt's Gallery', *City Limits*, November 30.
1990 Andrew Renton, *Blitz*, February.
 Caroline Collier, '*British Art Show* ', *Women's Art Magazine*, September.
 James Hall, '*Seven Obsessions* ', *The Sunday Correspondent*, August 26.
 Bruce Bernard, '*British Art Show* ', *The Independent Magazine*, June 2.
 Marjorie Allthorpe-Guyton, '*Seven Obsessions*: Whitechapel', *Artforum*, November.
 Jonathan Watkins, '*British Art Show* ', *Art International*, Winter.
 Fiona Barber, '*T.S.W.A.*', *Women's Art Magazine*, December.
 Laurie Peake, '*Seven Obsessions*', *Women's Art Magazine*, December.
 Kate Bush, 'Melanie Counsell: Matt's Gallery', *Artscribe*, March-April.
1991 Michael Archer, '*T.S.W.A.*', *Artscribe*, January-February.
 Fiona Barber and Valerie Sutton, '*T.S.W.A.*', *Circa*, January-February.

IAN DAVENPORT

Born 1966, Sidcup, Kent.

EDUCATION
1984-85 Northwich College of Art and Design.
1985-88 Goldsmiths' College, University of London, B.A. (Hons.)

ONE-PERSON EXHIBITIONS
1990 Waddington Galleries, London.

GROUP EXHIBITIONS
1985 *Young Contemporaries*, Whitworth Art Gallery, Manchester.
1988 *Freeze*, PLA Building, London.
 Ian Davenport, Gary Hume, Michael Landy,

Karsten Schubert Ltd, London.

1989 *Current*, Swansea Arts Workshop (Old Seamen's
 Chapel), Swansea.
 West Norwood 1, West Norwood Railway
 Arches 7, 8 and 9, London.

1990 *The British Art Show 1990*, McLellan Galleries,
 Glasgow; Leeds City Art Gallery; Hayward
 Gallery, London.

1990-91 *Carnet de voyages 1*, Fondation Cartier pour
 l'art contemporarin, Jouy-en-Josas.

PUBLICATIONS

1990 *Ian Davenport*, London: Waddington Galleries.
 Text by Norman Rosenthal.

REVIEWS

1989 Michael Archer, '*Ian Davenport, Gary Hume,
 Michael Landy*: Karsten Schubert Ltd', *Artforum*,
 February.
 Angela Bulloch, '*Freeze* ', *Art & Design*, vol. 5,
 nos. 3-4.
 'British Arts Under 40', *Art & Design*, vol. 5, .
 nos. 3-4, September.
 Richard Shone, '*Ian Davenport, Gary Hume,
 Michael Landy* ', *The Burlington Magazine*, vol.
 CXXXI, no. 1030, February.

1990 Andrew Graham-Dixon, 'Pupils of the Cool
 School', *The Independent*, January 30.
 Tim Hilton, 'Home Groan', *The Guardian*,
 January 31.
 Giles Auty, 'Capricious climates', *The Spectator*,
 October 20.
 Mary Rose Beaumont, 'Ian Davenport at
 Waddington's', *Arts Review*, 19 October.
 Roger Bevan, 'Abstract', *Antique & New Art*,
 Winter.
 Kate Bush, '*The British Art Show 1990*, McLellan
 Galleries ', *Artscribe*, May.
 John Cornall, 'Minimalism Realism in *The British
 Art Show 1990* ', *The London Magazine*, vol.
 30, no. 7-8, October-November 1990.
 Miranda Carter, 'The Tote Gallery', *Harpers &
 Queen*, August.
 William Feaver, 'Hear hear, O Isreal', *The
 Observer*, October 14.
 Liam Gillick, 'Ian Davenport', *Artscribe*, March-
 April.
 Andrew Graham-Dixon, 'Leaving a mark', *The
 Independent*, October 9.
 Alistair Hicks, 'New star's course seems all too
 predictable', *The Times*, October 19.
 Rose Jennings, 'Ian Davenport at Wadding
 ton's', *City Limits*, October 11-18.
 Sarah Kent, 'Ian Davenport at Waddington's',
 Time Out, October 10-17.
 Richard Shone, 'London, Davenport at

Waddington', *Burlington Magazine*, no.
1052, vol. CXXXII, November 1990.
Joseph Williams, 'Creative Accountancy', *The
Times*, October 23.
Andrew Renton, *Blitz*, December.

1991 Interalia (David Beech & Mark Hutchison), 'Ian
 Davenport: Waddington Galleries', *Artscribe*,
 January-February.
 Enrique Juncosa, 'Ian Davenport', *Lapiz*, no. 72,
 November.
 Jane Rankin-Reid, 'Painting Alone', *Artscribe*,
 January-February.
 Andrew Renton, '*Ian Davenport*: Waddington
 Galleries ', *Flash Art*, January-February.

GRENVILLE DAVEY

Born Launceston, Cornwall, 1961.

EDUCATION

1981-82 Exeter College of Art & Design.
1982-85 Goldsmiths' College, University of London. B.A.
 (Hons.)

ONE-PERSON EXHIBITIONS

1987 Lisson Gallery, London.
1989 Lisson Gallery, London.
 Primo Piano, Rome.
1990 Stichting De Appel Foundation, Amsterdam.
1991 Galerie Crousel-Robelin Bama, Paris.

GROUP EXHIBITIONS

1986 Showroom Gallery, London.
1988 *19&&*, Centre national d'art contemporain de
 Grenoble.
 Aperto, XLIII Biennale de Venezia, Venice.
 Artists and Curators, John Gibson Gallery, New
 York.
 British Artists, Tanya Grunert Gallery, Cologne.
1989 *Ateliers en Liberté 1989, Aspects de la jeune
 sculpture européene*, Fondation Cartier, Paris.
 *Grenville Davey, Michael Craig-Martin, Julian
 Opie*, Lia Rumma, Naples.
 Prospect '89, Frankfurter Kunstverien, Frankfurt.
 Melancholia, Galerie Grita Insam, Vienna.
 Psychological Abstraction, Deste Foundation for
 Contemporary Art, House of Cyprus, Athens.
 *Richard Wentworth, Grenville Davey, Gerard
 Williams*, Sala I, Rome.
 A Perspective on Contemporary Art - Colour

and/or Monochrome', National Museum of Modern Art , Tokyo; National Museum of Modern Art Kyoto.

1990 The British Art Show 1990, McLellan Galleries, Glasgow; Leeds City Art Gallery; Hayward Gallery, London.
OBJECTives: The New Sculpture, Newport Harbor Art Museum, Newport Beach, California.
Half-Truths, The Parrish Art Museum, Southampton, New York.
Real Allegories, Lisson Gallery, London.
Grenville Davey, Jürgen Drescher, Wilhelm Mundt, Thomas Backhauss, Düsseldorf.

1991 OPAC, Fundacio Caixa de Pensions, Barcelona.

PUBLICATIONS

1988 Aperto, Venice: XLIII Biennale de Venezia, Fabbri Editori. Text by Dan Cameron.

1989 A Perspective on Contemporary Art - Colour and/or Monochrome, Tokyo: National Museum of Art.
Grenville Davey, London: Lisson Gallery. Text by Marjorie Allthorpe-Guyton.
Melancholia, Vienna: Galerie Grita Insam. Texts by Dan Cameron and Burghart Schmidt.
Richard Wentworth, Grenville Davey, Gerard Williams, Rome: Sala I. Text by Lynne Cooke.
Prospect '89, Frankfurt: Frankfurter Kunstverein. Text by Peter Weiermair.
Psychological Abstraction, Athens: Deste Foundation for Contemporary Art. Text by Jeffrey Deitch.

1990 The British Art Show 1990, London: Southbank Centre.
OBJECTives: The New Sculpture, Newport Beach, New York: Newport Harbor Art Museum, Rizzoli. Text by Lynne Cooke.
Grenville Davey, Amsterdam: Stichting De Appel Foundation. Edna van Duyn (ed.).
Half-Truths, New York: The Parrish Art Museum, Southampton. Text by Marge Goldwater.

1991 Grenville Davey, Barcelona: OPAC, Fundacio Caixa de Pensions. Text by Teresa Blanch .

REVIEWS

1988 Sarah Kent, 'Grenville Davey, Shirazeh Houshiary', Time Out, October 14-21.
Marjorie Allthorpe-Guyton, 'Grenville Davey. Lisson ', Flash Art, no. 138, January-February.
Michael Archer, 'Grenville Davey: Lisson Gallery', Artforum, January.
Stuart Morgan, 'Degree Zero: Grenville Davey', Artscribe, January-February.

Gregorio Magnani, 'Venice Biennale', Flash Art, October.
Stuart Morgan, 'Cold Comfort', Artscribe, summer.
Bernardo Mercuri, 'Young Art', Tema Celeste, October-December.
Lieven ven den Abeele, '19&&', Artefactum, no. 24, June-August.

1989 Philippe Piguet, 'Un, deux, trois...sculptures', Art Press, February 2-8.
Daniel Dobbels, 'Jeunes et en formes', Liberation, February 17.
Philippe Carteron, 'Un, deux, trois...sculptures', Le Nouvel Observateur, February 2-8.
Norbert Messler and Verena Auffermann, 'Prospect '89 Elendsgestalten und Saulenheiligen: Kunst uber Kunst uber Kunst', Noema, April-May.
Brian Hatton, 'Grenville Davey: Lisson Gallery', Flash Art, summer.
Jeffrey Deitch, 'Astrazione Psicologica', Flash Art, October-November.
Arturo Silva, 'Color and/or monochrome', Daily Yomiuri, 19 October.
Sarah Kent, 'Grenville Davey: Lisson Gallery', Time Out, 5-12 April.
Enzo Bilardello, 'Le luci e le ombre', Corriere della Sera, 20 November.
Ester Coen, 'Le gallerie', Il Giornale dell'arte, no. 73, December.

1990 Adrian Dannatt, 'Eastside Story', Flash Art, January-February.
Enzo Bilardello, 'Grenville Davey: Roma, Primo Piano', Artefactum, February-March.
Lucilla Meloni, 'Richard Wentworth, Grenville Davey, Gerard Williams', Tema Celeste, no. 24, January-March.
Carolyn Christov-Bakargiev, 'Grenville Davey, Primo Piano; Davey, Wentworth, Williams, Sala 1', Flash Art Italia, no. 154, February-March.
Liam Gillick, 'Critical Dementia: The British Art Show ', Art Monthly, no. 134, March.
Edward Lucie-Smith, 'The British Art Show ', Modern Painters, January.
Andrew Graham-Dixon, 'Pupils of the Cool School', The Independent, January 30.
Phyllis Braff, 'Sculpture that Demands Viewer Involvement', The New York Times, August 19.
William Wilson, 'Sculpture show lends meaning to emptyness', Los Angeles Times, April 10.
Cathy Curtis, 'Three sculptors discuss the art of OBJECTives ', Los Angeles Times, April 10.
Let Geerling, 'Grenville Davey', Metropolism, September.
Mark Peeters, 'Grenville Davey', NRC Handelsblad, 7 September.

CATHY DE MONCHAUX

Born 1960, London.

EDUCATION
1980-83 Camberwell School of Art, B.A. (Hons.)
1985-87 Goldsmiths' College, M.A.

ONE-PERSON EXHIBITIONS
1985 Winchester Gallery, Winchester.
1988 Mario Flecha Gallery, London.
 Artist of the Day, Angela Flowers Gallery,
 London.
1989 *The Invisible Man* (with Sophie Horton),
 Goldsmiths' Gallery, London.
1990 Laure Genillard Gallery, London.
 Studio Guenzani, Milan.

GROUP EXHIBITIONS
1984 *The Whitechapel Open*, Whitechapel Art
 Gallery, London.
1985 *The Whitechapel Open*, Whitechapel Art
 Gallery, London.
1986 *The Whitechapel Open*, Whitechapel Art
 Gallery, London.
1987 Mario Flecha Gallery, London.
 The Whitechapel Open, Whitechapel Art
 Gallery, London.
1988 *The Whitechapel Open*, Whitechapel Art
 Gallery, London.
1989 *Promises, Promises*, Serpentine Gallery, London,
 Ecole de Nimes, Nimes, France.
 It's a Still Life, Arts Council Touring Exhibition,
 Galerie Konrads.
1990 *The British Art Show 1990*, McLellan Gallery,
 Glasgow; Leeds City Art Gallery; Hayward
 Gallery, London.
 Je reviens de chez le charcutier, curated by
 Bernard Marcade, Galerie Ghislaine Hussenot,
 Paris.
 Laure Genillard Gallery, London.
 Visions 90, Centre international d'art
 contemporain de Montréal, Montréal, Canada.

PUBLICATIONS
1989 *Promises, Promises*, London: Serpentine Gallery.
 Text by Adrian Searle.
 Bienale de Barcelona 1989.
1990 *It's a Still Life*, London: Arts Council Touring
 Exhibition.
 The British Art Show 1990, London: Southbank
 Centre.

REVIEWS
1990 Sarah Kent, 'Preview', *Time Out*, no. 979,
 February.

Mary Rose Beaumont, 'Performance', *Tatler*,
March.
Simon Morley, *Tema Celeste*, no. 28, March.
Andrew Renton, *'Promises, Promises', Flash Art*,
no. 154, October.
James Hall, 'Gender-bending Version of
Pygmalion Myth', *The Sunday Correspondent*,
May 13.
Tony Godfrey, 'Cathy de Monchaux', *Art in
America*, September.
Martin McGeown, 'Cathy de Monchaux', *Art
Press*, September.

DOMINIC DENIS

Born 1963, London.

EDUCATION
1984-86 Chelsea School of Art.
1986-89 Goldsmiths' College, University of London, B.A.
 (Hons.)

ONE-PERSON EXHIBITIONS
1990 Harry Zellweger, Lugano.

GROUP EXHIBITIONS
1988 *Freeze*, PLA Building, London.
1990 *Modern Medicine*, Building One, London.
 Gambler, Building One, London.
 British Art, Basel.

PUBLICATIONS
1988 *Freeze*, London. Text by Ian Jeffrey.
1990 *Modern Medicine*, London: Building One.
 Gambler, London: Building One. Text by Liam
 Gillick.

REVIEWS
1988 Sasha Craddock, *'Freeze:* The Fast Docklands
 Train to Simplicity ', *The Guardian*, September
 13.
1989 Angela Bulloch, *'Freeze '*, *Art & Design
 Magazine*, vol. V, no. 3-4, September.
1990 John Stock, *'Modern Medicine'*, *The Times*,
 March 27.
 James Hall, *'Modern Medicine'*, *Sunday
 Correspondent*, April 22.
 Mark Currah, *'Modern Medicine'*, *City Limits*,
 April 25.
 Sarah Kent, *'Modern Medicine'*, *Time Out*,
 April 25.
 Andrew Renton, *'Modern Medicine'*, *Blitz*, June.
 Andrew Renton, *'Modern Medicine'*, *Flash Art*,
 summer.
 'Modern Medicine', *Artscribe*, summer

ANGUS FAIRHURST

Born 1966, Kent.

EDUCATION
1985-86 Canterbury College of Art.
1986-89 Goldsmiths' College, University of London, B.A. (Hons.)

ONE-PERSON EXHIBITIONS
1990 *You in Mind (Eyes and Mouth)*, Karsten Schubert Ltd, London.
1991 Karsten Schubert Ltd, London.

GROUP EXHIBITIONS
1988 *Freeze*, PLA Building, London.
1990 *Modern Medicine*, Building One, London.
 Gambler, Building One, London.
 A Group Show, Karsten Schubert Ltd, London.

PUBLICATIONS
1988 *Freeze*, London. Text by Ian Jeffrey.
1990 *Modern Medicine*, London: Building One.
 Gambler, London: Building One. Text by Liam Gillick.

REVIEWS
1988 Sasha Craddock, 'Freeze, The Fast Docklands Train to Simplicity ', *The Guardian*, September 13.
1989 Angela Bulloch, 'Freeze', *Art & Design Magazine*, vol. V, no. 3-4, September.
1990 John Stock, 'Modern Medicine', *The Times*, March 27.
 Sarah Kent, 'Modern Medicine', *Time Out*, April 25, London.
 Andrew Renton, 'Modern Medicine', *Blitz Magazine*, June.
 Andrew Renton, 'Modern Medicine', *Flash Art*, vol. XXIII, no. 153, Summer.
 'Modern Medicine', *Artscribe*, no. 82, summer.
 David Batchelor, Kate Bush, Liam Gillick, Jutta Köether, Sotiris Kyriacou & Adrian Searle, 'It's a maggot farm, the B-Boys and Fly-Girls of British Art', *Artscribe*, November-December.

ANYA GALLACCIO

Born 1963, Glasgow.

EDUCATION
1984-85 Kingston Polytechnic
1985-88 Goldsmiths' College, University of London. B.A. (Hons.)

GROUP EXHIBITIONS
1988 *Freeze*, PLA Building, London.
 Poetic Figuration in the Eighties, Lauderdale House, London.
1989 *New Year, New Talent*, Anderson O'Day, London.
 The Drum Show, Broadgate Arena, London.
 The Return of Ulysses, English National Opera, London.
1990 *East Country Yard Show*, Surrey Docks, London.
 Next Phase, Wapping Pumping Station, London.

PUBLICATIONS
1988 *Freeze*, London. Text by Ian Jeffrey.
1990 *Next Phase*, London: WiseTaylor Partnership. Text by Ian Jeffrey.

REVIEWS
1988 Sascha Craddock, 'Freeze, The Fast Docklands Train to Simplicity', *The Guardian*, September 13.
1989 Mark Currah, *City Limits*, October 5-12.
 Mark Currah, 'The Gold-rush', *City Limits*, November 23 - 30.
 Richard Dorment, 'The Dangerous Art of Stage Design', *Daily Telegraph*, November 7.
1990 David Lillington, *Time Out*, June 13-20.
 Liz Brooks, 'East Country Yard Show', *Artscribe*,
 Andrew Renton, 'East Country Yard Show', *Flash Art*, October.
 David Batchelor, Kate Bush, Liam Gillick, Jutta Köether, Sotiris Kyriacou & Adrian Searle, 'It's a maggot farm, the B-Boys and Fly-Girls of British Art', *Artscribe*, November-December.
 Tony White, 'East Country Yard Show', *Performance*, September 1990.

LIAM GILLICK

Born 1964, Aylesbury.

EDUCATION
1983-84 Hertfordshire College of Art
1984-87 Goldsmiths' College, University of London, B.A. (Hons.)

ONE-PERSON EXHIBITIONS
1989 *84 Diagrams*, Karsten Schubert Ltd, London.
1991 *Documents* (with Henry Bond).
 Karsten Schubert Ltd, London.
 Documents (with Henry Bond), Centre d'Art Contemporain, A.P.A.C., Nevers, France.

GROUP EXHIBITIONS

1990 *The Multiple Projects Room*, Air de Paris, Nice.

PUBLICATIONS

1991 *Documents*, London and Nevers: One-Off Press and A.P.A.C. Nevers.

REVIEWS

1991 Rose Jennings, '*Documents*, Karsten Schubert Ltd', *City Limits*, no. 488.
 Michael Archer, '*Documents*, Karsten Schubert Ltd', *Artforum*, 1991, March.
 Ian Jeffrey, 'Bond & Gillick', *Art Monthly*, no. 144, March.

MARKUS HANSEN

Born 1963, Heidelberg.

EDUCATION

1981-85 University of Reading, B.A. (Hons.)

ONE-PERSON EXHIBITIONS

1988 *Keeping the Peace*, Wunschik Peterson Gallery, Dusseldorf.
1989 Wunschik Peterson Gallery, Dusseldorf.
 Aviation/Vanitas, Camerawork, London.
1990 Interim Art, London.
1991 James Hockey Gallery, Farnham.

GROUP EXHIBITIONS

1984 South Hill Park Performance Festival, Bracknell.
1985 Camerawork, London.
1988 *Hommage to Joseph Albers*, Flaxman Gallery, London.
 Fragments from False Houses, Pomeroy Purdy Gallery, London.
 Internationale Photozene, Museum Ludwig, Cologne.
 Dusseldorfer Kunstverein E.V., Dusseldorf.
1990 Interim Art, London.

PUBLICATIONS

1988 *Keeping the Peace*, London: Camerawork. Text by Kate Bush.

REVIEWS

1988 *Der Dusseldorfer*, September
 Marion Diwo, *Apex*, November.
1989 Kate Bush, *Time Out*, February.
 Mark Currah, *City Limits*, March.
 Andreas Broeckmann, 'Am Rande des Risses', *Apex*, October.
1990 Helena Goldwater, *Artscribe*, November-

December.
 Andrew Renton, 'Disfiguring: Certain New Photographers and Un-certain Images', *Creative Camera*, no. 306, November.
 John Cornall, *City Limits*, June 7-14.

DAMIEN HIRST

Born 1965, Yorkshire.

EDUCATION

1983-84 Jacob Kramer College of Art, Leeds.
1986-89 Goldsmiths' College, University of London.

GROUP EXHIBITIONS

1987 Old Court Gallery, Windsor.
 Whitworth Young Contemporaries, Manchester.
1988 Old Court Gallery, Windsor.
 Freeze, PLA Building, London.
1989 *New Contemporaries*, ICA London; Third Eye Centre, Glasgow.
1990 *Modern Medicine*, Building One, London.
 Gambler, Building One, London.

PUBLICATIONS

1988 *Freeze*, London. Text by Ian Jeffrey.
1990 *Modern Medicine*, London: Building One.
 Gambler, London: Building One. Text by Liam Gillick.

REVIEWS

1988 Sasha Craddock, '*Freeze*: The Fast Docklands Train to Simplicity', *The Guardian*, September 13.
1989 Angela Bulloch, '*Freeze*', *Art & Design Magazine*, vol. V, no. 3-4, September.
1990 John Stock, '*Modern Medicine*', *The Times*, March 27.
 James Hall, '*Modern Medicine*', *Sunday Correspondent*, April 22.
 Mark Currah, '*Modern Medicine*', *City Limits*, April 25.
 Sarah Kent, '*Modern Medicine*', *Time Out*, April 25.
 Andrew Renton, '*Modern Medicine*', *Blitz*, June.
 Andrew Renton, '*Modern Medicine*', *Flash Art*, Summer.
 '*Modern Medicine*', *Artscribe*, Summer
 David Batchelor, Kate Bush, Liam Gillick, Jutta Köether, Sotiris Kyriacou & Adrian Searle, 'It's a maggot farm, the B-Boys and Fly-Girls of British Art: Five Statements and a Conversation', *Artscribe*, no. 84, November-December.

GARY HUME

Born 1962, Kent.

EDUCATION
1985-86 Liverpool Polytechnic.
1986-88 Goldsmiths' College, University of London,
 B.A. (Hons.)

ONE-PERSON EXHIBITIONS
1989 Recent Work, Karsten Schubert Ltd, London.

GROUP EXHIBITIONS
1988 Freeze Part II, Surrey Docks, London.
 Ian Davenport, Gary Hume, Michael Landy,
 Karsten Schubert Ltd, London.
1989 Steve di Benedeto, Gary Hume, Julian
 Lethbridge, Nicholas Rule, Matthew Weinstein,
 Lorence Monk Gallery, New York (curated by
 Clarissa Dalrymple).
 Angela Bulloch, Gary Hume, Michael Landy,
 Esther Schipper, Cologne.
1990 A Paintings Show, Michael Craig-Martin, Gary
 Hume & Christopher Wool, Karsten Schubert Ltd,
 London.
 The British Art Show 1990, McLellan Galleries,
 Glasgow; Leeds City Art Gallery; Hayward
 Gallery, London.
 The Köln Show, Cologne.
 East Country Yard Show, London.

PUBLICATIONS
1988 Freeze, London. Text by Ian Jeffrey.
1990 Angela Bulloch, Gary Hume, Michael Landy,
 Cologne: Esther Schipper. Text by Andrew
 Renton.
 The British Art Show 1990, London: Southbank
 Centre.
 Nachschub: The Köln Show, Cologne: Spex.
 A Paintings Show, London: Karsten Schubert Ltd.
 Text by Lynne Cooke.

REVIEWS
1988 Sasha Craddock, 'Freeze, The Fast Dockland
 Train to Simplicity', The Guardian, September
 13.
1989 Richard Shone, 'Ian Davenport, Gary Hume,
 Michael Landy', The Burlington Magazine,
 February.
 Michael Archer, 'Ian Davenport, Gary Hume,
 Michael Landy', Artforum, February.
 Sarah Kent, 'Gary Hume', Time Out, July 12-19.
 Andrew Renton, Blitz, August.
 Adrian Dannatt, 'Gary Hume: Karsten Schubert
 Ltd', Flash Art, October.
 Merlin Carpenter, Artscribe, November-
 December.
 James Roberts, Artefactum, November-
 December.
1990 William Feaver, 'When is a door not a door?,
 The British Art Show', The Observer, January
 28.
 Peter Fuller, 'The British Art Show', The Sunday
 Telegraph, January 28.
 Matthew Collings, 'Britain is Best', Modern
 Painters, Spring.
 Liam Gillick, 'The British Art Show', Art Monthly,
 March.
 Stuart Morgan, 'The British Art Show', Artscribe,
 May.
 Kate Bush, 'The British Art Show', Artscribe,
 May.
 Andrew Renton, 'Birth of the Cool', Blitz, June.
 'The Köln Show', Artscribe, no. 82, summer.
 John Cornall, 'East Country Yard Show', City
 Limits, June 28.
 Andrew Renton, 'The Koln Show', Blitz, July.
 Andrew Graham-Dixon, 'The Midas Touch?', The
 Independent, July 31.
 Liz Brooks, 'East Country Yard Show', Artscribe,
 no. 83, September-October.
 Gordon Burn, 'Playing to the Galleries', The
 Sunday Times Magazine, September 30.
 Andrew Graham-Dixon, 'Golden Years', Vogue
 September.
 Meyer Raphael Rubenstein, 'The Köln Show', Art
 News, September.
 Andrew Renton, 'East Country Yard Show',
 Flash Art, no. 154, October.
 Tony White, 'East Country Yard Show', Artist's
 Newsletter, October.
 Tony White, 'East Country Yard Show',
 Performance, October.
 Andrew Renton, 'Disfiguring: Certain New
 Photographers and Uncertain Images', Creative
 Camera, no. 306, October-November.

MICHAEL LANDY

Born 1963, London.

EDUCATION
1979-81 Loughton College of Art.
1981-83 Loughborough College of Art.
1985-88 Goldsmiths' College, University of London, B.A.
 (Hons.)

ONE-PERSON EXHIBITIONS
1989 Gray Art Gallery, New York.

Karsten Schubert Ltd, London.

1990 Studio Marconi, Milan.

Tanja Grunert, Cologne.

1990 *Market*, Building One, London.

GROUP EXHIBITIONS

1987 Showroom, London.

1988 *Freeze*, Part I, PLA Building, London.

Ian Davenport, Gary Hume, Michael Landy,
Karsten Schubert Ltd, London.

*That Which Appears is Good, That Which is
Good Appears*, Tanja Grunert, Cologne.

Show and Tell, Riverside Studios, London.

1989 *Dan Flavin, Michael Landy, Thomas Locher*,
Karsten Schubert Ltd, London.

Home Truths, curated by Kate McFarlane,
Castello di Rivara, Turin.

La Biennal de Barcelona.

Angela Bulloch, Michael Landy, Gary Hume,
Esther Schipper, Cologne.

Interim Jeune I, Interim Art, London.

1990 *The Köln Show*, Cologne.

Multiples, Hirschl & Adler Modern, New York.

East Country Yard Show, London.

A Group Show, Karsten Schubert Ltd, London.

PUBLICATIONS

1988 *Freeze*, London. Text by Ian Jeffrey.

1989 *La Biennal de Barcelona*.

1990 *The Cologne Show*, Cologne: Spex.

Artificial Nature, Athens: Deste Foundation for
Contemporary Art. Text by Jeffrey Deitch.

Multiples, New York: Hirschl & Adler Modern.

Home Truths, Turin: Franz Paludetto. Text by
Kate Bush.

Angela Bulloch, Michael Landy, Gary Hume,
Cologne: Esther Schipper. Text by Andrew
Renton.

East Country Yard Show, London.

1991 *Market*, London: One-Off Press. Text by Kate
Bush.

REVIEWS

1988 Sasha Craddock, 'Freeze, The Fast Dockland
Train to Simplicity', *The Guardian*, September
13.

Sasha Craddock, 'Show and Tell ', *The
Guardian*.

1989 Richard Shone, 'Ian Davenport, Gary Hume &
Michael Landy', January, *The Burlington
Magazine*, January.

Sarah Kent, 'Show and Tell ', *Time Out*, January
5-12.

Mark Currah, 'Show and Tell ', *City Limits*,
January 5-12.

Michael Archer, 'Ian Davenport, Gary Hume &

Michael Landy ', *Artforum*, February.

Liam Gillick, 'Show and Tell ', *Art Monthly*,
February.

Andrew Renton, *Blitz*, August.

Mark Currah, *City Limits*, September 14-21.

Mark Currah, *City Limits*, November 23-30.

Liam Gillick, 'Grenville Davey, Gary Hume,
Michael Landy', *New Art International*, May.

Tim Hilton, 'Interim Jeune 1, Interim Art', *The
Guardian*, May 31.

David Lillington, 'Interim Jeune 1', *Time Out*,
June 7-14.

Mark Currah, 'Interim Jeune 1', *City Limits*, June
8-15.

Angela Bulloch, 'Freeze', *Art & Design
Magazine*, vol. V, no. 3-4, September.

Adrian Dannatt, 'Interim Jeune 1', *Flash Art*,
no. 148, October.

1990 Jutta Köether, 'Three from England: Esther
Schipper', *Flash Art*, January-February.

Adrian Dannatt, 'Eastside Story', *Flash Art*,
January-February.

William Jeffett, 'Contemporary Art Fair
Strategies', *Apollo*, May.

Andrew Renton, 'Birth of the Cool', *Blitz*, June.

'Köln Show', *Artscribe*, no. 82, summer.

Andrew Renton, *Blitz*, July.

John Cornall, 'East Country Yard Show', *City
Limits*, June 28.

Andrew Graham-Dixon, 'The Midas Touch?', *The
Independent*, July 31.

Miranda Carter, 'The Tote Gallery', *Harpers and
Queen*, August.

Liz Brooks, 'East Country Yard Show', *Artscribe*,
no. 83, September-October.

Meyer Raphael Rubenstein, 'The Köln Show ',
Art News, September.

Private Eye, September 28.

Gordon Burn, 'Playing to the Galleries', *The
Sunday Times*, September 30.

William Feaver, 'Market ', *The Observer*,
October 7.

James Hall, 'Market ', *Sunday Correspondent*,
October 7.

Cathy Milton, 'Enterprising artist cashes in',
The Independent, October 11.

Sarah Kent, 'Market ', *Time Out*, October 10-17.

Tony White, 'East Country Yard Show', *Artist's
Newsletter*, October.

Tony White, 'East Country Yard Show',
Performance, October.

Andrew Renton, 'Michael Landy, Tanja Grunert',
Flash Art, no. 154, October.

Andrew Renton, 'East Country Yard Show',
Flash Art, no. 154 October.

Andrew Graham-Dixon, 'Young Turks and Old

Masters', *Art News*, November, pp. 124-126.
David Batchelor, Kate Bush, Liam Gillick, Jutta
Koether, Sotiris Kyriacou & Adrian Searle, 'It's a
Maggot Farm; the B-Boys and Fly Girls of British
Art: Five Statements and a Conversation',
Artscribe, no. 84, November-December.
Richard Shone, 'Landy at Building One',
Burlington Magazine, vol. CXXXII, no. 1052,
November.

1991 Martin McGeown, 'Michael Landy, Building One;
Meyer Vaisman, Waddington Galleries', *Art
Press*, January.
Kiron Khosla, 'Michael Landy: Building One',
Artscribe, no. 85, January-February.
Stella Santacatterina, 'Michael Landy at Building
One', *Tema Celeste*, no. 29, January February.

ABIGAIL LANE

Born 1967, Cornwall.

EDUCATION
1985-86 Bristol Polytechnic
1986-89 Goldsmiths' College, University of London. B.A.
(Hons.)

GROUP EXHIBITIONS
1988 *Freeze*, PLA Building, London.
1989 *The New Contemporaries*, ICA, London and
touring.
Home Truths, curated by Kate McFarlane,
Castello di Rivara, Turin.
1990 *Modern Medicine*, Building One, London.

PUBLICATIONS
1988 *Freeze*, London. Text by Ian Jeffrey.
1989 *The New Contemporaries*, London: ICA. Text by
Sasha Craddock.
Home Truths, Turin: Castello de Rivara. Text by
Kate Bush.
1990 *Modern Medicine*, London: Building One.

REVIEWS
1988 Sascha Craddock, '*Freeze*, The Fast Docklands
Train to Simplicity', *The Guardian*, September
13.
1989 Angela Bulloch, '*Freeze*', *Art & Design
Magazine*, vol. V, no. 3-4, September.
1990 James Stock, '*Modern Medicine*', *The Times*,
March 27.
James Hall, '*Modern Medicine*', *Sunday
Correspondent*, April 22.
Mark Currah, '*Modern Medicine*', *City Limits*,
April 25.

Sarah Kent, '*Modern Medicine*', *Time Out*, April
25.
Andrew Renton, '*Modern Medicine*', *Blitz*, June.
Andrew Renton, '*Modern Medicine*', *Flash Art*,
no. 153.
'*Modern Medicine*', *Artscribe*, Summer, no. 82.

LANGLANDS & BELL

Ben Langlands
Born 1955, London.
Nikki Bell
Born 1959, London.

EDUCATION
1977-80 Middlesex Polytechnic, (B.A. Hons.)

ONE-PERSON EXHIBITIONS
1986 *Traces of Living*, Interim Art, London.
1987-88 *White November*, AIR Galleries, London.
1989 Luis Campana Galerie, Frankfurt.
1990 *Surrounding Time*, Fondation pour l'architecture,
Brussels.
Luis Campana Galerie, Frankfurt.
1991 Interim Art, London.
Valentina Moncada, Rome.

GROUP EXHIBITIONS
1978 *Red Ashes*, University of Reading.
1980 Sainsbury Centre for the Visual Arts, Norwich.
1984 *Inter-course*, Hayward Gallery, London.
1986 *Borough Market*, film for Siteworks,
Bookworks, London.
Artists' Books, Nexus, Philadelphia.
1987 Bookworks, London.
Center for Book Arts, New York.
University of Toledo.
Palaces of Culture, The Great Museum, City
Museum and Art Gallery, Stoke-on-Trent.
1988 *Twenty Years of British Art from the Sackner
Archive*, Bass Museum of Art, Miami.
*That Which Appears is Good, That Which is
Good Appears*, Tanja Grunert, Cologne.
1989 Ralph Wernicke, Stuttgart.
Perspektivismus, Galerie Bleich-Rossi, Graz.
Le Magasin, L'Ecole, L'Exposition, Le Magasin,
Grenoble.
1990 Galleri Nordanstad-Skarsted, Stockholm.
Massimo Audiello Gallery, New York.
Ralph Wernicke, Stuttgart.
Interim Art, London.
1991 Kunstverein, Weil am Rhein, Germany.

PUBLICATIONS

1987 Palaces of Culture, Stoke-on-Trent: City Museum
 and Art Gallery. Text by Emma Dexter.
 Langlands & Bell, White November, AIR
 Gallery.

1989 Langlands & Bell, London and Frankfurt: Interim
 Art and Luis Campana.
 Le Magasin, L'Ecole, L'Exposition. Grenoble : Le
 Magasin. Text by Louis Neri.

Reviews

1980 Bette Spektorov, 'New Art and New Patronage',
 The Times, November 1.

1981 Alex MacGregor, 'Bookworks at South Hill
 Park', Artscribe, no. 29.

1984 Amanda Sebestyen, 'The Ruined Book', City
 Limits, August 3.
 Cathy Courtney, 'The Ruined Book',
 Performance, September-October.

1985 Lloyd Grossman, 'Literarty', The Sunday Times,
 July 25.

1986 Monica Petzel, 'Traces of Living', Time Out, July
 16.
 Mark Currah, 'Traces of Living', City Limits, July
 17.
 Cathy Courtney, 'Traces of Living', Crafts
 Magazine, July-August.
 Cathy Courtney, 'Artists'Books: A Developing
 Genre', Art Monthly, December-January.

1987 Pamela Petro, 'Bookworks London in New
 York', American Book Collector, Summer Issue.
 Andrew Graham-Dixon, 'A Museum of Mirrors',
 The Independent, September 25.
 Peter Gwyn, 'White November', Arts Review,
 December.
 Tom Baker, 'Back to the Furniture', The Face,
 December.
 Sarah Kent, 'Langlands & Bell at AIR', Time Out,
 December 30.
 Mark Currah, 'White November', City Limits,
 December 30.

1988 Langlands & Bell, 'White November', AND
 Journal of Art, no. 13, January.
 Michael Archer, 'Palaces of Culture', Artscribe,
 March-April.
 Cathy Courtney, 'Use & Ornament', Crafts
 Magazine, March-April.
 Cathy Courtney, 'The British Museum', Art
 Monthly, December-January.

1989 Cathy Courtney, 'Langlands & Bell', Art Monthly,
 June.
 Mathias Ricker, Auftritt, June.
 Mathias Ricker, 'Banalität ohne Substanzverlust',
 Main Echo, no. 20, June.
 Cynthia Rose, 'Off the Wall', American Way,
 Summer.
 Reinhard Hauff, 'Langlands & Bell at Luis
 Campana', Flash Art, October.
 Helmut Draxler, 'Perspektivismus', Noema,
 October.
 Sabine Vogel, 'Langlands & Bell at Luis
 Campana', Artforum, September.
 Peter Dittmar, 'Kunstmarkt', Die Welt, November
 18.
 Andrew Renton, 'Langlands & Bell', Flash Art,
 March-April.
 Michael Archer, 'Satellite', Artscribe, January.
 Christoph Blase, 'Der Tod flog mit',
 Kunstbulletin, January 15.
 Adrian Dannatt, 'Eastside Story', Flash Art,
 January-February.
 Beatrice von Bismarck, 'Spuren des Lebens',
 Dokument + Analyse, January.
 Deborah Drier, 'Cologne Redux', Art and
 Auction, February.
 Christoph Blase, 'Rettung im Wirrwar de grossen
 Stadt', Frankfurter Allegmeine, March 26.
 Adrian Dannatt, 'What Price When Buying Art?',
 The Times, March 27.
 Paolo Bianci, Künstlerpaare, Kunstforum,
 March-April.
 Adrian Dannatt, 'Artwork Partwork', Building
 Design, May 18.
 Jacques Soulillou, 'Ben Langlands & Nikki Bell',
 Fondation pour l'architecture', Art Press, no.
 148, June.
 Fiona Dunlop, 'Contemporary Visions of Utopia',
 Art International, October.

SIMON LINKE

Born 1958, Benalla, Australia.

EDUCATION

1977-81 St Martins School of Art, B.A. (Hons.)
1983 Royal College of Art.
1985-86 Goldsmiths' College, University of London, M.A.

ONE-PERSON EXHIBITIONS

1986 Gray Art Gallery, New York.
1987 Galerie 't Venster, Rotterdam.
 Lisson Gallery, London.
 Tony Shafrazi Gallery, New York.
1988 Stichting De Appel, Amsterdam.
1989 Kohji Ogura Gallery, Nagoya, Japan.
1990 Lisson Gallery, London.

GROUP EXHIBITIONS

1982 A Critics Choice: Adrian Searle, Atlantis Gallery,

London.

1983 *Tolly Cobbold*, Fitzwilliam Museum, Cambridge.

1986 *Critics Space III*, AIR Gallery, London.
Prospect '86, Frankfurter Kunstverein, Frankfurt.
Artfor(u)m, Gracie Mansion Gallery, New York.
Il Cangiante, Padiglione d'Arte Contemporanea,
Milan.

1987 *Terrae Motus*, Grand Palais, Paris.
Der Reine Alltag, Galerie Christopher Durr,
Munich.
Room Enough, Suermond-Ludwig Museum,
Aachen.

1988 *Cultural Geometry*, Deste Foundation for
Contemporary Art, Athens.
Something Solid, Cornerhouse, Manchester.
Aperto, XLIII, Biennale de Venezia, Venice.
Complexity and Contradictions, Scott Hansen
Gallery, New York.

1989 *Words*, Tony Shafrazi Gallery, New York.
*A perspective on Contemporary art - Colour
and/or Monochrome*, The National Museum of
Modern Art, Tokyo; The National Museum of
Modern Art, Kyoto.

1990 *Real Allegories*, Lisson Gallery, London.
Ad Perpetuam Memoriam, capc Musée d'art
contemporain de Bordeaux, Bordeaux.

PUBLICATIONS

1986 *Critics' Space III*, London: Air Gallery. Text by
Fenella Crichton.
Il Cangiante, Milan: Padiglione d'Arte
Contemporanea.
*Prospect '86: Eine internationale Austellung
aktueller Kunst*, Frankfurst: Frankfurter
Kunstverein.

1987 *Simon Linke*, London: Lisson Gallery. Text by
Jeffrey Deitch.
Der Reine Alltag, Munich: Galerie Christopher
Durr. Text by Rainer Metzger.
Room Enough, Aachen: Seurmondt-Ludwig
Museum. Text by Renate Puvogel.
Terrae Motus, Naples: Fondazione Amelio,
Istituto per l'Arte Contemporanea.
Cultural Geometry, Athens: Deste Foundation for
Contemporary Art. Text by Jeffrey Deitch and
Peter Halley.
Something Solid, Manchester: Cornerhouse. Text
by Marjorie Allthorpe-Guyton.
XLIII Biennale di Venezia, Venice: Fabri Editori.
Text by Dan Cameron.

1989 *Simon Linke*, Nagoya: Kohji Ogura Gallery (in
co-operation with Lisson gallery). Text by James
Roberts.
Synnyt: Sources of Contemporary Art, Helsinki:
Museum of Contemporary Art.
A Perspective on Contemporary Art - Colour

and/or Monochrome, Tokyo: The National
Museum of Modern Art.

1990 *Surrogaat/Surrogate: 15 Years of Galerie 't
Venster from Kiefer to Koons*, Amstelveen: SDU
Uitgeverij. Jan Donia (ed.).
Ad Perpetuam Memoriam, Bordeaux: capc
Musée d'art contemporain de Bordeaux.

REVIEWS

1986 John Spurling, 'Critics' Space III ', *The New
Statesman*, February 14.
Michael Shepherd, 'Critics' Space III ', *The
Sunday Telegraph*, February 16.
Sarah Kent, 'Critics' Space III ', *Time Out*,
February 13-19.
Stuart Morgan, 'Critics' Space III ', *Artscribe*, no.
57.

1987 'Intense woede', *Het Vrije Volk*, February.
Lynne Cooke, 'Interview with Simon Linke and
Julian Opie', *Flash Art*, no. 133, April.
Wim Van Sideren, 'Warhol Voorbij: Jeff Koons,
Ken Lum & Simon Linke', *Vinyl Magazine*, April.
Kim Levin, 'Simon Linke: Tony Shafrazi Gallery',
Village Voice, June 9.
Stuart Morgan, 'The Twighlight Zone', *Artscribe*,
no. 64, July.
David Batchelor, 'Simon Linke: Lisson', *Artscribe
International*, no. 64, July.
'Simon Linke at Tony Shafrazi, New York and
Lisson Gallery, London', *Artscribe*, September.

1990 Andrew Renton, 'Simon Linke', *Flash Art*, May-
June.
John Cornall, *City Limits*, March 8.
Sarah Kent, 'On Simon Linke', *Time Out*, March
14.
Andrew Renton, *Blitz*, April.
Andrew Graham-Dixon, 'Join the Professionals',
The Independent, February 27.

SARAH LUCAS

Born 1962, London.

EDUCATION

1983-84 London College of Printing.

1984-87 Goldsmiths' College, University of London, B.A.
(Hons.)

GROUP EXHIBITIONS

1986 The Showroom, London.

1988 *Freeze*, PLA Building, London.

1990 *East Country Yard*, Surrey Docks, London.

PUBLICATIONS

1988 *Freeze,* London. Text by Ian Jeffrey.
1990 *East Country Yard,* London.

REVIEWS

1990 James Hall, *The Sunday Correspondent,*
 June 17.
 John Cornall, 'East Country Yard Show':
 City Limits, June 28.
 Andrew Graham-Dixon, 'The Midas
 Touch': *The Independent,* July 31.
 Liz Brooks, 'East Country Yard Show',
 Artscribe, no. 83, September-October.
 Tony White, 'East Country Yard Show',
 Performance, September.
 Tony White, 'East Country Yard Show',
 Artists Newsletter, October.
 Andrew Renton 'Disfiguring: Certain New
 Photographers and Uncertain Images', *Creative
 Camera 306,* October-November.
 Ian Jeffrey, 'The New New, a response', *Creative
 Camera 308,* February-March.

LISA MILROY

Born 1959, Vancouver.

EDUCATION

1976 Banff School of Fine Art.
1977-78 L'Université de la Sorbonne, Paris.
1978-79 St Martins School of Art, London.
1979-82 Goldsmiths' College, University of London, B.A.
 (Hons.)

ONE-PERSON EXHIBITIONS

1984 Nicola Jacobs Gallery, London.
 Cartier Foundation, Paris.
1986 Nicola Jacobs Gallery, London.
 Khiva Gallery, San Francisco.
1988 Nicola Jacobs Gallery, London.
1989 John Berggruen Gallery, San Francisco
 Third Eye Centre, Glasgow; Southampton City
 Art Gallery, Southampton; Plymouth Art Gallery,
 Plymouth.
 Mary Boone Gallery, New York.
1990 Kunsthalle, Bern.
1991 Nicola Jacobs Gallery, London.

GROUP EXHIBITIONS

1983 Charterhouse Gallery, London.
 Young Blood, Riverside Studios, London.
1984 *Problems of Picturing,* Serpentine Gallery,
 London.
1985 *John Moores Liverpool Exhibition 14,* Walker Art
 Gallery, Liverpool.
1986 *Sixth Sydney Biennale.*
 Aperto, XIII Venice Biennale.
 Japonisme, Northern Centre for Contemporary
 Art, Sunderland.
 Au coeur du maelstrom, Palais des Beaux Arts,
 Brussels.
 Objects as Art, Plymouth Arts Centre, Plymouth.
 No Place Like Home, Cornerhouse, Manchester.
1987 *Winter 87,* Nicola Jacobs Gallery, London.
 John Moores Liverpool Exhibition 15, Walker Art
 Gallery, Liverpool.
 *Current Affairs: British Painting and Sculpture in
 the 1980's,* Museum of Modern Art, Oxford.
 *British Art of the 1980s: Sweden and Finland
 1987,* Liljevalchs Konsthall, Stockholm and Sara
 Hilden Museum Tampere.
 *Cries and Whispers: Paintings of the 1980s from
 the British Council Collection,* Touring Australia
 and New Zealand.
 Three Artists from Britain, Jack Shainman
 Gallery, Washington D.C. and New York.
1988 *Winter 88,* Nicola Jacobs Gallery, London.
 New British Painting, Contemporary Art Centre,
 Cincinatti.
1989 *Art of the 80s,* from the collection of Chemical
 Bank, The Montclair Art Museum, Montclair,
 New Jersey.
 Lisa Milroy, Tony Cragg and John Murphy, from
 the Saatchi Collection, Pierides Museum of
 Contemporary Art, Athens.
 Subject/Object, Nicola Jacobs Gallery, London.
 John Moores Liverpool Exhibition 16, Walker Art
 Gallery, Liverpool, (first prize winner).
 Ten Years at Nicola Jacobs, Nicola Jacobs
 Gallery, London.
1990 *The British Art Show 1990,* McLellan Galleries,
 Glasgow; Leeds City Art Gallery; Hayward
 Gallery, London.
 Brtish Art Now, Japan.
1991 *Winter 91,* Nicola Jacobs Gallery, London.

PUBLICATIONS

1987 *Art Brittiskt 1980-Tal,* Stockholm: British Council.
 Text by Lynne Cooke.
 *Current Affairs - Brtish Painting and Sculpture in
 the 1980s,* Oxford: Museum of Modern Art and
 British Council. Text by Lewis Biggs.
1989 *British Figurative Painters of the 1980s I,* Tokyo:
 Art Random, Kyoto Shoin International Co. Ltd.

Text by Marco Livingstone.
New British Art at the Saatchi Collection,
London: Thames & Hudson. Text by Alistair
Hicks.
1990 *The British Art Show 1990,* London: South Bank
Centre.
British Art Now: A Subjective View, Tokyo:
Text by Andrew Graham-Dixon.
Models of an Elusive World, Bern: Kunsthalle
Bern. Text by Ulrich Loock.
Pop Art: A Continuing History, London: Thames
& Hudson. Text by Marco Livingstone.

REVIEWS

1983 Brian Hatton, 'Young Blood', *Artscribe,* no. 41,
April.
Marina Vaizey, 'To See is to Believe',
The Sunday Times, April 1.
1984 Waldemar Januszczak, 'Lisa Milroy', *The
Guardian,* March 28.
Michael Newman, 'Lisa Milroy', *City Limits,*
March 28.
Waldemar Januszczak, 'Lisa Milroy', *The
Guardian,* March 31.
Marina Vaizey, 'Playing Serious Games',
The Sunday Times, April 24.
Sarah Kent, 'Lisa Milroy', *Time Out,* April 12.
Sarah Kent, 'Art's New Avant Garde', *Time Out,*
August 30.
John Russell-Taylor, 'Problems of Picturing', *The
Times,* September.
William Feaver, 'Problems of Picturing', *The
Observer,* September 23.
Sarah Kent, 'Fabrications Not Lies', *Artscribe,*
September-October.
Stuart Morgan, 'Lisa Milroy', *Artforum,*
December.
1985 Sarah Kent, 'Critical Images', *Flash Art,* March.
1986 Sarah Kent, 'Lisa Milroy', *Time Out,* March 12.
William Feaver, 'Fish, Phalluses & Marriage',
The Observer, March 16.
Waldemar Januszczak, 'A Tap on the
Barometer', *The Guardian,* March 19.
Mark Currah, 'Lisa Milroy', *City Limits,* March
27.
Jutta Koether, 'Pure Invention', *Flash Art,* April.
Sarah Kent, 'Lisa Milroy', *Time Out,* April 2.
Richard Shone, 'Lisa Milroy', *Burlington
Magazine,* May.
Caroline Collier, 'Lisa Milroy', *Flash Art,* May-
June.
Ian Jeffrey, 'Noises of the World', *London
Magazine,* June.
Lynne Cooke, 'Taking the Side of Things',
Artscribe, June-July.

Michael Brenson, 'In Venice the Biennale Sinks
into a Sea of Ambiguity', *The New York Times,*
July 13.
1987 Sarah Kent, 'Lisa Milroy', *Time Out,* January 20.
Andrew Graham-Dixon, 'Painters for the
Eighties', *The Independent,* July 1.
Paul Richard, '3 Artists at Shainman', *The
Washington Post,* November 21.
1988 J.W. Mahoney, 'Lisa Milroy at Jack Shainman
Gallery', *New Art Examiner,* February.
Andrew Graham-Dixon, 'On the Edge', *The
Independent,* April 5.
Andrew Graham-Dixon, 'Lisa Milroy', *Vogue,*
June.
Andrew Graham-Dixon, 'Friendly Fixtures', *The
Independent,* June 7.
John Russell-Taylor, 'Lisa Milroy', *The Times,*
June 14.
Richard Dorment, 'A New Light on Still Lives',
The Daily Telegraph, June 15.
Richard Shone, 'Lisa Milroy', *Burlington
Magazine,* July.
John Roberts, 'Lisa Milroy', *Artscribe,*
September.
1989 David Lee, 'Travelling in Thought', *The Times,*
October 20.
William Feaver, 'Character Cats and
Shepherd's-pie Skies', *The Observer,* October
22.
Lynne Cooke, 'Special Report: British Art in the
Eighties', *The Journal of Art,* November,
'Lisa Milroy', *The New York Times,* December 1.
1990 Edward Lucie-Smith, 'A British Art Show',
Modern Painters, January.
John Russell-Taylor, 'Taking a Narrow View',
The Times, January 26.
Waldemar Januszczak, 'Crossing Fingers for the
Future', *Sunday Correspondent,* January 28.
Tom Lubbock, '*The British Art Show 1990*', *The
Independent on Sunday,* January 28.
Andrew Graham-Dixon, 'Pupils of the Cool
School', *The Independent,* January 30.
Tim Hilton, 'Home Groan', *The Guardian,*
January 31.
David Batchelor, 'Show Business', *New
Statesman,* February 2.
Kate Bush, '*The British Art Show 1990*',
Artscribe, May.
Andrew Renton, 'Birth of the Cool', *Blitz,* June.
Bruce Bernard, 'The Young Pretenders',
Independent on Sunday, June 2.
Matthew Collings, 'A Catalogue of Apology',
City Limits, June 7 - 14.
Sarah Kent, 'Art', *20-20,* June.
Richard Cork, 'Woolly or Wily?', *The Listener,*
July 5.

JULIAN OPIE

Born 1958, London.

EDUCATION
1979-82 Goldsmiths' College, University of London, B.A. (Hons.)

ONE-PERSON EXHIBITIONS
1983 Lisson Gallery, London.
1984-85 Kölnischer Kunstverein, Cologne; Groninger Museum, Groningen.
1985 Lisson Gallery, London.
 Sculptures, Institute of Contemporary Arts, London.
1986 Franco Toselli Gallery, Milan.
1988 Lisson Gallery, London.
 Galeria Montenegro, Madrid.
 Skulpturen, Paul Maenz, Cologne.
1990-91 Lisson Gallery, London.

GROUP EXHIBITIONS
1982 Lisson Gallery, London.
 Sculpture for a Garden, Gunnersbury Park, London.
1983 Charter House Square, London.
 Young Blood, Riverside Studios, London.
 The Sculpture Show, Hayward and Serpentine Galleries, London.
 8 Sculptors' Drawings, Air Gallery, London.
 Making Sculpture, Tate Gallery, London.
1984 *Artists for the 1990s - 10 Galeries, 10 Artists*, Paton Gallery, London.
 Underwater, Plymouth Arts Centre, Plymouth.
 Sculpture Symposium 1984, St Jean-Port, Quebec.
 William Morris Today, Institute of Contemporary Arts, London.
 Perspective '84, Internationale Kunstmesse, Basel.
1984-85 *Julian Opie and Lisa Milroy*, Fondation Cartier pour l'art contemporarin, Jouy-en-Josas, France.
 Metaphor and/or Symbol: a Perspective on Contemporary Art, The National Museum of Modern Art, Osaka.
1985 *The British Show*, Art Gallery of Western Australia, Perth; Art Gallery of New South Wales, Sydney; Queensland Art Gallery, Brisbane; The Exhibition Hall, Melbourne; National Art Gallery, Wellington.
 XIIIième Biennale de Paris, Grande Halle de la Villette, Paris.
 Still Life: A New Life, Harris Museum and Art Gallery, Preston; Bradford Art Galleries and Museum, Bradford; Hatton Gallery, Newcastle-on-Tyne; Carlisle Museum and Art Gallery,

Carlisle; City Museum and Art Gallery, Stoke-on-Trent.
 Anniottanta, Cultura del Commune de Ravenna, Ravenna; Bologna, Imola, Romagna.
 Three British Sculptors: Richard Deacon, Julian Opie and Richard Wentworth, The Israel Museum, Jerusalem.
 Place Saint Lambert Investigations, Espace Nord, Liège.
 Figure 1, Aberystwyth Arts Centre, Aberystwyth.
 Sculpture in a Garden, Bluecoat Gallery, Liverpool.
1986 *Forty Years of Modern Art 1945-1985*, Tate Gallery, London.
 Skulptur - 9 Kunstnere fra Storbrittanien, Louisiana Museum of Modern Art, Humlebaek.
 XVII Triennale de Milano, Milan.
 De Sculptura - Eine Ausstellung der Wiener Festwochen 1986, Wiener Festwochen im Messepalast, Vienna.
 Englische Bildhauer, Galerie Harald Behm, Hamburg.
 Prospect '86, Frankfurter Kunstverein, Frankfurt.
 Correspondentie Europa, Stedelijk Museum, Amsterdam.
1987 *Terrae Motus*, Grand Palais, Paris.
1986-90 *Focus on the Image: Selection from the Rivendell Collection*, (organised by the Art Museum Association of America), Phoenix Art Museum, Phoenix Arizona; Museum of Art, University of Oklahoma; Munson-Williams-Proctor Institute Museum of Art, Utica, New York; University of South Florida Art Galleries, Tampa; Lakeview Museum of Art and Sciences, Illinois; University Art Museum, California State University, Long Beach; Laguna Gloria Art Museum, Austin, Texas.
1987 *British Art of the 1980s*, Liljevalchs Konsthall, Stockholm; Sara Hilden Museum, Tampere.
 Casting an Eye, Cornerhouse, Manchester.
 Untitled, Hal Bromm Gallery, New York.
1988 *Europa Oggi- Europe Now*, Museo d'Arte Contemporanea, Prato.
 Les Années 80: à la surface de la pienture, Centre d'art contemporain, Abbaye St-André, Meymac.
 Wolff Gallery, New York.
1988-89 *Britanica: 30 ans de sculpture*, Musée des Beaux Arts, André Malraux, Le Havre; Musé d'Evreux, Evreux; École d'Architecture de Normondie, Rouen.
 British Sculpture 1960 to 1988, Museum van Hedendaagse Kunst, Antwerp.
1989 *Grenville Davey, Michael Craig-Martin, Julian Opie*, Lia Rumma Gallery, Naples.

Mediated Knot, Robbin Lockett Gallery, Chicago.
Object/Objectif, Galerie Daniel Templon, Paris.
Skulptur Teil II, Galerie Six Friedrich, Munich.
D+S Austellung, Hamburg Kunstverein, Hamburg.

1990 *OBJECTives: The New Sculpture*, Newport Harbor Art Museum, Newport Beach, California.
The British Art Show 1990, McLellan Galleries, Glasgow; Leeds City Art Gallery; Hayward Gallery, London.
Biennale of Sidney, Sidney.
Studies on Paper: Contemporary British Sculptors, Connaught Brown, London.
Bild und Wirklichkeit, Galerie Albrecht, Munich.
Sculpture, Margo Leavin Gallery, Los Angeles.
Real Allegories, Lisson Gallery, London.
Work in Progress: International Art in the Caja des Pensiones Foundation Collection, Caja des Pensiones Foundation, Madrid.

PUBLICATIONS

1983 *Making Sculpture*, London: Tate Gallery.
The Sculpture Show, London: The Arts Council of Great Britain. Text by Fenella Crichton.
Beelden 83, Rotterdam: Rotterdam Arts Council. Text by Paul Hefting.

1984 *Julian Opie*, Cologne: Kölnischer Kunstverein. Texts by Wulf Herzogenrath and Kenneth Baker.
Metaphor and/or Symbol: A Perspective on Contemporary Art, Tokyo: The National Museum of Modern Art. Text by Masanoi Ichikawa.

1985 *Julian Opie*, London: Lisson Gallery. Texts by Michael Craig-Martin and Art and Language.
Drawings 1982 to 1985, London: Institute of Contemporary Arts.
The British Show, Sydney: Art Gallery of New South Wales. Text by Michael Newman.
XIII ième Biennale de Paris, Paris: Biennale de Paris.
Still Life: A New Life, Preston: Harris Museum and Art Gallery.
Anniottanta, Ravenna: Cultura del Comune de Ravenna.
Three British Sculptors: Richard Deacon, Julian Opie and Richard Wentworth, Jerusalem: The Israel Museum.

1986 *XVII Triennale di Milano*, Milan. Text by Georges Teyssot.
De Sculptura-Eine Ausstelung der Wiener Festwochen 1986, Vienna: Wiener Festwochen. Text by Harald Szeemann.
Correspondentie Europa, Amsterdam: Stedelijk Museum.
Forty Years of Modern Art 1945-1985, London: Tate Gallery.
Skulptur-9 Kunstnere fra Storbrittanien,

Humlebaek, Denmark: Louisiana Museum of Modern Art.
Prospect 86: Eine Internationale Ausstelung Actueller Kunst, Frankfurt: Frankfurter Kunstverein.
Focus on the Image: Selection from the Rivendell Collection, The Art Museum Association of America.

1987 *British Art of the 1980s*, London: The British Council.
Terrae Motus, Naples: Fondazione Amelio, Instituto per l'Arte Contemporanea.

1988 *Europa Oggi/Europe Now*, Prato: Museo d'Arte Contemporanea. Text by Michael Newman.
Julian Opie, London: Lisson Gallery. Text by Michael Newman.
Les années 80: à la surface de la peinture, Meymac: Centre d'art contemporain, Abbaye St-André. Texts by Bernard Lamarche-Vadel and Gérard-Georges Lemaire.
Britannica: 30 ans de sculpture, Le Havre: Musée de Beaux Arts André Malraux. Texts by Catherine Grenier, Françoise Cohen and Lynne Cooke.

1989 *British Object Sculptors of the '80s II*, Kyoto: ArT Random. Marco Livingstone (ed.).
Mediated Knot, Chicago: Robbin Lockett Gallery. Text by Kathryn Hixson.
Object/Objectif, Paris: Galerie Daniel Templon. Texts by David Moos and Rainer Crone.
D+S Austellung, Hamburg Kunstverein, Hamburg.

1990 *The British Art Show 1990*, London: The South Bank Centre.
OBJECTives: The New Sculpture, Newport Beach: Newport Harbor Art Museum. Text by Kenneth Baker.
Biennale of Sydney, Sydney.
Work in Progress. International Art in the Caja de Pensiones Foundation, Madrid: Caja de Pensiones Foundation.

REVIEWS

1983 Marina Vaizey, 'Playing serious games', *The Sunday Times*, April 24.
John Russell Taylor, 'Young blood', *The Times*, April 26.
Mary Rose Beaumont, '*The Sculpture Show*', *Arts Review*, September.
Alistair Hicks, 'Talent under production', *Mercury*, September.
William Feaver, 'Mr Futile's Progress', *The Observer*, October 2.
Jutta Koether, 'Julian Opie. Die Sympathische Plastik', *Spex*, no. 12, December.
Michael Newman, 'The bankable sculpture of

Julian Opie, *The Face*, March.

Sandra Miller, *Art Press*, no. 75, November.

Waldemar Januszczak, 'Three into two won't go', *The Guardian*, August 16.

William Feaver, 'From Camel to Camey', *The Observer*, London, August 21.

Fiona Byrne-Sutton, 'Riverside Studios, *Young Blood*', *Art Line*, no. 7, June.

1984 Michael Newman, 'La Double Ironie de Julian Opie', *Art Press*, February.

Annelie Pohlen, 'Julian Opie und Tony Cragg', *Kunstforum*, no. 75, September-October.

Ruud Schenk, 'Opie Verliefd', *Metropolis M*, no. 5.

'Skulptur aus England', *Vorwärts*, no. 8.

1985 Mona Thomas, 'Intimes gentillesses du homme Julian Opie', *Beaux Arts Magazine*, no. 24, May.

Sarah Kent, *Time Out*, April 18-24.

William Packer, *Financial Times*, April 16.

Richard Cork, 'In a Hurry', *The Listener*, May 2.

Richard Shone, 'London Exhibititions', *Burlington Magazine*, May.

Christopher Andreae, 'Having a Fling with History', *Christian Science Monitor*, June 29 - July 5.

Meir Ronnen, 'Life as a Pun', *Jerusalem Post Magazine*, August 16.

'Design for London Living', *Avenue*, November.

John Russell Taylor, 'A masterly turn to the south', *The Times*, April 30.

Waldemar Januszczak, 'The wage of affluence', *The Guardian*, April 30.

1986 Kenneth Baker, 'Julian Opie', *Louisiana Revy*, March.

Alistair Hicks, 'A rediscovery of power out of obscurity', *The Times*, November.

Larry Berryman, 'Julian Opie: Lisson Gallery', *Arts Review*, December 5.

'Sheets of Steel', *The Sunday Telegraph*, November 9.

1987 Lynne Cooke, *Flash Art*, February.

Lynne Cooke, 'Interview Julian Opie and Simon Linke', *Flash Art*, April.

Kenneth Baker, 'Julian Opie: Humorous, Cerebral Sculpture', *San Francisco Chronicle*, June 13.

Simon Watney, 'Julian Opie: Lisson', *Artscribe*, March.

Diane B. Paul, 'The Nine Lives of Discredited Data', *The Sciences*, May-June.

David Lovely, 'Cast an Eye: Cornerhouse', *Artscribe*, May.

Marina Vaizey, 'Life Studies', *Burlington Magazine*, January.

Stuart Morgan, 'Julian Opie: Lisson Gallery',

Artforum, February.

1988 Andrew Graham-Dixon, 'Pretty Vacant', *The Independent*, March 8.

Marina Vaizey, 'Nurturing talent in a narrow frame', *The Sunday Times*, March 13.

Tom Baker, 'House of Fun', *The Face*, April.

'Exhibition Reviews', *Burlington Magazine*, April.

Lynne Cooke, 'Identify the Object', *Art International*, Summer.

Kazu Kaido, *Bijutso Techo*, vol. 40, no. 594, May.

Fernando Huici, 'Poética de la indeterminión', *El Pais*, November 5.

'Del caos al vacio del orden', *Guia del Ocio*, October 17-23.

Jose Ramon Danvila, 'Julian Opie: el vacio atrapado', *El punto*, October 21-27.

'Crónicas de exposiciones', *Lapiz*, no. 53.

1990 Liam Gillick, 'Critcal Dementia: The British Art Show', *Art Monthly*, no. 134, March.

Andrew Renton, 'Birth of the Cool', *Blitz*, June.

1991 Andrew Renton, 'Julian Opie: Lisson', *Flash Art*, no. 157, March-April.

SIMON PATTERSON

Born 1967, Leatherhead, Surrey.

EDUCATION
1985-86 Hertfordshire College of Art & Design.

1986-89 Goldsmiths' College, University of London, B.A. (Hons.)

ONE PERSON EXHIBITIONS
1989 Third Eye Centre, Glasgow.

GROUP EXHIBITIONS
1987 Institute of Education, University of London.

1988 *Freeze Parts I and III*, PLA Building, London.

1989 *1789-1989 - Ideas and Images of Revolution*, Kettle's Yard Gallery, Cambridge.

Trumpton City Art Gallery. Trumpton.

1990 *Milch Part II*, Milch, London.

Group Show, Milch, London.

PUBLICATIONS
1988 *Freeze*, London. Text by Ian Jeffrey.

1989 *1789-1989 - Ideas and Images of Revolution*, Cambridge: Kettle's Yard.

Republicans, Third Eye and Arefin Inc.: Glasgow and London.

REVIEWS

1989 Andrew Renton, *Blitz*, April.
 Angela Bulloch, *Art & Design*, vol. 5, nos. 3-4,
 September.
 C. Minton, 'Vas ist Kunst', *Das Bömhole*, May.
1990 Andrew Renton, *Blitz*, July.
 Adrian Doughnut, *Flash Art Italia*,
 April-May.
 Reinhardt Kreig, 'Kunst ist ein Kunst?', *Das
 Bömholz*, June.
 Ariadne Dorrit, *Flash Art*, March-April.
1991 Stuart Morgan, 'Milch is good for you',
 Artscribe, January-February.

PERRY ROBERTS

Born 1954, Newcastle upon Tyne.

EDUCATION

1973-74 Newcastle upon Tyne College of Art.
1974-77 Bristol Polytechnic, B.A.
1987-89 Goldsmiths' College, University of London, M.A.
1990 Artist in Residence, Rijksakademie, Amsterdam.

SOLO EXHIBITIONS

1989 Goldsmiths' project space, London.
 Laure Genillard Gallery, London.
1991 Laure Genillard Gallery, London.

GROUP EXHIBITIONS

1975 Royal West of England Academy, Bristol.
1978 *British Contemporary Drawing*, Marlborough.
1987 Royal Academy, London.
1981 London Group, Waterloo Gallery, London.
1982 *Works on Paper*, Aspex Gallery, Portsmouth.
1983 Open Exhibition, Whitechapel Gallery, London.
1984 London Group, 100 Artists, Showroom Gallery,
 London.
1986-87 *Beyond Appearance*, Hampshire County
 Museum Service Touring Exhibition.
1988 *Homage to the Square*, Flaxman Gallery,
 London.
1989 *Six British Artists*, Rijksakademie, Amsterdam.
 Minimal Means, Showroom Gallery, London;
 John Hansard Gallery, Southampton.
 Summer Exhibition, Laure Genillard Gallery,
 London.
1990 *Drawings*, Laure Genillard Gallery, London.
 Reihung 2, Vera Munro Gallery, Hamburg.
 Museum Dhondt-Dhaenens, Deurle, Belgium.
1991 Third Eye Centre, Glasgow.
 Chisenhale Gallery, London.

PUBLICATIONS

1989 *Perry Roberts*. London: Laure Genillard Gallery.
1990 Ghent: Museum Dhondt-Dhaenens.
 Over Schilderen/On Painting (Blank Page No 3),
 Amsterdam: Rijksacademie Publications.
1991 *Perry Roberts, Craig Wood,* Glasgow, London:
 Third Eye Centre/Chisenhale Gallery. Text by
 James Roberts.

REVIEWS

1989 William Jeffett, *'Perry Roberts'*, *Artefactum,* no.
 30, March.
 Sarah Kent, *'Fresh Paint'*, *Time Out*, no. 989.
 Marjorie Allthorpe-Guyton, 'Perry Roberts: Laure
 Genillard' *Flash Art*, no. 147, summer.
 Kate Bush, 'Perry Roberts: Laure Genillard',
 Artscribe, no. 77, September-October.
 Jonathan Watkins, *Art International* 8, March.
 Andrew Cross, *Arts Review*, December 1989.

TESSA ROBINS

Born 1965, Chelmsford.

EDUCATION

1985-88 Middlesex Polytechnic B.A. (Hons.)

ONE-PERSON EXHIBITIONS

1989 Laure Genillard Gallery, London.
1990 Wilma Tolksdorf Galerie, Hamburg.
1991 Modulo, Lisbon.

GROUP EXHIBITIONS

1990 Summer Show, Laure Genillard Gallery, London.
1991 Graeme Murray Gallery, Edinburgh.
 Group Show, Victoria Miro Gallery, London.

PUBLICATIONS

1989 Laure Genillard Gallery, London.

REVIEWS

1989 Mark Currah, 'Tessa Robins', *City Limits*,
 November 23.
 Michael Archer, 'Tessa Robins', *Art Monthly*,
 December-January.
1990 Adrian Dannatt, 'Tessa Robins, Laure Genillard',
 Flash Art, May-June.

CAROLINE RUSSELL

Born 1962
Lives and works in London

Education:
1980-83 Ruskin School of Arts, University of Oxford, B.A.
1986-88 Goldsmiths' College, University of London, M.A.

ONE-PERSON EXHIBITIONS

1988 Anthony Reynolds Gallery, London.
1989 *Display 21*, Chisenhale Gallery, London.
1990 Laure Genillard Gallery, London.
1991 Instituto de La Juventud, Madrid.

GROUP EXHIBITIONS

1984 *New Sculpture in Oxford*, St. Paul's Art Centre,
 Oxford.
 City Sculpture, Ikon Gallery, Birmingham.
1985 *Women and Towers,* Partridge Works,
 Birmingham.
1986 Group Show, Chisenhale Gallery, London.
1988 *19&& Magasin*, Centre national d'art
 contemporain, Grenoble.
 Grey Matter, Ikon Gallery, Birmingham.
 Whitechapel Open, Whitechapel Art Gallery,
 London.
 Show and Tell, Riverside Studios, London.
1989 *Concept 88 Reality 89,* Essex University.
 Europa 92: Fields of Vision, Zenit Deposito
 d'Arte, Turin.
1990 *The British Art Show*, McLellan Galleries,
 Glasgow; Leeds City Art Gallery; Hayward
 Gallery, London.
 Galerie Conrads, Neuss.
 76 46 01 46 L'art Britannique contemporain,
 Ecole des Beaux-Arts de Grenoble.
 Swimming Underwater, Imagination Ltd,
 London.

PUBLICATIONS

1989 *Concept 88-Reality 89,* Essex University.
1990 *The British Art Show 1990,* London: Southbank
 Centre.
 Swimming Under Water, London: Imagination
 Ltd. Text by Dick Hebdidge.

REVIEWS

1988 Andrew Nuti, '*19&&*', *Artline*, vol. 4, no. 1.
 Stuart Morgan, 'Cold Comfort', *Artscribe*,
 Summer.
 Lieven Van den Abeele, '*19&&*', *Artefactum*,
 June-August.
 Sarah Kent, 'Caroline Russell', *Time Out*, June
 22-29.
1989 Sarah Kent, '*Show and Tell*', *Time Out*, January

4-11.
 Liam Gillick, '*Show and Tell*', *Art Monthly*,
 February.
 Kate Bush, '*Show and Tell*', *Flash Art*, March-
 April.
 Sarah Kent, 'Caroline Russell', *Time Out*,
 May 31-June 7.
 Liam Gillick, 'Caroline Russell', *Art Monthly*,
 June.
 Michael Archer, 'Caroline Russell', *Artforum*,
 September.
 Jonathan Watkins, 'International View', *Art
 International*, Winter.
1990 Willian Feaver, 'When is a door not a door?',
 The Observer, January 28.
 Tom Lubbock, '*The British Art Show*', *The
 Independent on Sunday*, January 28.
 Waldemar Januszczak, '*The British Art Show*',
 The Sunday Correspondent, January 28.
 Andrew Graham-Dixon, '*The British Art Show*',
 The Independent, January 30.
 Kate Bush, '*The British Art Show*', *Artscribe*,
 May.
 Andrew Renton, 'Birth of the Cool', *Blitz*, June.
 Matthew Collings, 'A Catalogue of Apology',
 City Limits, June 7-14.
 Sarah Kent, '*The British Art Show*', *Time Out*,
 June 20-27.
 Caroline Collier, '*The British Art Show*',
 Women's Art Magazine, September-October.
 Andrew Graham-Dixon, 'The Golden Years',
 Vogue, September.
 Sarah Kent, 'Caroline Russell', *Time Out*,
 January 16-23.
 Rose Jennings, 'Caroline Russell', *City Limits*,
 January 24-31.
 May Anne Francis, 'Caroline Russell', *Art
 Monthly*, February.
 Andrew Renton, 'Caroline Russell: Laure
 Genillard', *Flash Art*, March-April.

RACHEL WHITEREAD

Born 1963, London.

EDUCATION

1982-85 Brighton Polytechnic B.A.
1985-87 Slade School of Art UCL, Postgraduate Higher
 Diploma, Sculpture.

AWARDS

1989 The Elephant Trust.
1989 GLA Production Grant.

SOLO EXHIBITIONS

1988 Carlile Gallery, London.
1990 *Ghost,* Chisenhale Gallery, London.
1991 Arnolfini Gallery, Bristol.
 Karsten Schubert Ltd, London.

SELECTED GROUP EXHIBITIONS

1987 *Whitworth Young Contemporaries,* Manchester.
1988 *Riverside Open,* Riverside Studios, London.
 Slaughterhouse Gallery, London.
1989 *Concept 88 Reality 89,* University of Essex
 Gallery.
 Einleuchten: Will, Vorstel und Simul in HH,
 Hamburg.
1990 *The British Art Show 1990,* McLellan Galleries,
 Glasgow; Leeds City Art Gallery; Hayward
 Gallery, London.
 A Group Show, Karsten Schubert Ltd, London.

PUBLICATIONS

1989 *Concept 88 Reality 89,* University of Essex
 Gallery.
1990 *Einleuchten: Will, Vorstel und Simul in HH,*
 Hamburg: Christians Verlag.
 The British Art Show1990, London: Southbank
 Centre.
 Ghost, London: Chisenhale Gallery. Text by Liam
 Gillick.

REVIEWS

1990 Kate Bush, *'British Art Show', Artscribe,* May.
 Andrew Renton, 'Birth of the Cool', *Blitz*
 Magazine.
 William Feaver, *British Art Show, The Observer,*
 January.
 Liam Gillick, *'The British Art Show', Art Monthly,*
 March.
 James Hall, *'Ghost', The Sunday Correspondent,*
 June 24.
 William Feaver, *'Ghost, British Art Show', The*
 Observer, July 1.
 Andrew Graham-Dixon, *'Ghost', The*
 Independent, July 3.
 Sarah Kent, *'Ghost', Time Out,* July 11.
 Andrew Renton, 'Rachel Whiteread:
 Chisenhale', *Flash Art,* October.
 Liz Brookes, 'Rachel Whiteread at Chisenhale',
 Artscribe, November-December.
1991 Tim Hilton,'Making Room for a Ghost', *The*
 Guardian, January 9.
 Sacha Craddock, 'Critic's Choice', *The Guardian,*
 February 27.
 Patricia Bickers, 'Rachel Whiteread: Arnolfini
 and Karsten Schubert Ltd', *Art Monthly,* no. 144,
 March.
 William Feaver, 'Stiff Upper Lip', *The Observer,*

March 3.
Sarah Kent, 'Rachel Whiteread: Karsten
Schubert Ltd', *Time Out,* March 13.

GERARD WILLIAMS

Born 1959, Manchester.

EDUCATION

1977-78 Manchester Polytechnic.
1978-81 Brighton Polytechnic, B.A. (Hons.)

ONE-PERSON EXHIBITIONS

1986 Interim Art, London.
1989 Anthony d'Offay Gallery, London.
1990 Galleria Franz Paludetto, Turin.
 Interim Art, London.

GROUP EXHIBITIONS

1985 *Whitechapel Open,* Whitechapel Art Gallery,
 London.
1986 *Whitechapel Open,* Whitechapel Art Gallery,
 London.
 Despatches, O.Y.B. Gallery, London
1987 *Whitechapel Open,* Whitechapel Art Gallery,
 London.
 The Icon Show, Mario Flecha Gallery, London.
1988 *Whitechapel Open,* Whitechapel Art Gallery,
 London.
 Summer Show, Anthony d'Offay Gallery,
 London.
 Summer Show, Interim Art, London.
 That Which Appears is Good, That Which is
 Good Appears, Tanja Grunert Gallery,
 Cologne.
1989 *Home Truths,* curated by Kate MacFarlane,
 Castello di Rivara, Turin.
 Richard Wentworth, Grenville, Davey, Gerard
 Williams, Sala 1, Rome.
1989-91 *It's a Still Life,* touring exhibition, Britain.
1990 *Leche-Vitrines,* Le Festival ARS Musica, Brussels.
 T.A.C. 90, Sala Parpalló/Diputacion de
 Valencia, Valencia.
 Realismi, curated by Cecilia Casorati, Galleria
 Giorgio Perano, Turin; Ileana Toynta
 Contemporary Art Center, Athens.
 What is a Gallery?, Kettles Yard, Cambridge.
 Maureen Paley Interim Art, London.

PUBLICATIONS

1989 *It's a Still Life,* London. Text by Rodger Malbert.
 Richard Wentworth, Grenville Davey, Gerard
 Williams, Rome: Sala 1. Text by Lynne Cooke.
1990 *Home Truths,* Turin: Franz Pahidetto. Text by
 Kate Bush.

Leche-Vitrines, Brussels. Text by Michel
Assenmaecker.
What is a Gallery?, Cambridge: Kettles Yard.
Realismi, Turin and Athens. Text by Cecilia
Casorati.

REVIEWS

1986 Rita Porkorny, 'Gerard Williams, Interim Art',
 New Art In Europe, no. 14.

1988 Stuart Morgan, 'Gerard Williams', *Artscribe*, no.
 72, November-December.

1989 Sarah Kent, 'Gerard Williams, Anthony
 d'Offay', *Time Out*, February 1-8.
 Edward Lucie-Smith, 'Tweetie-Pie of the Art
 Market', *The Independent*, April 22.
 Angela Vettese, 'Un maniero per dodici', *Il Sole
 24 Ore*, October 22.
 Vittoria Lanzilotti, 'Atelier nel castello di artisti
 inglesi e tedeschi...', *Stampa Sera*, October 12.
 Angelo Mistrangelo, 'L'avanguardia dentro il
 castello', *Stampa Sera*, November 2.
 'Tre scultori inglesi alla Sala 1', *La Republica*,
 November16.
 Enzo Bilardello, 'Le luci e le ombre', *Corriere
 Della Sera*, November 20.
 'Tres Scultori Inglesi', *Proposte*, December 7-21.

1990 Lucilla Meloni, 'Richard Wentworth, Grenville
 Davey, Gerard Williams: Sala 1', *Tema
 Celeste*, no. 24, January-March.
 Carolyn Christov-Bakargiev, 'Grenville Davey:
 Primo Piano,Wentworth, Davey, Williams: Sala
 Uno', *Flash Art*, no. 154, February-March.
 'Gerard Williams', *Juliet*, no. 46.
 'Talleres de arte contemporáneo en Bétera
 Cultura', *Hoja Del Lunes*, March 19.
 E.L. Chavarri, 'TAC-90', *Las Provincias*, March
 20.
 Andújar, 'Blasco Visita los Talleres de Arte',
 Las Provincias, March 22.
 Maria José Obiol, 'Experimentar con arte', *El
 País*, March 23.
 F. Arias, 'Taller de arte internacional', *Hoja Del
 Lunes*, March 26.
 Rafael Prats, 'El taller de Bétera', *El Mercantil
 Rivelles Valenciano*, March 29.
 J.A. Blasco, 'La nueva generación de
 artistsas', *Carrascosa El Mercantil Valenciano*,
 April 3.
 Tom Lubbock, 'Simplicity and the great hanging
 debate', *The Independent on Sunday*, July 15.
 F. Arias, 'TAC90: arte de todos los pelajes en la
 viña del señor', *Hoja Del Lunes*, June 18.
 Sarah Kent, 'Gerard Williams, Interim Art', *Time
 Out*, July 18-25.
 'New Art at Kettle's Yard', *The News Line*,
 August 21.

CRAIG WOOD

Born 1960, Leith, Edinburgh.

EDUCATION

1984-85 Dyfed College of Art, Camarthen.
1985-88 Goldsmiths' College, University of London, B.A.
 (Hons.)

ONE-PERSON EXHIBITIONS

1989 The Crypt, Bloomsbury, London.
1990 Laure Genillard Gallery, London.
 Galerie des Archives, Paris.
 Galerie Etienne Ficheroulle, Brussels.

GROUP EXHIBITIONS

1988 *Monumental Works*, The Crypt, London.
 Death, Kettles Yard Gallery, Cambridge.
1989 *Current*, Swansea Arts, Wales.
 Norwood 1, Arches 7,8,9, west Norwood,
 London.
1990 *Modern Medicine*, Building One, London.
 Summer Show, Laure Genillard Gallery, London.
 Exposition 1-1990, Centre International d'art
 Contemporain de Montreal, Montreal.
1991 Galerie des Archives, Paris.
 Graeme Murray Gallery, Edinburgh.
 Perry Roberts and Craig Wood, Third Eye
 Centre, Glasgow; Chisenhale Gallery, London.
 Symposium im Fort Kugelbake, Cuxhaven.

PUBLICATIONS

1991 *Perry Roberts and Craig Wood*, Glasgow and
 London: Third Eye Centre/Chisenhale Gallery.
 Text by James Roberts.

REVIEWS

1989 Mark Currah, 'The Gold Rush', *City Limits*,
 November 23-30.
1990 Shelagh Wakely, 'Craig Wood', *Time Out*,
 February 7-14.
 Sachigo Tamashige, 'Craig Wood', *Nikkei Art*,
 April.
 Doris V. Drateln, 'Craig Wood', *Kunstforum*,
 April-May.
 James Roberts, 'Gladstone Thompson, Craig
 Wood', *Artefactum*, April-May.
 Jonathan Watkins, 'Metamorphic Strategies', *Art
 International*, Summer.
 Olivier Zahm, 'Craig Wood', *Art Press*,
 September.
 Eric Troncy, 'Craig Wood', *Artscribe*, November-
 December.

ACKNOWLEDGEMENTS

The editors would like to thank: the artists; the discussion participants; Nikos Stangos at Thames & Hudson; Peter Chater at Karsten Schubert Ltd; Laure Genillard and Muriel Charriere at Laure Genillard Gallery; Rose Alexander and Glenn Scott Wright at Interim Art; Nicholas Logsdail, Sharon Essor and Elizabeth McRae at Lisson Gallery; Robin Klassnik at Matt's Gallery; Tim Taylor at Waddington Galleries; Michael Brady, and everyone at Art Monthly.

Andrew Renton was born in Manchester in 1963. He was educated at the
Manchester Grammar School, The University of Nottingham and the University of
Reading, where he obtained his Phd. He has contributed to many periodicals on
contemporary art and is the British correspondent for Flash Art.

Liam Gillick was born in Aylesbury in 1964. Since leaving Goldsmiths' College in
1987 he has exhibited work in Britain and abroad. In addition he has contributed
to various art magazines including Artscribe, Art Monthly, Arts and Flash Art.